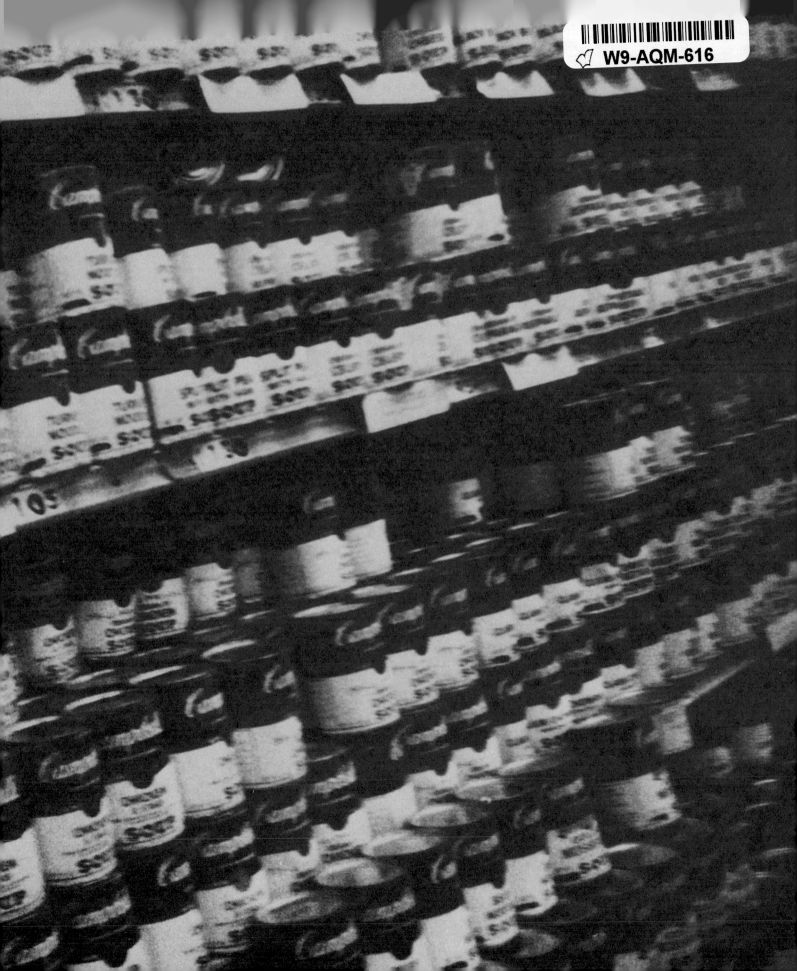

daido **MORIYAMA** : stray dog

SANDRA S. PHILLIPS ALEXANDRA MUNROE DAIDO MORIYAMA

daido **MORIYAMA**: stray dog

San Francisco Museum of Modern Art · Distributed Art Publishers, New York

This catalogue is published on the occasion of the exhibition
Daidō Moriyama: Stray Dog, organized by Sandra S. Phillips
at the San Francisco Museum of Modern Art and
the Japan Society Gallery, New York. The catalogue is
co-published by the San Francisco Museum of Modern Art
and Distributed Art Publishers, New York.

EXHIBITION SCHEDULE
San Francisco Museum of Modern Art
May 14–August 3, 1999

Japan Society Gallery, New York
The Metropolitan Museum of Art
September 23, 1999–January 3, 2000

Fotomuseum Winterthur, Switzerland
January 29–March 26, 2000

Museum Folkwang, Essen, Germany
May 21–July 2, 2000

Harvard University Art Museums, Cambridge,
Massachusetts
August 12–October 29, 2000

Museum of Photographic Arts, San Diego
November 2000–January 2001

Beginning in the spring of the year 2001
the exhibition will travel to several museum venues in Japan.

Distributed Art Publishers/D.A.P.
155 Sixth Avenue
New York, New York 10013
Tel: 212.627.1999
Fax: 212.627.9484

The exhibition *Daidō Moriyama: Stray Dog* is supported by
The Japan Foundation.

The Japan Society Gallery presentation of this exhibition is
supported by The W.L.S. Spencer Foundation.

Note to the Reader: In this publication macrons have been
used to indicate long vowels in Japanese names and words
such as Tōno and sayōnara. Macrons have been omitted in
words that have a standardized English alternative such as
Tokyo and Osaka. The title of Moriyama's book *Nippon gekijō
shashinchō* is translated here as *Japan: A Photo Theater.*
The book is also known as *Nippon Theater.*

LIBRARY OF CONGRESS
CATALOGING-IN-PUBLICATION DATA

Phillips, Sandra S., 1945–
 Daidō Moriyama : stray dog / Sandra S. Phillips
and Alexandra Munroe.
 p. cm.
 Catalog of an exhibition held at the San Francisco
Museum of Modern Art, May 14–Aug. 3, 1999.
 Includes bibliographical references.
 ISBN 0-918471-50-8 (hardcover)
 1. Photography, Artistic—Exhibitions. 2. Moriyama,
Daidō, 1938– —Exhibitions. 3. Photography—Japan—
Exhibitions. I. Moriyama, Daidō, 1938– . II. Munroe,
Alexandra. III. San Francisco Museum of Modern Art.
IV. Title. V. Title: Stray dog.
TR647.M667 1999
770'.92—dc 21
[b] 98-49868
 CIP

Publication Manager: Kara Kirk
Editor: Karen Jacobson
Designer: Keiko Hayashi
Production: Betsy Joyce
Publication Assistant: Alexandra Chappell

Front Cover: Detail of plate 22: *Stray Dog, Misawa,
Aomori,* 1971 (Cat. No. 133)
Back Cover: Detail of plate 93: *Osaka,* 1996 (Cat. No. 193)
Frontispiece: *Housing Development, Tokyo,* 1967 (Cat. No. 30)

PHOTOGRAPHY CREDITS
Figures: Fig. 2: photo by Ben Blackwell, © Eikoh Hosoe,
courtesy Howard Greenberg Gallery; fig. 3: photo by Ben
Blackwell, reproduced with the permission of the artist;
figs. 4–7, 27, 31: photo by Tokyo Metropolitan Museum of
Photography; figs. 8–10, 12–13, 28: photo by Ben Blackwell;
fig. 11: photo by Ben Blackwell, © 1999 Andy Warhol
Foundation for the Visual Arts/ARS, New York; fig. 14: photo
by Fine Arts Museums of San Francisco; fig. 15: photo
© Henri Cartier-Bresson, courtesy of Magnum Photos, Inc.;
fig. 16: © Ken Domon, photo courtesy of the Ken Domon
Museum of Photography; fig. 17: © Kikuji Kawada, photo
courtesy of the Tokyo Metropolitan Museum of Photography;
figs. 18–19: © Ikkō Narahara, photo courtesy of the Tokyo
Metropolitan Museum of Photography; figs. 20–22:
© Shōmei Tōmatsu, photo courtesy of the Tokyo Metropolitan
Museum of Photography; figs. 23–24: © Eikoh Hosoe, photo
courtesy Howard Greenberg Gallery, New York, and the Tokyo
Metropolitan Museum of Photography; fig. 25: © Masahisa
Fukase, photo courtesy of the Tokyo Metropolitan Museum
of Photography; figs. 26, 30: Takayuki Komori Collection;
fig. 29: National Museum of Modern Art, Tokyo.
Plates: All copy photography is by Ben Blackwell except
as noted here: pls. 26, 67–69, 71–74, 78, 80, 82, 88,
90–94: copy photography by Daidō Moriyama; pl. 34: photo
courtesy of the National Museum of Modern Art, Tokyo.

Printed and bound in Italy

Daidō Moriyama was born outside Osaka in 1938, just seven years before the atomic bombings of Hiroshima and Nagasaki, events that would alter the course of history and the character of Japanese life and culture. Every country experienced dramatic change in the decades following World War II, but in Japan, which had been a relatively insular and traditional society before the war, the change was especially radical and occurred with astonishing speed. For Moriyama and many other artists of his generation, the "new" Japan became the core subject of their work. It is the complex nature of the change that has informed Moriyama's photographs: the startling juxtaposition of age-old tradition with contemporary practice, the paradox of a culture that found the transformation at once disturbing and liberating, shocking and compelling.

Moriyama's pictures are grainy, full of harsh contrasts, deliberately raw, and eschew technical sophistication. Yet in them stylistic elements derived from the popular media—tabloids, advertisements, television—have been transformed into a subtle, sophisticated aesthetic, one that has been shaped by the photography of William Klein and Andy Warhol, the novels of James Baldwin and Jack Kerouac, and the experimental theater of Shūji Terayama. Moriyama has filtered these diverse influences through his own distinctive perspective to create an extraordinary body of work.

That we have the good fortune to view these photographs is due in large part to the exceptional efforts of Sandra Phillips, curator of photography at SFMOMA and organizer of this exhibition. Dr. Phillips spent a number of years working with the artist to develop *Daidō Moriyama: Stray Dog,* and we are grateful for her energy, enthusiasm, and serious exploration of the work and its cultural context. The fortuitous discovery of a cache of the artist's original prints only increases the richness and importance of this exhibition.

We are indebted to the lenders to the exhibition, whose names are listed on page 6, for their willingness to share their artworks with us. A number of colleagues at lending institutions went out of their way to facilitate loans and assisted Dr. Phillips in her research, particularly Michiko Kasahara, Fuminore Yokoe, and Kazuko Sekiji, of the Tokyo Metropolitan Museum of Photography, and Rei Masuda, of the National Museum of Modern Art, Tokyo. Assistance was also provided by colleagues at Taka Ishii Gallery, Los Angeles and Tokyo; at Zeit-Foto, Tokyo, especially Etsuro Ishihara and Minoru Maeda; and at Laurence Miller Gallery, New York.

We are delighted that *Daidō Moriyama: Stray Dog* will travel to a number of other museums in the United States and abroad, and it has been a pleasure to work with colleagues at these institutions, including James Cuno, director of the Harvard University Art Museums; Ute Eskildsen, director of the photography department of the Museum Folkwang in Essen, Germany; Maria Morris Hambourg, curator in charge of the Department of Photographs at the Metropolitan Museum of Art, New York; Arthur Ollman, director of the Museum of Photographic Arts, San Diego; and Urs Stahel, director of the Fotomuseum Winterthur in Winterthur, Switzerland.

On behalf of Dr. Phillips, we would like to thank Dr. Peter Duus, the William H. Bonsall Professor of History at Stanford University; Eikoh Hosoe, who initially hired Moriyama as his assistant and later helped to preserve his work at the Tokyo Institute of Polytechnics; Kohtaro Iizawa, writer and photography historian; Yasuhiro Ishimoto; Robert L. Kirschenbaum; Kōji Taki; Peter Kovach, former counselor for cultural affairs at the American embassy in Tokyo; John Szarkowski, director emeritus of the Department of Photography at the Museum of Modern Art, New York; and Dr. Marc Treib, professor of architecture at the University of California, Berkeley.

Many staff members at both of our institutions worked long and hard to mount this exhibition. At SFMOMA, we would like to recognize in particular the efforts of Theresa Andrews, associate conservator; Susan E. Bartlett, assistant registrar; Olga Charyshyn, registrar; Suzanne Feld, curatorial associate; Lori Fogarty, senior deputy director; Tina Garfinkel, head registrar; Barbara Levine, exhibitions director; Kent Roberts, installation manager; Ariadne Rosas, secretary for the Department of Photography; Thom Sempere, graphic study manager; Heida Q. S. Shoemaker, Getty/Kress fellow in conservation; Marcelene Trujillo, exhibitions assistant director; Greg Wilson, museum preparator; and interns Alyson Belcher, Ann Do, and Caroline Mastreani. A special word of thanks is also due John R. Lane, former director of SFMOMA and current director of the Dallas Museum of Fine Arts, for his early support for this endeavor.

At the Japan Society Gallery, we would like to recognize Jane Rubin, assistant director; Richard Pegg, curator of education; and Takahide Tsuchiya, assistant to the director, for their assistance with many aspects of this project. In addition, we offer special thanks to Ambassador William Clark, Jr., president of the Japan Society, for encouraging the presentation of contemporary Japanese art at the Japan Society Gallery, and to John Wheeler, vice president; Carl Schellhorn, vice president and treasurer; and Elizabeth Costa, director of development, for their strong commitment to this undertaking.

This publication, which so thoughtfully evokes the spirit of Moriyama's oeuvre, was produced at SFMOMA. We are especially grateful to Keiko Hayashi, the museum's graphic design manager, who designed this volume, and to Kara Kirk, publications and graphic design director, and Alexandra Chappell, publications coordinator, who shepherded the project through its many stages. We are equally indebted to Miwako Tezuka, who compiled the chronology, bibliography, and exhibition history; to Karen Jacobson, who contributed her editorial expertise; and to Betsy Joyce, for graphic design production.

Because so little material on Moriyama has been published in English, much translation work was required to complete this project. We are especially grateful to Linda Hoaglund, who translated the two excerpts from writings by the artist that are included in this volume, and to C. Miki Wheeler, Joseph Sorensen, and Christine Shippey, who translated countless research documents. On behalf of Linda Hoaglund, we gratefully acknowledge Judith Aley for her editorial assistance, and Kazuhide Miyamoto and Hiroe Kawakami, of the publishing house Shinchōsha, for sharing their wisdom on the history of Japanese photography.

We are greatly obliged to the Japan Foundation for its generous organizational support of *Daidō Moriyama: Stray Dog*. Our sincere appreciation goes as well to the W.L.S. Spencer Foundation for support of the presentation at the Japan Society Gallery.

Deepest personal thanks are also due to Koko Yamagishi, a longtime friend of Daidō Moriyama's and a mainstay to the photographers who were of particular interest to her late husband, Shōji Yamagishi, editor of *Camera Mainichi*. She aided our efforts in ways too numerous to list here. We also express our gratitude to Rui Takagi, assistant to Ms. Yamagishi.

And, finally, we thank Daidō Moriyama for his patience and understanding during the organization of this complex transcontinental project and for his intelligence and his splendid gift.

David A. Ross
San Francisco Museum of Modern Art

Alexandra Munroe
Japan Society Gallery

daido MORIYAMA : stray dog SANDRA S. PHILLIPS

There is a photograph of a stray dog in the street. The dog is potentially dangerous or, at the very least, wary, guarded, caught in the impersonal hustle, the coldness and rudeness of a rough urban street. Protected by his heavy, matted coat, he cautiously observes the photographer. The picture was made on the fly, the conjunction of two beings in a moment, seen almost out of the corner of the eye. It is very different from the grand, poised pictures in the tradition of street photography, especially as practiced by Henri Cartier-Bresson. The dog is seen askew; the frame is tilted up, proving the spontaneous nature of the picture's creation. The image is grainy and dark, verging on unfocused. It is a hypnotic, hard, and very personal picture. Frozen in the present, the dog also has a primitive, mysterious energy that transcends the immediate moment. He appears somehow magical, demonic, even possessed (pl. 22).

Daidō Moriyama encountered this dog in 1971, on the streets of Misawa, Aomori Prefecture, at the northernmost tip of Honshu, Japan's main island, near a U.S. Air Force base. Moriyama made the picture at a moment of tense, creative photographic activity in Japan, in which he was one of the principal players. He was born in Ikeda City, near Osaka, the great mercantile city of Japan, in 1938. The child of a middle-class family (his father was in the insurance business), Moriyama trained in graphic design at the Osaka Municipal School of Industrial Art and worked briefly in that field. He soon decided to pursue photography, however, and apprenticed with a local professional, Takeji Iwamiya. In 1961 Moriyama went to Tokyo, hoping to work for the photographer's cooperative VIVO. He arrived a week before the group dissolved,[1] but one of its members, Eikoh Hosoe, needed an assistant. Moriyama worked for him for the next three years.

VIVO represented the first collaborative professional photographer's organization of the postwar period; its members attempted to establish a new

visual territory, neither the established "art photography" based on traditional Japanese forms and inflected by pictorialist aestheticism, nor the journalistic work published during the war. The VIVO photographers, in different ways, were consciously trying to describe the new society that emerged after the war and their country's great sea change from defeated imperialist state to something new and unknown. Their work grew out of and expanded upon the photojournalistic tradition the photographers knew from magazines and from the American traveling exhibition *The Family of Man*.[2] Rather than documenting

the societal changes in a straightforward way—in the manner of Ihei Kimura (a.k.a. Ihee Kimura), who made, among many other pictures, the arresting and provocative record of a Japanese couple walking side by side on the street, American style (traditionally Japanese women would show deference by walking several paces behind the man)—the work from VIVO was more personal and psychologically engaged (fig. 1). Most of it was in thirty-five-millimeter format and printed with pronounced grain, in the style of the times. The photographers' main intent was to respond to their changed, highly charged society.

Critics and observers of postwar Japanese culture have rarely failed to remark not only on its radical, bold character but also on its lack of consistent precedent and linear development.[3] Unlike its Western counterpart, the Japanese avant-garde was an expression of a dissident culture that always remained outside the mainstream. Much Japanese art of the 1960s and early 1970s in all areas—painting, film, theater, literature, and photography—

was deeply shocking and provocative, reactive to politics and social concerns. Thus, a symposium on photography and its relationship to both artistic expression and documentation, published in *Camera Mainichi* in 1965, is evidence of the dynamism of the medium and also of the challenges Japanese photographers faced, trying to extract lyrical expression from their charged and complex subject matter.[4] Like the Japanese New Wave cinema, the carnival-inspired theatrical performances of Moriyama's friend Shūji Terayama, and other outbursts of radical creative energy, photography of this period in Japan was umbilically connected to the conflicting social forces it recorded. In the works of his contemporaries Moriyama discovered deep, untapped sources of emotional energy, which shaped him profoundly.

Moriyama's employer, Eikoh Hosoe, was the first internationally recognized artistic photographer of his generation in Japan. He was also a sought-after commercial photographer and needed to spend much time managing his career. As a result, the young apprentice was able not only to learn his métier but also to get to know the work of other members of the VIVO group. Moriyama had access to VIVO's files and could study the members' contact sheets and prints. The most personally meaningful work he found was that of Shōmei Tōmatsu, eight years his senior, who never accepted commercial projects and insisted on making his own kind of pictures. He was a very different photographic personality from Hosoe.

At the time Moriyama was assisting Hosoe, the older photographer was engaged in an artistic project, a series devoted to Yukio Mishima (1925–1970), the author of *The Sailor Who Fell from Grace with the Sea* (1963) and *The Sea of Fertility* tetralogy, completed at his death. The elaborate and deeply self-conscious project, entitled *Ordeal by Roses* (*Barakei,* 1963), originated from Mishima's need for a publicity photograph. On their first meeting, encouraged to improvise, Hosoe asked Mishima

to lie on his back in front of the family pool, wrapped him in the garden hose, and made a picture of a beautiful youth in bondage, which delighted the author (fig. 2). Mishima immediately commissioned the photographer to make an extended symbolic portrait, recording his defiantly sexual, muscular body. Mishima solemnly told Hosoe, "I am your subject matter," and the two became partners in a kind of inventive theater. Hosoe paired the writer, usually dressed only in the traditional Japanese loincloth, with reproductions of Italian Renaissance and Baroque paintings or composed imaginative couplings of Mishima's form with dismembered female bodies.

Mishima, although politically a radical conservative, was also a liberating force in postwar Japanese artistic circles. His novel *Forbidden Colors* (1954) was the basis of the dancer Tatsumi Hijikata's first major performance. Although the novel itself seems artificial in its construction, the energy and intensity of the main character—a young, married homosexual man whose fierce self-possession and erotic conviction defied the conventions of Japanese society—resonated eloquently with contemporary readers. Mishima's work appears to have little in common with that of Moriyama, and yet the writer articulated an emotional void, a nausea and anxiety that resembled the existential crises described by Albert Camus and Jean-Paul Sartre.[5] Mishima was also deeply affected by the dancer Hijikata's investigation of eroticism, madness, obsession, and rage. Hijikata's work drew upon a primeval, agrarian Japaneseness and articulated an emotional extremism that ran counter to the ravenous assimilation of modern American material and popular culture that was prevalent in Japan after the war.[6]

fig. 2 | Eikoh Hosoe
Ordeal by Roses #6, c. 1961
Courtesy Howard Greenberg Gallery

Mishima was of great importance to Moriyama: "I was an avid reader of the novelist Yukio Mishima since I was about fifteen. My concerns lay in Mishima's literary world (not his political world). During the period of the project *Ordeal by Roses*, Mishima was a star writer, so when I first encountered the works of Hosoe, I was really impressed."[7]

Mishima's concerns—and Hosoe's photographs—relate to Moriyama's photographic interests only in a larger sense. Moriyama is an expressionist: he possesses a dark, intense eroticism and an appreciation for the tragic. He understands the conflicts in Japanese society—between acceptance of Western culture and the quest for a separate Japanese identity, between acceptance of modernity and admiration for traditional Japanese ritual and custom. These conflicts also resonated in Mishima. It was Moriyama's gift to infuse the commonplace, populist appreciation of what he found on the street with a foreboding energy, to fuse Mishima's two worlds—that of conventional society and the powerful undercurrent of the forbidden—and to do it in the language of the everyday.

Moriyama's vision was immeasurably enriched by his acquaintance with the work of two American artists: William Klein and, a little later, Andy Warhol. *Less than one year after I had entered the world of photography (while still in Osaka), I saw my first collection of photographs by a foreign photographer. It was William Klein's* New York. *If the first book on photographs and photography I saw were, for instance, by Cartier-Bresson, I probably would not have been so shocked. The page I opened to had a commanding image of New York City, all backlit, and I certainly was shocked. And then the many other images, some grainy and rough, some high contrast, all went beyond the meaning inherent in the photos themselves, and I was overwhelmed. At that time, what moved me the most was the simple realization that photography was such a free art form.*[8]

Klein's book *New York,* published in 1956 in Paris, came out in a Japanese edition the following year. It proved instantly successful; many young photographers were fascinated by these pictures. Klein's innovative format encompassed a plethora of urban subjects—pop advertisements, isolated shoppers, deranged children, murderers, gangsters, indulgent rich people—all subsumed by a dizzy vitality (fig. 3). For Japanese photographers it provided the possibility of a new subject: the modern, industrialized Western city, a subject depicted briefly in Japanese art during an earlier period of Western experimentation, the 1920s and 1930s, and one these young photographers embraced with enthusiasm.[9] The style of the pictures—deeply indebted to the tabloids and, in particular, the graphic, gritty work of Weegee—was profoundly moving to the Japanese audience. Perhaps as important, however, was Klein's combination of the pathetic, the vital, and the humorous, as well as his frank hostility to New York: its clamor, its dirt, the massive overgrowth of commercial signage, the dangerous energy or bleakness of life on its streets, the brutality or vacant hostility of its citizens, its destructiveness to the spirit.

His expressionist intent led Klein to treat pictures very experimentally. Often he deliberately threw the subject out of focus, vertiginously tilted the frame, cropped invasively, bleached the pictures relentlessly, or exaggerated the grain. These techniques tended to accentuate the sense of disorientation that the photographer found nascent in the subject. Moriyama writes: "I was so touched and provoked by Klein's photo book [*New York*] that I spent all my time on the streets of Shinjuku, mixing myself in with the noise and the crowds, doing nothing except

fig. 3 | William Klein
Spread from the book *Life Is Good and Good for You in New York: Trance Witness Revels,* 1956
Collection of the San Francisco Museum of Modern Art. Library

clicking with abandon the shutter of a camera which I seized from a friend." He continues: "Photojournalists in Japan mainly expressed the 'anxiety and loneliness of a city people' or 'provocative criticism of material civilization.' This was irrelevant to me. I learned from his photos real experiences, not theories. Klein's images, which were rough, simple, and even violent at a glance, made me realize the limitless freedom, beauty, and tenderness of photographic art."[10]

When Klein came to Tokyo in 1961 (his book *Tokyo* was published in 1964), he photographed the bold, graphic calligraphy of its signs and the surreal, frenetic street theater; in fact, he worked with Hijikata and some of his dancers on improvised street theatrics. Klein briefly used VIVO's darkroom, and thus its members came to know him as well as his work. But Klein's presence in Tokyo was, for his audience in Japan, an afterthought, and his work in *Tokyo* seemed mannered after the volcanic eruption of *New York.*[11]

In 1964 Hosoe left for Europe, and Moriyama's work for him ended. The younger artist found a home in Zushi, a suburb near Tokyo close to the American naval base at Yokosuka, where he had begun to photograph. With Hosoe's encouragement, Moriyama set out as a freelance photographer and, through Shōmei Tōmatsu, met another photographer who would become a close friend and colleague: Takuma Nakahira, who was at that time editor of the magazine *Gendai no me* (The modern eye).

In 1965, Moriyama writes:

I met Takuma Nakahira regularly. We both lived in Zushi (ten minutes apart on opposite sides of the Yokosuka line railroad tracks) and both had a lot of time on our hands. That summer, in particular, we saw each other almost every day. We would meet in a coffee bar called "Tamaya" at lunchtime and then go diving for fish in the rock pools at Hayama Beach before continuing to Kotsubo Beach, where

we would sit and discuss the work of other photographers.

I visited Yokosuka almost every day for six months to take photographs. It was at Yokosuka that I learned the technique of taking quick shots in the street, and, around the same time, it was there that I first came to appreciate the pleasure that the act of taking a photograph can provide. I showed these photographs to Shōji Yamagishi, who worked for the Camera Mainichi *magazine and was one of the most radical editors in the business at the time. The first time I showed him my work he agreed to publish it without hesitation and went on to say that he would print anything else I brought him.*[12]

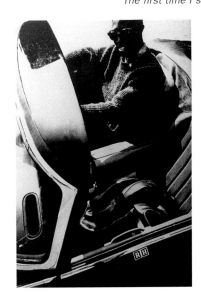

Moriyama became an active freelance photographer who published most conspicuously in *Camera Mainichi*. During the postwar period Japan, like many other industrialized countries, had its professional corps of photojournalists and commercial workers who were published in the mass press. Like their contemporaries in the United States, these photographers worked their craft and were not burdened by the belief that they were artists.

In the mid-1960s, even as now, the main outlet for a photographer was print: books, magazines, and ephemeral printed matter. The 1960s and 1970s also saw the emergence of special photography magazines sponsored by large media businesses, such as *Asahi Camera* and *Asahi Graph,* which operated under the umbrella of the major national newspaper *Asahi Shimbun,* and *Camera Mainichi,* sponsored by the newspaper *Mainichi Shimbun.* These specialized publications were directed toward the amateur market, profiting from Japan's postwar production of camera equipment and film.

fig. 4 | Daidō Moriyama
Yokosuka, from *Camera Mainichi,*
no. 8, 1965
Collection of the Tokyo Metropolitan
Museum of Photography

The photography magazines, especially *Camera Mainichi,* reflected not only Japan's exhilarating political and social turmoil but also the imaginative visual language of the new generation of photographers who responded to this fertile postwar tumult. Yamagishi, who had been a photographer himself, worked carefully with the chief editor to fashion a magazine that, for several years, balanced commercial necessity with the adventurous work of younger photographers. Modern photography as an art form in Japan was invented in these pages.[13] It was an unanticipated, unheralded but genuine aesthetic expression, as important as (although different from) the work of the so-called new documentary photographers who came of age simultaneously in New York, such as Diane Arbus, Lee Friedlander, and Garry Winogrand. Yamagishi had the confidence and clarity of vision to support these photographers, especially Moriyama, Tōmatsu, and Masahisa Fukase. Under his charismatic guidance, *Camera Mainichi* became a practical forum for them to challenge themselves and learn from one another, informed by what they saw around them.

Yamagishi's presence was of signal importance to Moriyama:

My first meeting with Yamagishi came just as I was starting my career as a photographer, and the experience would be a decisive one. . . . Back when I still didn't even know my own photos and when I didn't have a clear or conscious view of myself as a photographer, he published a series of photographs in rapid succession in the magazine Camera Mainichi, *and gave me help as far as supporting themes. I consider him my benefactor because he helped me find my style, an effort that was like excavating for some precious metal.*[14]

Moriyama's first published essay, which appeared in *Camera Mainichi* in August 1965, was devoted to the large U.S. naval base at Yokosuka, an important cold war presence for the American military. This

special territory was a revelation to Moriyama. There he photographed an exuberant young black serviceman driving a convertible (fig. 4); American-style neon and billboards advertising the pleasures of American goods such as Coca-Cola and the availability of Japanese women in local bars; and a young Japanese man stitching American military insignia for anyone who wanted these curious decorations (pl. 5).

In Japan's highly homogeneous, traditional, and still relatively isolated society, foreigners were considered more separate and distinctive from the general population than they were in other countries, but to Moriyama the Americans represented not only exoticism but also a freedom and energy that he associated with modernity. Just as Brassaï sought out subcultures in Paris and Weegee gravitated toward the criminals and bums of New York, Moriyama was attracted to the poetry and glamour of American low life, as seen at the military bases. He was fascinated not only by the novelty and crude venality of Yokosuka but also by its energy. He photographed the girls lingering outside the bars (one, surprised, runs barefoot up a tiny, trash-strewn alley; pl. 28); mixed couples, even those with a commercial relationship, in egalitarian postures (see pls. 7, 33); and the plethora of American material goods—the banks of watches, slot machines, coffee mugs in souvenir shops, advertisements of all sorts. The overload of American kitsch was regarded with fascination, just as what he thought he found in the animating spirit of the Americans was to him strange, new, and liberating.

Moriyama was not the only photographer to visit

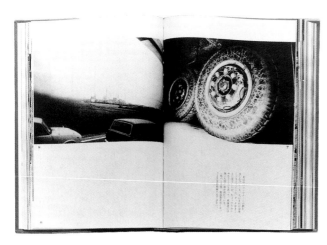

fig. 5 | Daidō Moriyama
From the series *National Highway 1 at Dawn,* published in *Camera Mainichi,* no. 12, 1968
Collection of the Tokyo Metropolitan Museum of Photography

American bases or to study, with irony or anger or detached interest, what seemed the almost wholehearted popular acceptance of American culture and its attendant ideology in postwar Tokyo. For the generation of Japanese photographers who came to maturity after the war—including Tōmatsu, Yasuhiro Ishimoto, and Ikkō Narahara (a.k.a. Ikko)—this changed, "Americanized" Japan was the core subject of their work. The premodern, prewar society, which eschewed foreign influence, artificially linked the "modern," "Westernized," "democratic" Japan in a simplified but persistent opposition. Even in such journalistic investigations of the country as Werner Bischof's dignified, sympathetic book *Japan,* this duality is maintained.[15]

In one of Moriyama's pictures, two Japanese soldiers are seated in a provincial coffee shop, the early morning light touching their young faces with delicacy and immutability (pl. 26). It is a complex picture, made so by recent history. After the war the occupying American forces engineered the adoption of a "peace constitution," in which Japan renounced the sovereign national right to wage war. By the time of the Korean War it was swiftly and conveniently subverted in the interest of American cold war strategy in Asia. In Moriyama's image the fragile, sensitive faces of the young members of the "self-defense forces," the supposedly harmless American-imposed army, take on a powerful, memorable ambiguity, one that is particularly resonant when the faces of young, self-immolating members of the Japanese Imperial Army are recalled.

When Moriyama photographed Yokosuka, the naval base was of immense importance in the recently escalated but undeclared war in Vietnam, a conflict that, as it evolved, would fuel the antiwar sentiments of the left and the student movement.[16] What Moriyama found there, however, was a spirit of revolt, the breaking of bonds of tradition, the ideals, at least, of democracy and modernity.

Many of the photographers who responded to these dynamic events in Japan were regularly published in *Camera Mainichi.* Their work was not overtly political. In fact, by Japanese standards it was not political at all, but personal. There were, for instance, pages devoted to the large, impersonal housing developments (*danchi*) quickly erected for the upwardly mobile "salarymen" and workers; stories about students organizing with farmers to prevent the destruction of agricultural land around the Haneda airport, used by the Americans in their military operations in Vietnam; and images of the Japanese counterculture. Some of the pictures testified to the presence of Americans in Japan: portraits of children of mixed race, called "half-breeds"; essays on young American girls living in Japan; and Tōmatsu's photographs of the cold, hollow interior of the American embassy. There were, scattered among the fashion shots that must have ensured the magazine's success, pictures of Japan's emergent industry, the labor force, and the new industrial wastelands. And there were Moriyama's photographs, full of freedom and speed, shot from a car window on the new highways around Tokyo (fig. 5).

There were two prominent figures, both older than Moriyama, whose pictures regularly appeared in *Camera Mainichi:* Yasuhiro Ishimoto (b. 1921) and Shōmei Tōmatsu (b. 1930). Ishimoto, the older of the two, has had a most unusual career for a Japanese person. Born in San Francisco, he moved to Japan as a youth, then returned to the United States in 1941 to enter the University of California, Berkeley. During the war he was interned at Amache, Colorado, where he learned photography. Following

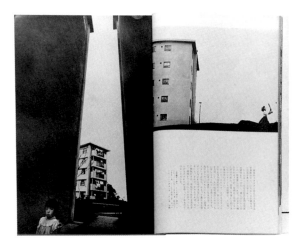

his release, he went directly to Chicago and studied at the Institute of Design with Harry Callahan and Aaron Siskind. Ishimoto returned to Japan in 1953, came back to Chicago five years later, then left for Japan again in 1961, becoming a naturalized citizen in 1969. Of all the Japanese photographers he was the most familiar with the history of American photography and with American culture. He was considered—and considered himself—something of an outsider in Japan. Perhaps because of his personal experience, he was especially sensitive to figures who seemed isolated or excluded.

When Ishimoto came back to Japan to stay, his work frequently appeared in magazines, especially *Camera Mainichi.* In 1963 he published a series entitled *Faces of Tokyo,* and two years later he worked on a project with Tōmatsu and Shigeichi Nagano, later published in book form as *The City.*[17] In Ishimoto's essay in *Camera Mainichi* on the *danchi,* his relationship to Callahan is evident in the spare overall design and his aesthetic appreciation of the sterility of the environment, reminiscent of the tall, impersonal canyons of skyscrapers he had seen in Chicago (fig. 6).[18] The pictures are a critical gloss on modernity as well as Western-style industrialism.

A more complex and diverse body of work was produced by Tōmatsu, even then the dominant voice of postwar Japanese photography. Both Tōmatsu's work and his presence were extremely influential for Moriyama, who had sought him out since his early association with the VIVO photographers.[19] Tōmatsu's projects of the 1960s and 1970s focused directly on the political issues that faced modern Japan: the aftermath of war, specifically the experience of the Nagasaki survivors and the extended presence of American troops. His book on Okinawa describes a complex historical and political situation with a combination of anger and delicacy.[20] During the 1960s he photographed the discordant and rebellious youth culture in the Shinjuku district of Tokyo.[21]

Tōmatsu's pictures possess a dynamism and intelligence that make them the major photographic statement of his generation. His chief tool is the detail, understood symbolically and seen with passionate clarity. Unlike Moriyama's, his is an entirely Japan-centered worldview; also unlike Moriyama, he is wholly critical of the invasive spread of American culture to Japanese soil. His picture of a snarling black sailor (fig. 7) offers a perception of American forces that is very different from Moriyama's. Rather than finding a new and liberating culture on the American bases, Tōmatsu saw something more sinister:

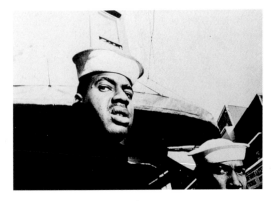

I believe that Americanization originated from the American military bases. I have the impression that America gradually seeped out of the meshes of the wire fences that surrounded the bases and before long permeated the whole of Japan. In 1945, the decisively beaten Japanese cities were filled with Allied soldiers and officers. They distributed chocolate and chewing gum to war starved faces. That was America. For better or worse, that is how I first encountered America. Since then I have been unable to pull myself away from the idea of "occupation." I am unable to avert my eyes from America, the country which has a strong grip on me, the country I've never seen but had a fateful meeting with, the foreign land which appeared in the concrete form of an army, the "occupation" by the American army.[22]

fig. 7 | Shōmei Tōmatsu
American Sailors, Yokosuka, 1966
Collection of the Tokyo Metropolitan
Museum of Photography

On the Road

Rather than perceiving Americanism as invasive or dehumanizing, Moriyama, unlike his older colleagues, had a more complex appreciation of the changes he witnessed. Motivated by Jack Kerouac's novel *On the Road*,[23] he set off to photograph what he encountered on Japan's newly erected highways.

Hitchhiking, or finding someone to drive him, he moved around in ordinary places, and his pictures—many of them blurry, offhand, taken through a car window at dawn or from behind a rain-spattered windshield—evoke the excitement, the photographer's quest for half-lit experience and adventure. It was an individual quest, a Route 66-style journey of self-realization, and it would anticipate the restlessness that accompanied the photographer in maturity. Moriyama's photographs of women in the street, pictures of the wasteland that precedes the cities, and images that convey the palpable exoticism of steel, rubber, and asphalt suggest a relationship to his subject matter that is more romantic than critical.

Another kind of journey occupied Moriyama in Tokyo. He sought out a kind of underworld of the theater, the pungent entertainment of ordinary, working Japanese; the wonderful and fertile variety of strip joints (both American and Japanese); the surviving progeny of traditional wandering troupes of actors playing in Kita-senju or Asakusa; the smoky bars in the gangster districts of the city; and the performing group of his friend Shūji Terayama, which played in tiny Shinjuku movie theaters after the crowd left or in a tent set up in a park. He followed the itinerant Dosa-Mawari troupe, photographing a smiling, hairy-chested middle-aged man made up as a geisha and a white-faced actor clenching a knife blade in his teeth, posed in front of a small hand-painted scrim, and he followed an actor who was a dwarf. By disclosing the artifice of the experience, these pictures reinforced the presence of the camera and the curious photographer. In the metaphor of theater-as-life, of all Japan as theater, everything seems equally unreal, equally vibrant and strange. As Moriyama has said: "My underlying thought was to show how in the most common and everyday, in the world of the most normal people, in their most normal existence, there is something dramatic,

remarkable, fictional. This kind of chaotic everyday existence is what I think Japan is all about."[24]

For Moriyama, the role of outsider was a cherished one. Just as he was taken with Kerouac's persona of the bohemian loner on the road, so, in fact, he idealized most outsiders: the actors, the habitués of pachinko parlors, the Americans at Yokosuka.[25] The style that he developed—askew camera, blurred focus—signaled that the picture was made in haste, on the run, in a secret gesture, before he fled. The actor lives a magical existence despite, or perhaps even because of, its marginal nature. The children

doing their homework by the roadside, glimpsed through the window of a passing car, the young prostitute running up the alley—all of these people share a kind of authentic existence outside the normal social fabric. Moriyama's taste in American literature, which ran not only to Kerouac's books but also to James Baldwin's *Another Country* and Nelson Algren's novels, accords with the Japanese idealization of the outsider as a special individual—suffering, free of constraint, and isolated.[26]

Moriyama's first book, *Japan: A Photo Theater* (*Nippon gekijō shashinchō*), was published in 1968 with a foreword written by Terayama, a major figure in Japanese experimental theater. Terayama was committed to reenergizing theater by taking it back into the street, reaffirming its relationship to ordinary people and everyday life, realigning it with the raucous low theater, similar to our vaudeville. He expanded his cast to include dwarfs, nude women, obese persons, and other antiheroes, and he projected a sense of the prehistoric, magical, even heroic through these marginal characters.[27]

Pictures of the group figure prominently in *Japan: A Photo Theater:* an actor boldly and seductively models rubber breasts; a strange tattooed man-woman

wrapped in a sheet entices an audience, calling them inside, sirenlike, with a primitive flute (fig. 8). In the book Moriyama introduced into this fabric actors more outrageous and sympathetic than those playing in the official theater and scenes as extraordinary and strange: an old woman, nude, smiling as beatifically as a Buddha at the cheap Atami hot-springs resort; a sanctimonious newly married couple in front of their housing development, clutching at a box of soap powder whose name is transliterated as "Number One" in katakana (pl. 10). In Moriyama's photographs the grotesqueries that inhabit Terayama's productions and Hijikata's performances and the works of such contemporaries as the novelist Kenzaburō Ōe and the filmmaker Susumu Hani all coalesce.[28] They are the antimodernist, folkloric, pre-Buddhist ghosts who persist in the midst of a prosperous, reemergent society. Moriyama admires the way in which American forms of cheap entertainment, such as the striptease, were transformed by the Japanese and, in the process, made more primitive, erotic, artful, and ritualistic.[29]

Moriyama usually made his pictures in series (many in *Japan: A Photo Theater* were made for *Camera Mainichi,* in a series entitled *Entertainers*), which he then ripped from their narrative fabric and conjoined, one or two pictures to each spread, into the discordant, highly evocative form of the pictorial book. In a review Shinichi Kusamori remarked on the apparent randomness of this early book, noting that it accurately and tellingly reflected the disjointed conjunctions of contemporary life in Japan.[30] In fact, the critic compares Moriyama to a satiated fly who cannot leave the carcass, so buried was he in his subject: the disjunctiveness and disturbance of modern experience. But it is this low theater of contemporary experience, in which both the folkloric, premodern Japan and the brutal and primitive passages in modern society are conjoined: a scene snatched from a current American film, the moment

of gory death from the film *Bonnie and Clyde* (U.S., 1967, directed by Arthur Penn); a striptease artist in Yokosuka seen in an almost religious, cultic moment; the happy Japanese gathering of Lion's Club members in their ritual American costumes (pls. 9, 28). These are all subjects that are both appropriated from recent history and, like the moments from Japanese theater, essentially and unequivocally Japanese.[31] The book closed with the earliest pictures Moriyama made as a self-defined photographer after he left Hosoe's studio: pictures of stillborn babies, aborted children he found in country hospitals—frightening, vulnerable, and new—a series he named *Pantomime* (pls. 95–96).

performances; they met after the sometimes violent student demonstrations or the wild, orgiastic parties of the youthful counterculture, of which Shinjuku was the center.[32]

The *Provoke* Era

In Shinjuku, Moriyama also continued his friendship with Takuma Nakahira, who had left *Gendai no me* and founded the magazine *Provoke* in 1968 with Kōji Taki. The move to Shinjuku intensified Moriyama's relationship with Nakahira, an articulate, politically impassioned, educated man. They shared studio facilities, and Nakahira invited him to participate in the second and third issues of the magazine, on

eroticism and the special expressive possibilities of photography, respectively. Nakahira was a great challenge to Moriyama and a great friend.[33]

Although Moriyama does not profess to be an intellectual, he was thrust into the atmosphere of existentialism

By 1966 Moriyama had moved to Shinjuku, the site of Tokyo's densest high-rise development. Shinjuku partly inspired the vision of the overpopulated, overdeveloped future city in the film *Blade Runner* (U.S., 1982, directed by Ridley Scott). Behind the massive postwar development, the enormous department stores and shops hawking the latest in electronic equipment, were the labyrinthine older quarters, the small bars and narrow wooden structures evocative of an older age and culture. This is where Moriyama found his friends in the evening, where he would talk and drink late into the night with the photographer Masahisa Fukase, Yamagishi, and others of his group. Like the Americans, they too experimented with drugs and absorbed rock music. They gathered at their favorite bars in the Golden Gai after watching Terayama's

and leftist political ideas at the offices of *Provoke*, and his pictures reflect the darkness, uncertainty, and disquiet experienced by many of his contemporaries. Moriyama was himself not actively politically engaged in any organized fashion; he left that duty to his friend. Nakahira was an intellectual. He was a Marxist and was deeply sympathetic to the student revolutionaries and, like most young Japanese, to the fertile intellectual activity in France. He also had studied Spanish and knew the problems and contradictions of revolutionary activity in Latin America, especially Cuba. After *Provoke* ended (the third and last issue appeared in August 1969), Nakahira went to Paris.[34]

In 1968, the year *Japan: A Photo Theater* was published, the American forces suffered the Tet Offensive and the most intense fighting on both

fig. 9 | Kōji Taki
Portrait of Takuma Nakahira, from
Provoke 2, 1969
Collection of the San Francisco
Museum of Modern Art. Library

fig. 10 | Takuma Nakahira
Untitled photograph, from
Provoke 3, 1969
Collection of the San Francisco
Museum of Modern Art. Library

sides of the doomed but volatile Vietnam War. The conservative Japanese government, approaching the 1970 renewal of the U.S.–Japan Security Treaty (or Anpō), which had caused such fractious protests ten years previously, feared a renewed eruption of protest. They need not have worried. Despite the international student uprisings—most notably in the U.S., Paris, and Prague—the treaty was renewed without any attendant turmoil, and the Japanese proudly displayed their robust economic growth at the 1970 Osaka Expo. The government co-opted the radicals. The younger generation seemed more interested in the Beatles than in large political issues— or even in smaller protests against environmental dangers (such as the mercury poisoning of Minamata, photographed by W. Eugene Smith and Shisea Kuwabara) and the bureaucratic control of government, called "democratic fascism." The idealism of the 1960s in Japan passed easily into the bland, self-centered decade that followed.[35] In 1970, claiming that Japan had lost its direction, Yukio Mishima— the nationalist, neo-fascist literary figure—shocked the nation, and appalled Moriyama, when he committed ritual suicide (*seppuku*) in protest.

The *Provoke* group evolved from an exhibition organized by Tōmatsu for the Photographic Society of Japan (JSP) and held at the Seibu Department Store in 1968. Entitled *The One-Hundred-Year History of Japanese Photography,* it was a large, comprehensive show and the first of its kind.[36] Nakahira and Kōji Taki were hired as Tōmatsu's assistants, but it became clear that they saw the older man as an authority figure and needed to separate from him.[37] Nakahira was eager to establish a forum for wide-ranging cultural criticism, unusual in Japan. He was also a poet and fascinated

fig. 11 | Andy Warhol
Spread from the exhibition catalogue
Andy Warhol (Stockholm: Moderna
Museet), 1968

by the relationship of photography to language. Although he believed that photography could be a kind of meta-language, he also acknowledged the special, discrete power of the medium, untouched by literary association.

Moriyama's contribution to *Provoke* consisted of two bodies of work. The first was a series of blurred, erotic nude figures. The second was a group of pictures of endless stacks of Coca-Cola bottles, boxes of detergent, and cans of V-8 Juice, made at night in a supermarket on Aoyama Street that carried American goods, called "Yours," as demonstrators roamed the streets outside and flashing police lights shone in the display windows. These were published in *Provoke*'s final issue. Although romanticized by an evocative and discreet use of blur, Moriyama's erotic pictures were powerful and bold, and new enough to capture the attention of his younger colleague Nobuyoshi Araki (b. 1940), who would study with Moriyama. Araki was fascinated by the magazine: "I was jealous of *Provoke,* especially Moriyama's nudes in the second issue. Those blurry nudes in love hotels. I wanted to join them but wasn't allowed because I was working for Dentsu. So I had to work alone. I used the company's facilities. I was inspired by *Provoke.* Most people paid no attention to it, but really it was like a bomb in Japanese photography."[38]

Around this time, a friend handed Moriyama a book on Warhol, perhaps in Taki's office at *Provoke* (fig. 11).[39] Moriyama understood the American's pictures instantly; they suited his view: hard, objective, passionately consumerist. Warhol provided Moriyama with a vision of palpable delight in materialism but also with a profound sense of its decadence, its hard impersonality, its ruthlessness and relentlessness. Moriyama was drawn to Warhol's understanding of media, eagerly appropriated by the Japanese. Pictures of pictures as well as goods occupied Moriyama, and he even expanded upon Warhol's car crash pictures in his deconstructive *Accident* series.

In this series, Moriyama obsessively rephotographed an image of a car wreck he had purloined from a police safety poster, reframing a sequence of details, close-ups of parts of the original, remaking it again and again, in a marvel of beauty, horror, excess, and despair (pls. 62, 64).[40]

In 1971 Moriyama made a trip to New York with Tadanori Yokoo, Japan's preeminent graphic designer, whom he knew through their common circle of friends and associates. Yokoo was closely connected to the world of experimental, avant-garde dance and theater.[41] The posters he made for his friends' performances, principally in the 1960s and 1970s, are a deliberate updating—through the imagery and high, bold coloration of Pop—of the populist Japanese art of ukiyo-e, the nineteenth-century woodblock prints of actors and courtesans and the life of the "floating world." Probably inspired by their mutual high regard for Warhol, Moriyama and Yokoo stayed together at the Chelsea Hotel in November and December, and while Yokoo planned his solo exhibition with members of the design department at the Museum of Modern Art, Moriyama went to the museum's photography department and studied the work of Weegee. Yokoo remarked that in New York Moriyama never ventured out on his own: "He never seemed to go out with the object of taking photographs, he just kept visiting the same streets like a dog urinating on telephone poles to mark its territory."[42]

Moriyama's pictures of New York were made in stylistic deference to William Klein's view of the city, and the book he produced, a self-published work with exquisite serigraphs and photocopies of brutal subjects, also acknowledged Warhol's creative understanding of media. Moriyama called it *Another Country* (1974), after James Baldwin's novel.[43] In 1972 Moriyama published two books, which are major expressions of their time: *Farewell Photography* (*Shashin yo sayōnara*), with an introductory conversation between the photographer and his friend Nakahira, and *Hunter* (*Kariudo*), edited by Shōji Yamagishi (with an introduction by Yokoo).

Although they were made at the same time, and even share some of the same photographs, these are two very different books. *Farewell Photography* was the more extreme, the more anarchic and existential. Moriyama describes it as the culmination of his experimental work in *Provoke* and the *Accident* series.[44] In *Farewell Photography* he pushed pictures to the point of illegibility. They are scratched, dirtied by dust; there are light flares, sprocket holes, bleached, rephotographed tabloid pictures. There are pictures of nothingness: a close-up of a dirty street, a blank wall, a reflection in a blank television screen, the end of a film roll. Surely no other photographic book has been so extreme—or so eloquent in evoking the shape of contemporary despair. In it Moriyama attempts to come to terms with the very nature of representation. He wrestles with the quandary of expression in a presumably transparent, objective medium and reaches a dead end: "Although I had intended to pursue the relationship between the watcher and the watched or that of taking photographs and presenting them, I suddenly came up against a brick wall. The publication did not leave me with a feeling of satisfaction; all that remained was irritation."[45] Moriyama could not be called an existentialist in any strict sense, but this book is certainly informed by the spirit of existential crisis that faced his friends and associates.

As experimental and extreme as *Farewell Photography* was, *Hunter,* which came out a few months later, was concrete, tied to the world, not as deliberately inventive or invasive, but no less tragic. In part, this was the result of Yamagishi's presence as editor.[46] In the introduction Yokoo remarked on Moriyama's restlessness, his need to travel, to always be on the move. "Maybe Moriyama *has* no hometown—at least not the conventional, physical sort. That must be why he wanders all over Japan taking pictures."

Perhaps even more cogently, he observes: "He takes his pictures from the point of view of a peeping Tom or a rapist. . . . Eyes that see from the windows of a moving car or from the shadows are those of a criminal. His pictures are like someone who talks, without looking people in the eye."[47]

Drawn from many sources and arranged in a disjunctive, lyrical sequence, but presented more clearly and formally than in the previous book, the pictures in *Hunter* appear to be the product of an intelligence at odds with what it sees, moved by its conflicts, its vitality, its modernity, and its link to tradition, but still an outsider, disenfranchised, unconnected. The photographer-hunter seems to be not so much spying on his subjects as trying to locate the authentic experience, the "reality" of feeling behind the peeling billboards, the concrete block structures draped with telephone wires, the dazzling masses of people crossing the street in Tokyo or busily rushing through the subway. This is an eloquent, personal book, impelled by an erotic energy and an almost frantic restlessness, as gentle as it is bleak, and close to the spirit of Kerouac, to whom it is dedicated.

Paradoxically, the divisions between photographer and photographed, the hunter and hunted, are perhaps clearer in *Hunter* than in *Farewell Photography,* a book about dissolution. Veils of soot; scrims of fog, darkness, or benday dots; reflections, fences, barriers; grain and blur—the photographer's presence as an observer, his distance from his subjects, even in the most erotic pictures, is very clear. As Yokoo observed: "Another thing about photography like his is its extremely political orientation. Some photographers are apolitical, no matter how much they try to take a political stand, but he is just the opposite. The more he tries to avoid political themes, the more political his work seems to become."[48]

Yet Moriyama is not an overtly political artist, not in the self-conscious sense that W. Eugene Smith was in his photographs of the mercury-poisoned residents of Minamata. Nor was Moriyama analytic and descriptive of the American presence in Japan, depicting the poisonous way the culture had insinuated itself into Japanese life, as Tōmatsu had. It is more accurate to say that during the late 1960s and early 1970s the culture of Japan was highly politicized. Tōmatsu was the more rational, Moriyama the more reactive, but both faced the uncertain climate of Japan at that moment. Making pictures in the streets and the countryside which described the melancholic beauty of an older, essentially rural society and the vivid but alienating contemporary chaos of the life of the city was a personally political act. Describing the intrusiveness, brutality, and excitement of these conflicting viewpoints, pairing the grimy view through a truck's windshield at dusk with an image of Bonnie and Clyde before their bloody death in a movie theater—these are reflections on the larger political reality.

As existential as *Farewell Photography* was, *Hunter* is as well, but its subjects are seen with clarity and even irony. It shows Japanese on the beach packed close together, baking like greased sardines in the sun, tanning themselves American-style, and depicts endless wastelands: expanses of garbage, dirty snow, empty sea. The hunter is as much the victim of these conflicts as the assailant. He suffers, in the words of his friend, from "the sickness of the heart," a sickness also described by David Riesman in *The Lonely Crowd.*[49]

Parts of Moriyama's series *Accident,* which had been published in *Asahi Camera,* also appeared in both *Farewell Photography* and *Hunter.* For the most part, these are appropriated pictures, taken from television screens and newspapers. Many are violent, Warhol-like, re-presenting news stories and scandals known only through the media: Bobby

fig. 12 | Daidō Moriyama
North Vietnam, Television News, 1968
Cat. No. 42

Kennedy's assassination, vignettes from the Vietnam War, paparazzi photos of Sukarno's wife with another man (pl. 32), and images from the nightly newscasts on Japanese television (fig. 12). Moriyama responded to the numbing quantity of mass-media imagery, the voyeuristic compulsiveness of it, the focus on both violence and sex. These pictures are another expression of the artist's distance from experience, another step beyond the views from a car window or through a fence, to a point where the observer's experience is filtered through the media. These are not so much specifically political as Warholian understandings of the massiveness and eroticism and, finally, the similarity of media images, which Moriyama discovered from the Warhol catalogue published by the Moderna Museet in Stockholm in 1968, which consisted principally of photographs. He also began to experiment with another Warhol obsession: the silkscreen.[50]

The Essential Japan

At this moment of professional recognition, Moriyama began to feel dissatisfied with his work and experienced a loss of direction. He published a magazine, *Record,* an experimental series of writings combined with pictures by him and his friends. It lasted for five issues (1972–73). He began to visit historic sites and scenic places in Japan, such as the temples at Nikko and the cherry blossoms that appear throughout the countryside in the spring, perhaps the most universal Japanese cultural symbols. Characteristically, the temple roofs are all askew and obscure; they are uncomfortable-looking jumbles of historical artifacts. Moreover, the cherry trees in bloom are grimy, often difficult to see; they are almost a negation of this ritual, a citified, ironic, unromantic review of Japan's historical and cultural appreciation of nature. It was a form of perversity almost—or at least a mixed expression of appreciation and sorrow—to photograph the pink cherry

blossoms and vivid, almost garishly red temples at Nikko in gray and black (pl. 67, 70).

The Japanese, who take pride in their "special relationship" to the natural world, modified this philosophical tradition with the encouragement of the occupying Americans after the war, when they engaged in American-style industrial development and appropriated the Western presumption that human beings could control or dominate nature for their own purposes. Thus, the traditions of moon viewing, traveling to see the cherry blossoms at their brief moment of splendor, or visiting the Nihon Sankei (three of Japan's most famous scenic spots), are associated with spiritual self-discovery. In the mid-1970s the Japanese railroad launched a "Discover Japan" campaign, encouraging travelers to find the "essential Japan" in the countryside. Only a few years later, in a similar campaign directed at the settled urban population, the countryside would be advertised as "exotic" territory.[51]

Like his contemporaries, and with Yamagishi's encouragement, Moriyama pursued his own search for the nativist Japanese spirit. Like his predecessors in this journey, he went into the Japanese countryside to confront the romanticized notion of the "native place of the spirit" (*Nihon kaiki*). The charged atmosphere he witnessed and photographed in the cities, the untrammeled economic growth celebrated in the Osaka Expo of 1970, began to crack with Richard Nixon's rapprochement with China and the "oil shocks," the first in 1973. Similarly there occurred a generational shift away from the model of the politically engaged artist, one affected by the meaninglessness and impersonality of contemporary life, to a structuralist understanding of society. Evoking Moriyama's interests, and those of his friends, the cultural anthropologist Masao Yamaguchi proposed that there was an essential relationship between Japanese peripheral characters—clowns, tricksters, actors, mythic figures—

and the center of modern Japan, underlining the importance of premodern Japan to its contemporary counterpart.[52] This new direction—toward reevaluating the essential Japan, in its pre-Western, premodern state, and its relationship to the engaging, alienating contemporary urban world—led to the making of Moriyama's *Tales of Tōno* (*Tōno monogatari*) of 1976.

Moriyama recalls: "At that time I was getting tired of my everyday life and the photos I'd been taking. I wanted to get in touch with nature, to see the original geographic features of Japan and the origins of the Japanese soul. And somehow the name of the town Tōno, meaning 'faraway fields,' brought about romantic images, even before I had ever seen it. On a completely personal level, I wanted my heart and soul to 'return home,' and I wanted to photograph that memory."[53]

The original *Tales of Tōno* was compiled in 1910 and reformulated in the 1930s by Kunio Yanagita, an anthropologist and folklorist who collected indigenous Japanese lore. He can be compared to the Brothers Grimm, who similarly collected folktales to establish a sense of national identity in Germany. Yanagita's tales are without the same moral certitude: his premodern, agrarian stories are disjointed, enigmatic, and ambiguous, presented in a strange commingling of reportage, anthropology, and fiction.[54]

Moriyama visited the area for only three days of intense work. The resulting prints are framed in pairs; different pictures, not necessarily of the same place, are put together cinematically (pls. 71–74). As published, Moriyama's *Tales of Tōno* is a small pocket book, with the paired pictures facing each other, prefaced by some experimental work in color and Moriyama's writing.

Moriyama's journeys north coincided with and were followed by a similar quest by his friend and fellow photographer Masahisa Fukase (b. 1934). Fukase is from Japan's northernmost island, Hokkaido, and shortly after Moriyama began his northbound journey, Fukase, first in flight from a difficult relationship and then following the relationship's collapse, began to make pictures that would result in a series entitled *Ravens* (fig. 13). These pictures, emotionally dark, even bleak and unflinching, take the haunted bird as their motif, a symbol of the photographer's private despair. But they are very consciously Japanese; in their design and context and the symbolic value Fukase attaches to the subject, they refer not only to older Japanese art but also to the impulse for flight; the obsession with moving on, with escape; the almost demonic power or possession of birds and cats; the ferociousness of the sea and the windy sky. Fukase shares this sense of doomed emotional turmoil with his friend Moriyama.

Recognition and Later Work

During this period, the mid-1970s, Japan's lively and distinctive photographic accomplishments began to receive acknowledgment from the United States. Responding to pictures he had seen in publications and moved by curiosity, John Szarkowski, the director of the Department of Photography at the Museum of Modern Art in New York, visited Japan, initially with Ishimoto's assistance, and shortly found his way to the offices of *Camera Mainichi,* where he discovered a kindred spirit in Shōji Yamagishi. Szarkowski was so impressed by the circle of photographers at *Camera Mainichi* and by the intelligent, friendly, and debonair Yamagishi that, as his interest deepened, he invited the Japanese editor to be his partner in an exhibition at his institution. Entitled *New Japanese Photography,* the show opened in 1974. (The museum had been responsive to the evolution of

contemporary artistic phenomena in Japan even earlier. In 1966 contemporary Japanese art received its first serious consideration in the United States in *The New Japanese Painting and Sculpture,* a show jointly sponsored by the San Francisco Museum of Art and the Museum of Modern Art.)[55] Moriyama's work was discussed in the brief catalogue essays for *New Japanese Photography* and presented as second only to that of Tōmatsu.[56] The organizers of the show recognized the existence of a "distinctly Japanese photography," in which Moriyama was acknowledged as a principal figure.

The show in New York virtually coincided with another exhibition held at the National Museum of Modern Art, Tokyo, in 1974, entitled *Fifteen Photographers Today,* which also included work by Moriyama.[57] Just as the culture of photography in the United States had shifted almost imperceptibly away from a practical, illustrational emphasis, the Japanese cultural establishment also acknowledged that photography, as practiced by gifted and innovative people, could have aesthetic value. Like some of his American and European contemporaries, Moriyama experimented with teaching. In 1974 he started a school for photography, called Workshop, with colleagues, including Fukase and Araki, and when that school disbanded, another one, Image Shop CAMP, formed in 1976. Moriyama even established an informal gallery with the CAMP group, an idea that he would continue to explore. This interest in teaching and exhibitions was symptomatic of the transitional nature of photography at that time.

Yamagishi became restless with the constraints at *Camera Mainichi* and finally left the magazine to try a life as a freelance critic and curator. He had the ambition to create a museum devoted to photography, an idea that proved to be premature. In 1979, however, he organized two important international exhibitions: *Japan: A Self-Portrait,* which took place at New York's International Center of Photography,

and *Self-Portrait: Japan* at the Venice Biennale, both including work by Moriyama.[58]

In 1977 Nakahira became ill with drug poisoning. Drugs and alcohol were as much a part of the 1960s revolution as sex and rock and roll, as much in Japan as elsewhere, and the effects of high living would exact their toll on Moriyama's circle of friends. By the end of the 1970s Japan's economy had fully reemerged, phoenix-like. Just as the idealism of the 1960s was consumed by the growth of capital in the United States, so too in Japan consumerism displaced idealism and left a strange, despairing lack of moral focus. The intensity and energy that politics had provided dissipated, leaving many of Moriyama's friends and associates overcome by a sense of outrage, but without the sense of direction provided by political anger. Many of them suffered these changed circumstances in personal ways or experienced a loss of direction. An even more profound loss occurred in 1979, when Yamagishi unexpectedly died.[59]

Moriyama—who had faced a creative crisis in *Farewell Photography,* testing the limits of the medium, attempting to photograph the void itself—now literally stopped making pictures. He probably never intended to abandon photography absolutely but needed to take a hiatus. Certainly Moriyama was not the only artist to experience a period of restless exhaustion and creative inaction.[60] It was probably never complete either; he worked restlessly with silkscreen and photocopy. It is a tribute to the seriousness and deep sensitivity of the photographer that this period was so long lasting and profound.

In 1982 Moriyama reentered photography with the book *Light and Shadow* (*Hikari to kage*). The pictures are large and clear—no moody grain, no expressive halftones. It is a worldview literally in black and white. This is a book with a new sensibility, a new clarity, and one that is very deliberately named. The world it depicts is cold, the world of the morning after, harsher, more objective, less impressionistic,

more hardboiled. The forms are larger, simpler, and more contrasted than those in the work made before his cæsura. The fedora hat in the store window swallows up the picture plane, its strange, abstract form both attractive and repellent, but seen with unsettling clarity, as if one has walked out into bright daylight from a darkened room (pl. 82). This book also marks Moriyama's conversion to resin-coated paper, accentuating the glare in the light areas and the uncertainty in the darks.

If anything, the next book, *Lettre à Saint-Lou* (1990), is even more grim and disturbing.[61] The photographer focuses on an ant colony infesting a log or a swarm of carp breaking the surface of water, making pictures of a squirming mass of primordial life. The rain-spattered window now displays a fly adhered to its surface; the detail of an interior shows cheap veneer pecked by tacks (pls. 84, 81). These are existential pictures without the romance or Baudelaire's *Fleure du mal* in the bright light of day. There are some concessions, however: pictures of fashionable, usually younger women (a hand, a part of the face) or a fresh bouquet, frozen by flash (pl. 85).

Moriyama is always rethinking his past work, integrating older ideas into new work. He has experimented with Polaroid; in the mid-1980s he arranged to have a large Polaroid camera put on the back of a truck so that he could move it around Tokyo. In other words, it became an extension of the hand-held technique, since he refused to work in the studio. Thus, he was able to make large black-and-white pictures outside, but with a more meditative character than the small-format pictures that are his custom. More recently, he made an installation of five-by-seven Polaroid prints, thousands of pictures of his living space, which is also his darkroom, systematically re-creating this interior. Earlier works tacked up on the walls, posters, appropriated pictures are all mixed in with articles of his daily life.

Most recently, he has produced three large books of photographs.[62] The last book, *Osaka* (1997), is entirely on the vital, vulgar port city, the commercial center where he was born. He says:

I've wanted to photograph Osaka for quite some time now. I had always thought that some day I'd do it, but never having had the right opportunity, I ended up losing interest for a while and looking elsewhere for subjects. And then last January (1996) I went to Osaka and Kobe under the auspices of a television station. As I wandered the troubled areas of both cities and shot pictures, I felt as though I was struck by a bolt of electricity. I immediately thought to myself, "This is it."[63]

This return was in many ways a time for Moriyama to reevaluate his past, to come home to his origins, to find in the karaoke parlors, the nightclubs, and the racy neon signs the imaginative power that informed his work when he moved to Tokyo as a young man to begin his career. The recent photographs are cleaner than the romantic pictures of the 1970s, a clear and logical continuation by a photographer still experimenting with his form. These late pictures are exhibited in very large formats, often tacked to the gallery walls in a collage installation. Reproduced in book form, they are less singular, more filmic—closer to the experience of watching slides projected quickly, rather than looking at pictures carefully, one after the other.

The Scar

After a hundred and twenty years of modernization since the opening up of the country, contemporary Japan is split between two opposite poles of ambiguity. This ambiguity, which is so powerful and penetrating that it divides both the state and its people, and affects me as a writer like a deep-felt scar, is evident in many ways. The modernization of Japan is oriented toward learning from and imitating the west, yet the country is situated in Asia and has firmly maintained its traditional culture.[64]

Like his contemporary Kenzaburō Ōe, Moriyama has been persistently fascinated by Japan's ambiguous but powerful relationship to the West, to the spirit of democracy it seemed to imply to members of his generation, to a countercultural appreciation of alternatives in a still highly stratified, essentially conservative society. And like many others of his generation, he also appreciated the quest for the essential Japanese spirit, an understanding of Japanese culture at its most primitive origins, which he found not only in the rural parts of the country but also in the American bases, on the road, in the small cafés in Shinjuku. What he is most appreciative of, what he sees with his developed lyric eye, is

the poetry of what Ōe calls the "spiritual deficit" in Japan's appetite for Western consumerism, and it is his special power to present this understanding inflected with the culture's larger ambiguity.

Moriyama has a special affinity with the inventor of the photographic medium, the nineteenth-century French aristocrat Joseph-Nicéphore Niépce, who placed a camera obscura facing the courtyard of his estate and made an exposure so long that it recorded the path of the sun for eight hours, so that both sides of the courtyard were illuminated and the result was confused in a way that Moriyama found primitive and singularly expressive: "Continuing to sense such an image, I cannot somehow help thinking that the essence of my memories and photography turns upon a certain spot in that scene of a summer day in Saint-Lou, 163 years ago, in a quest

to reproduce that light and time."[65] He also discovered the work of a prewar photographer from Osaka, Nakaji Yasui. In an appreciation of Yasui's work—the older photographer depicted the poor, circus members, and other outsiders (his last series was entitled *Jews in Exile*)—Moriyama noted, "One of photography's essential qualities is its amateurism; another is its anonymity."[66] These are not disingenuous observations. Moriyama responds to photography's actuality, the power of the medium to render lived experience, which, to him, is related to the return to origins, to essentials, the very Japanese preference for primitivist emotive reaction over a more objective, deliberate, and rational relationship to the world outside, which is a more Western stance.

Moriyama and his contemporaries—not only in photography but also in theater, film, dance, and literature—engaged in a pursuit of origins that accounted for a radical, new, and at the same time ultimately Japanese modern art. Not closely tied to the progressive stylistic system of European modernism, many of them, including Moriyama, were able in this way to make bold, raw, new aesthetic statements. Their work is dynamically mythic, disturbingly irrational, and resonantly contemporary.

At the same time, Moriyama's work, which pursues certain subjects—Kabuki theater, the journey, the tattooed bandit, and the courtesan—is deeply connected to the Japanese print tradition of ukiyo-e. This is a tradition that Moriyama knows well and one that is, in fact, as frequently brutal as it is eloquently decorative.[67] Rather like his own photography, such pictures operated in the robust vernacular tradition, as a popular art, as opposed to the aristocratic art of painting. Perhaps closest to Moriyama's spirit is the turn-of-the-century woodblock artist Yoshitoshi, whose work reflected the social chaos of late Tokugawa Japan: its bloody samurai wars, which Yoshitoshi depicted with uncommon goriness; its preoccupation with ghosts, with political dysfunction, with the

underworld of gangster, Kabuki, and courtesan. Beyond his earlier sadistic—and picturesque— prints are mature works that are more ambiguous and disturbing. *Fujiwara no Yasumasa Playing the Flute by Midnight* (fig. 14) shows the courtier playing his marvelous instrument as the bandit lurks charmed, but waiting to strike. The picture is pervaded by a sense of profound anxiety.[68]

It is instructive to compare Moriyama's work to that of the young Cartier-Bresson, an artist he has been aware of but who has not been an essential influence, or of deep interest to him. As a young man, this French *flâneur,* informed by surrealism and leftist political ideas, photographed bums in the street, working people at rest, prostitutes in Mexico, and the intoxicating chaos of the city (fig. 15). Cartier-Bresson's inspired perception enabled him to find in that chaos a child leaning back, falling against a rough, paint-spattered wall in an ambiguous moment—was it pleasure, or pain? But the distinctive quality of this work, as with all Cartier-Bresson's pictures, is the tense relationship between disturbing disorder and the rational, quickly perceived rightness of the gesture, its delicacy of form, his ability to sense order in a depiction of psychological strangeness. There is not the pervasive anxiety of Yoshitoshi's print.

Another distinguishing aspect of Moriyama's pictures is their powerful, dark eroticism. In his earliest book, in a darkened room filled with smoke, obscuring the expectant faces of the spectators at this almost religious ritual, we see a stripper recumbent on the stage—poised, powerful, and mysterious— holding her leg aloft, opening her body to the audience (pl. 34). Moriyama acknowledges the power of female sexuality, a power once venerated in the ancient Japanese rural fertility religion and present

fig. 15 | Henri Cartier-Bresson
Valencia, Spain, 1933
Courtesy of the artist and
Magnum Photos, Inc.

in the crudest of Western-inspired male rituals. This allure of extreme experience, this holy attachment to the unnerving power and beauty of what is shameful or forbidden, is what Mishima found in Dostoyevski. He quotes the Russian author at the beginning of his *Confessions of a Mask:* "Beauty is a terrible and awful thing! It is terrible because it never has and never can be fathomed, for God sets us nothing but riddles. Within beauty both shores meet and all contradictions exist side by side. . . . The devil only knows what to make of it! but what the intellect regards as shameful often appears splendidly beautiful to the heart. The dreadful thing is that beauty is not only terrifying but also mysterious."[69]

Let us return to the stray dog, the ultimate outsider, wild but aware of the topography of the town he inhabits. Not a participant, but an observer, somewhat discomforting but also enviable because free, always restlessly moving on, always fending for himself. It is no accident that the stray dog is found near an American air force base just as the Vietnam War is reaching its ambiguous conclusion—ambiguous not only for Americans but also in its disturbing implications for the Japanese. The dog has an undeniable, admirable power and an unsettling curiosity. It has haunted Moriyama.

Notes

Unless otherwise noted, all translations from the Japanese are by Joseph Sorensen, C. Miki Wheeler, or Christine Shippey.

1. VIVO was formed after the 1957 exhibition *The Eyes of Ten* and lasted from 1959 to 1961 (see Alexandra Munroe's essay in this volume for more on VIVO). There was a catalogue for *The Eyes of Ten* and a brochure for the show that traveled to the Santa Barbara Museum of Art, *VIVO: Six Japanese Photographers*. See *Santa Barbara Museum of Art: Gallery Notes* 3, no. 5 (October 1978), essay by Bob Werling. See also Tatsuo Fukujima, "Approaching the VIVO Exhibit," pts. 1–2, trans. Steven Rocca and John Wilson. This is an unpublished text on the VIVO group and was generously provided by the Santa Barbara Museum of Art Library.

2. *The Family of Man* traveled to twenty sites in Japan in 1956 in two versions, one larger and one smaller. It was seen by 845,554 people. I am grateful to the Department of Photography, Museum of Modern Art, New York, for providing this information.

3. During the 1910s and 1920s there was a well-known, though small, group of experimental artists whose work was suppressed during the war. There has been much recent study on the early avant-garde in Japan and its links to Europe.

4. See "What Should We Photograph?" *Camera Mainichi* (January 1965), a panel discussion with Yasuhiro Ishimoto, Shigeichi Nagano, and Shōmei Tōmatsu. Moriyama also says that he believes Tōmatsu knew, admired, and learned from Eugene Smith's journalistic work for *Life* magazine (letter to author, June 1998).

5. See Marguerite Yourcenar, *Mishima: A Vision of the Void,* trans. Alberto Manguel (New York: Farrar, Strauss, and Giroux, 1986). Yourcenar also remarks on Mishima's aggressive sexuality, which she considers new to Japanese art. It must be said that, unlike Mishima, Moriyama was never comfortable with elite society.

6. Alexandra Munroe, *Japanese Art after 1945: Scream against the Sky,* exh. cat. (New York: Harry N. Abrams, 1994), 189–90, 193. See also Alexandra Munroe's essay in this volume.

7. Moriyama, letter to author, June 1998.

8. Ibid.

9. Moriyama, conversation with the author and former photographer Kōji Taki, Tokyo, June 1998.

10. From Daidō Moriyama, "An Encounter with Striking Images," in *William Klein* (Tokyo: Pacific Press Service, 1987), unpaginated.

11. William Klein, *Life Is Good and Good for You in New York: Trance Witness Revels* (Paris: Editions du Seuil, 1956), and idem, *Tokyo,* preface by Maurice Pinguet (New York: Crown Publishers, 1964). The Hijikata piece was after Jean Genet's *Notre-Dame des fleurs* (1944). See also Mark Holborn, *Beyond Japan: A Photo Theater* (London: Barbican Art Gallery and Jonathan Cape, 1991), 105–19. Klein's *Tokyo* was the last of a series of books focusing on major urban centers published under Chris Marker of the French publishing house Editions du Seuil.

12. Daidō Moriyama, "Afterword/A Photographic Biography," in *Inu no toko* (The time of the dog), trans. Gavin Frew (Tokyo: Sakuhinsha, 1995), 346.

13. See Shōji Yamagishi, introduction to *New Japanese Photography,* ed. John Szarkowski and Shōji Yamagishi (New York: Museum of Modern Art, 1974), 11–13.

14. Moriyama, letter to author, June 1998.

15. See Werner Bischof, *Japan,* with text by Robert Guillain, trans. J. G. Weightman (New York: Simon and Schuster, 1955).

16. See John W. Dower, "Peace and Democracy in Two Systems: External Policy and Internal Conflict," in *Postwar Japan as History,* ed. Andrew Gordon (Berkeley, Los Angeles, and Oxford: University of California Press, 1993), 3–33. Moriyama was aware of the antiauthoritarian impulses of the French student movement; indeed, the Japanese links to the French left were generally closer than their relationship with the antiwar movement in America.

17. *The City,* The Image Today, no. 8 (Tokyo): Chūo Kōron, 1971). Ishimoto returned to Japan in part because he was troubled by McCarthyism

18. Yasuhiro Ishimoto, "Faces of Tokyo (8), Housing Development," *Camera Mainichi* 6 (1963).

19. See Moriyama's own acknowledgment of Tōmatsu's importance to him in the essay reprinted in this catalogue (pp. 45–48), as well as a perhaps unconscious acknowledgment of Tōmatsu's own peripatetic existence, recorded in his autobiographical essay "The Gaze of a Stray," written about a period in 1960 when he gave up his regular routine and "left the house behind in order to break the cycle of inertia." He continues: "What happens when you no longer have a home to return to? Unable to focus your gaze, you zigzag along an aimless course. Looking down, you find yourself staring at the ground as you walk, gazing like a stray dog." Translated by Linda Hoaglund from Shōmei Tōmatsu, "Collected Stories," May 1976, reprinted in *What Now?! Japan through the Eyes of Shōmei Tōmatsu* (Tokyo: Jikko linkai, 1981).

20. Shōmei Tōmatsu, *The Pencil of the Sun: Okinawa and Southeast Asia,* ed. Noboru Kitajima (Tokyo: Camera Mainichi, 1975). On Tōmatsu's complex relationship with his own country and the influence of American culture, the editor describes him as saying that "upon leaving the Okinawa Islands for Japan, that he had not really come to Okinawa but to Japan, and was not leaving for Japan but for America" (unpaginated).

21. Tōmatsu's major books include *11:02—Nagasaki* (Tokyo: Shashinodo-jin-sha, 1966), *Okinawa* (Tokyo: Shaken, 1969), *Nippon* (Nagasaki: Shaken, 1967), and *Oh! Shinjuku* (Tokyo: Shaken, 1969). See also Moriyama's own account: "I got to know Shōmei Tōmatsu when I became Hosoe's assistant after I came out to Tokyo. That was in 1961. Since then Tōmatsu's lifestyle and the images he captures in his photographs have captivated me, and I was highly influenced by him. One might even say he gave me my start in photography. Tōmatsu certainly approaches his camerawork from a very political angle, constructing a theme but then approaching his subjects objectively. This is very different from my own approach. I am not, at least

consciously, political, and I do not resign myself to a theme" (letter to author, June 1998). Tōmatsu also worked with Ken Domon and others on *Hiroshima-Nagasaki: Document* (1961), published by the Japan Conference for Banning the A-bomb.

22. From *Shōmei Tōmatsu: Japan, 1952–1981*, exh. cat. (Graz: Fotogalerie in Forum Stadtpark; Edition Camera Austria, 1984), with essays by Kazuo Nishii, Shinji Ito, and Otto Poreicha. See also Munroe, *Scream against the Sky*, chap. 8.

23. *Inu no toki*, 347.

24. Letter to the author, June 1998.

25. Although there are similarities between Moriyama's work and that of Robert Frank and they shared an appreciation of Kerouac, Moriyama was aware of, but not especially interested in, Frank's photography until the 1980s.

26. See Ian Buruma, *Behind the Mask: On Sexual Demons, Sacred Mothers, Transvestites, Gangsters, and Their Japanese Cultural Heroes* (New York: New American Library, 1984), esp. chaps. 5–7, 10.

27. Terayama also worked with Tadanori Yokoo, the designer who combined traditional ukiyo-e forms with a pop contemporaneity. Yokoo designed the cover for Hosoe's *Ordeal by Roses* and would write the introduction to Moriyama's book *Hunter*. See also Masao Yamaguchi, *Kingship, Theatricality, and Marginal Reality in Japan: Text and Context: The Social Anthropology of Tradition*, ed. Ravindak Jain. (Philadelphia: Institute for the Study of Human Issues, 1977), 153–76, in which the author discusses the sacred in marginal characters in ancient Japan, especially actors and courtesans.

28. For example, the deformed baby who plays an auspicious role in Ōe's book *A Personal Matter* and the touching and devastating friendship between the wife of a "salaryman" and a junk dealer and blind girl in Hani's film *She and He*.

29. See Buruma, *Behind the Mask*, chap. 1; James R. Brandony, "Performance: Edo/Tokyo," in *Tokyo: Form and Spirit* (Minneapolis: Walker Art Center, 1986), 155–64. Kabuki and the puppet theater, Bunraku, were subject to excessive governmental attention because they were truly democratic: anyone could attend. In a rigidly structured society this was to be feared. When a series of laws (1841–43) forced the theaters to move outside the city of Edo (the old name for Tokyo), the teahouses where the geisha lived moved with them, forming the "Floating World" known through the ukiyo-e woodblock prints. See also Barbara London, "Experimental Film and Video," in *Scream against the Sky*, 285–97.

30. Shinichi Kusamori, "Aobae no yona Jodo: Moriyama Daidō Nippon Gekijo Shashincho" (Tenacious as a blue-bottle fly: Daidō Moriyama, Japan: a photo-theater), *Camera Mainichi*, (August 1968): 34–35.

31. On the conflict in modern Japan, beginning with the Meiji restoration in 1868, between an openness to European culture and an adherence to *kokutai*, the "native political essence," see Alexandra Munroe, "*Circle*: Modernism and Tradition," in *Scream against the Sky*, 125. Also, see Ian Buruma, on Japanese striptease, in *Behind the Mask*, 11–13.

32. See Shōmei Tōmatsu, *Oh! Shinjuku* (1969), where the photographer writes: "Shinjuku is a place for young people. Shinjuku is a place where you can get off the train anywhere you want. Shinjuku is a 'happening' stage. Shinjuku is a place for hippies. Shinjuku is a place for sex. Shinjuku is a womb of civilization. Shinjuku is a giant supermarket" (unpaginated). The orgiastic parties were photographed by Moriyama's friend Masahisa Fukase and were published in his book *Homo Ludence* (Tokyo: Chuo-Kōronsha, 1971).

33. See Moriyama's comments in "The *Provoke* Era: Turning Point in Postwar Japanese Photography," *Déjà-vu*, 931010, no. 14 (1993): 149. See also Tōmatsu's comments (ibid., 150): "When I received the first issue I saw it more as a political than a photography magazine. Their language concerning photography was very refreshing. The best work was Nakahira's in the second issue. He had come out of my influence. He had learned from everything, from the New Wave to the Beats to William Klein the culture of the 50's and 60's which includes VIVO and *Provoke*."

34. Although Nakahira is still alive, he suffered the effects of drug and alcohol poisoning and retains no memory. Information on Nakahira has been generously augmented by Kōji Taki, as well as by Moriyama himself.

35. See J. Victor Koschmann, "Intellectuals and Politics," in *Postwar Japan as History*, 414–18.

36. This was accompanied by a slim catalogue in Japanese and a larger one in English, eventually published as a two-volume set.

37. Kōji Taki was an art critic in the 1960s, became a photographer with Nakahira at *Provoke*, and then, in the 1970s, pursued a career as a philosopher interested in aesthetic issues, especially architecture. The poet Takahiko Okada was another founding member of *Provoke*.

38. "The *Provoke* Era," 150.

39. This was probably Andy Warhol et al., eds., *Andy Warhol* (Stockholm: Moderna Museet, 1968). In the chronology of *Moriyama Daidō* from the series *Nihon no shashinka* (Photographers of Japan), no. 37 (1997), he states that a friend probably showed him this catalogue in 1967.

40. Kōji Taki points out that Roland Barthes's work on photography's role as a medium of communication was known in Japan in the 1960s. On Moriyama's interests in Warhol and appropriated photographs and his relationship to Pop Art, see also Fujieda Teruo, "Sekai o byōkachi ni miru," in *Shashin Eizō* no. 3 (winter 1996): 100–103 (from an album of critical writings in the collection of the Tokyo Polytechnic Institute).

41. Yokoo's posters are seen in Moriyama's pictures of Terayama's performances (fig. 8), and he worked with Hosoe designing the Mishima book. Yokoo was also deeply identified with the dancer Hijikata and made posters for him as well. See Donald Richie, "Japan's Avant-Garde Theater," *Japan Foundation Newsletter* 7 (April–May 1979): 1–2. Yokoo also played in Nagisa Ōshima's film *Diary of a Shinjuku Thief* (1968) and designed the posters as well.

42. *Asahi Camera*, April 1972, quoted in *Inu no toki*, 348. Moriyama says further: "I did not behave like that just because I was in New York. I acted the same when I was in Tokyo too."

43. Copies of *Another Country* were produced and distributed at the Shimizu Gallery in Tokyo as part of the exhibition he had there.

44. *Inu no toki,* 348.

45. Ibid., 349. Moriyama has also stated: "I do not consider myself an existentialist, but when I think about the cyclical nature of myself and the world, time and light, history and the present, and myself and photography, I can't help but think that all of that is the meaning of 'existence,' and that perception and actual physical feeling play a large role. I think that one might call such a view 'existential.' Of course there were the concerns of Sartre and Camus, and perhaps, to a lesser extent, Heidegger. My own concern, however, is not so much theoretical or logical, but more one of perception and physical feeling. Photography and existence have an extremely close relationship, at least in my way of thinking" (letter to author, June 1998). Existentialist thought was important to both Nakahira and Terayama, according to Taki.

46. *Hunter* was one of a series published by Yamagishi, which included monographs on Tōmatsu, Fukase, and several others. They all followed the same format.

47. From Tadanori Yokoo, "A Cowering Eye," in *Hunter* (Tokyo: Chūō-kōron-sha, 1972), unpaginated.

48. Ibid.

49. David Riesman, *The Lonely Crowd: A Study of the Changing American Character* (New Haven: Yale University Press, 1950).

50. On the Stockholm catalogue, see note 39 above. Moriyama experimented with yet another Warholian idea, the billboard, in his June 1970 project *Scandal.*

51. Marilyn Ivy, *Discourses of the Vanishing: Modernity, Phantasm, Japan* (Chicago and London: University of Chicago Press, 1995), 30ff.

52. See Koschmann, "Intellectuals and Politics," 417–18; see also ibid., 193. Moriyama does not know the work of Yamaguchi directly, although he is aware of the connection between Japanese theater and Shinto religious practices.

53. Moriyama, letter to author, July 1998.

54. Mishima appreciated them in particular for what he called their "unforeseen ghastliness, like when someone starts to talk and then suddenly stops speaking" (in Ivy, *Discourses of the Vanishing,* 83; see also 93). The collection of ghost tales was glorified in the Meiji period, as "essentially Japanese," free of Western materialism and individualism. In the 1960s the city of Tōno actively promoted itself as a nativist tourist site (ibid., 100ff.), presenting itself as a kind of nostalgic hometown for the citified Japanese population. As such, it was much photographed, mainly by tourists.

55. Dorothy C. Miller and William S. Liberman, *The New Japanese Painting and Sculpture,* exh. cat. (New York: Museum of Modern Art, 1966).

56. Szarkowski and Yamagishi, eds., *New Japanese Photography.* The other photographers in the show were Ryoji Akiyama, Domon, Fukase, Hosoe, Narahara, Ishimoto, Tetsuya Ichimura, Bishin Jumonji, Kikuji Kawada, Masatoshi Naitoh, Ken Ohara, Tōmatsu, Hiromi Tsuchida, and Shigeru Tamura. The introduction was written by both Szarkowski and Yamagishi.

57. See *Fifteen Photographers Today,* exh. cat. (Tokyo: National Museum of Modern Art, 1974), with an introduction by Tsutomi Watanabe.

58. Shōji Yamagishi, ed., *Japan: A Self-Portrait,* exh. cat., trans. Hiroaki Sato and Philip Yampolsky (New York: International Center of Photography, 1979), with an introduction by Takeo Tomioka (trans. Hiroaki Sato); *Photography: Venice '79* (New York: Rizzoli, 1979).

59. Nakahira lost his memory in 1977; Fukase was entering a period of personal turmoil; Terayama (b. 1935) would die of cirrhosis in 1983.

60. In 1978 Moriyama produced *Japan: A Photo Theater II,* with an introduction by Yamagishi. It was a continuation rather than a reevaluation of the earlier book.

61. Its title pays homage to Joseph-Nicéphore Niépce, whose country estate was located at Saint Loup de Varenne, near Chalon-sur-Saône. Moriyama acknowledges the vitality of Niépce's first photograph, *Backyard with a Small Dovecote,* which he calls a "fossil of light and time." See Moriyama's afterword, "That Summer Day in St. Lou," in *Lettre à Saint-Lou* (Tokyo: Kawade shobō shinsha, 1990), unpaginated. A similarly ambiguous view out a window, formally resembling Niépce's, is an illustration of this text.

62. *Tokyo: Daidō Hysteric,* no. 4 (Tokyo: Hysteric Glamour, 1993); *Tokyo: Daidō Hysteric,* no. 6 (Tokyo: Hysteric Glamour, 1994); *Osaka: Daidō Hysteric,* no. 8 (Tokyo: Hysteric Glamour, 1997).

63. From an interview, "Moriyama Daidō no 'genzai': Intabyū, Shinsaku *Daidō hysteric no. 8, 1997 Osaka* o megutte" (The 'here and now' of Moriyama Daidō: An interview with him on his new collection, *Daidō hysteric, no. 8, 1997, Osaka*), in *Déjà-vu bis,* no. 11 (December 1997): 1–2.

64. Kenzaburō Ōe, "Japan, the Ambiguous, and Myself" (Nobel Prize speech, Stockholm, 1994), in *Japan, the Ambiguous, and Myself: The Nobel Prize Speech and Other Lectures* (New York, Tokyo, and London: Kodansha International, 1995), 117.

65. Moriyama "That Summer Day in St. Lou," unpaginated.

66. In *Déjà-vu,* 93410, no. 12 (1993): 158; see also the introductory essay by Iizawa Kohtaro, "Photography in the Present Tense: The World of Nakaji Yasui," 8–11. Yasui was very much the ardent amateur.

67. See Roger Keyes, *The Male Journey in Japanese Prints* (Berkeley: University of California Press; San Francisco: Fine Arts Museums of San Francisco, 1989).

68. In the story, Fujiwara no Yasumasa, a courtier who was a poet and accomplished flutist, crossed the moor, and the bandit Hakamadane Yasusuke heard him and, though intending to kill him, gave in to the charms of the instrument. This picture was so highly regarded that it was reenacted in Kabuki theater. See Eric van den Ing and Robert Schaap, *Beauty and Violence: Japanese Prints by Yoshitoshi, 1839–1892,* exh. cat. (Amsterdam: Van Gogh Museum, 1992), 63.

69. From *The Brothers Karamazov,* in *Confessions of a Mask* (New York: New Directions Books, 1958), epigraph.

postwar Japanese photography and the pursuit of consciousness ALEXANDRA MUNROE

In 1961 Daidō Moriyama left his native Osaka for Tokyo, where he was determined to join VIVO, a radical collective of contemporary photojournalists. Bearing an introduction from a prestigious colleague,[1] Moriyama headed for the VIVO studio in Tsukiji, the fish-market district bordering the Ginza, in downtown Tokyo, and a burgeoning haven for the avant-garde. There he encountered the young photographers Eikoh Hosoe (b. 1933) and Shōmei Tōmatsu (b. 1930) and was told the despairing news that VIVO was to disband within a week. Undeterred, Moriyama persuaded Hosoe to accept him as an assistant. Over the following three years, as an apprentice to Hosoe, Moriyama finally realized his ambition—to learn, and then to go beyond, VIVO's photographic style.

Although VIVO had been active only since 1959, it culminated a movement in postwar Japanese photography with roots dating back to the early 1950s and anticipated and profoundly influenced Japanese photographic style of the 1960s and 1970s. Using a grainy and high-contrast surface, and a cropped and abstract style to depict the fragmented reality of Japanese urbanism and the eerie conditions of Japanese modernity, these photographers forged a discourse on the fundamental questions of photography as praxis—its relationship to social and political revolution, its ambiguous function as both documentary evidence and art, and its structural dialectic between subjective and objective realism. Drawing on the prewar history in Japan of both photojournalism and surrealist art photography, and inspired by contemporary American photography, especially the gritty cityscapes of William Klein, VIVO arose in response to the existential and radical ideas that shaped Japan's postwar intellectual and cultural vanguard.

Although nearly a decade younger than the VIVO photographers, Moriyama was profoundly impacted by their work. In his writings and interviews, he

attributes great importance to his relationship with Tōmatsu and Hosoe in particular. Moriyama understood the political and social engagement at the heart of Tōmatsu's project, an abiding humanism that was sentimentally allied to left-wing ideas. Although he wrestled to be free of such external forces, striking against ideology to give form to his own individual experience, Moriyama's work remains part of the prevailing oppositional consciousness of postwar photojournalism. In contrast, what he drew from Hosoe was a sense of theatricality and eroticism. Artaud-like occultism pervades Moriyama's photographs, and lurid scenes of street sex, such as *Yokosuka* (pl. 28), recur in his work. The dark lyricism of his urban landscapes and their obsession with uncanny realms of experience are deeply connected to the larger avant-garde culture of the 1960s, amid which he lived and worked—a radically innovative culture of film, literature, and performance art shaped by societal trauma. "Chaotic everyday existence is what I think Japan is all about," Moriyama has commented. "This kind of theatricality is not just a metaphor but is also, I think, our actual reality."[2]

The third photographer who looms large in Moriyama's pantheon is Takuma Nakahira (b. 1938). A Marxist intellectual regarded as a charismatic young genius by his peers, Nakahira was editor of the influential leftist journal *Gendai no me* (The modern eye) when he and Moriyama met in 1964.[3] Tōmatsu, eight years their senior, introduced them. Deeply engaged in the political and social protest movements active in Japan in the early 1960s, Nakahira was also involved in the massive student protests of 1968–69. A critic and activist, he was committed to bringing radicalism to the forefront of contemporary reality, into actual lived experience. In 1968 he cofounded a quarterly journal, *Provoke,* which involved young poets and photographers in a provocative strategy to challenge received notions

of art and photography by breaking down formal conventions. Moriyama contributed to the second and third issues (cat. nos. 203–4), and the two remained close friends until 1977, when Nakahira collapsed from alcohol poisoning and lost his memory. What Moriyama gained from years of working closely with Nakahira, meeting daily in bars in Shinjuku and later Zushi, was the will to push the medium to its limit, to break through the prevailing orthodoxies of aestheticism and conceptualism in Japanese photography, to search for a new and relevant reality of photography. Moriyama has commented, "Nakahira's logic lies in recognizing that a photograph's reality is in humanity, in history, in society."[4]

By the late 1960s Moriyama was recognized as one of the most original and important Japanese photographers of the postwar period. Both within Japan and abroad, his work was central to the critical texts and group exhibitions that established contemporary Japanese photography among the most creative developments in the history of world photography. Uniquely, Moriyama's historical significance within the context of the VIVO and *Provoke* movements—whose formal innovations and intellectual concerns defined the style for postwar Japanese photography—is matched by his influence over younger photographers working today. Moriyama's eminent position, rooted in the postwar consciousness yet more vital than ever to contemporary Japan, can best be assessed by understanding the larger cultural histories of modern Japanese photography. Like any narrative, it is one Moriyama resists: "I was not against America, or the war, or against politics," he has argued. "I was *against photography.*"[5]

Postwar Photojournalism and the New Realism

The period from 1955 to 1970 marks one of the most tumultuous in modern Japanese history. Beneath the veneer of spectacular economic recovery and mobilization toward peace, prosperity, and

progress, social and political turmoil rocked the tenuous foundation of postwar Japan. A central event of this period—and arguably the major watershed in establishing the postwar political role of artists and intellectuals—was the leftist struggle against the renewal of the U.S.–Japan Security Treaty (*Nichi-Bei anzen hoshō jōyaku,* known as Anpō). The treaty, ratified in 1952, gave the United States the right to develop Japan as a military base in the expanding East Asian cold war arena. From the outset, the treaty sparked controversy and opposition.

Beginning in the mid-1950s, labor unions, women's groups, cultural organizations, and members of Japan's Communist and Socialist parties organized a succession of massive strikes and violent demonstrations opposing the treaty's renewal, which culminated in a national crisis in 1960. In the prewar era Marxism and various strains of socialist thought had flourished among intellectuals and the avant-garde, creating a sophisticated legacy of social and political critique. The postwar revival of leftism, while organized toward different goals, thus developed from a foundation with a mature level of discourse. The so-called Anpō movement associated with the new left, however, stimulated an unprecedented outburst of radical political action by ordinary citizens, including visual artists.

Both American and Japanese historians have studied the important intellectual, literary, and philosophical debates that marked the 1955–70 period. What is far less well known is the history of new artistic forms and practices that emerged from this period of unprecedented upheaval, and how artistic strategies underscored the leftist discourses in postwar Japan. The neo-Dada art movement, underground theater, New Wave cinema, and Ankoku Butoh dance all arose in the mid- to late 1950s in direct correspondence to the opposition, articulating not only a radical aesthetic in formal terms but also an altogether new cultural praxis.

On the stage, in the streets, and in the new journals that proliferated during this period, these emerging artists and intellectuals launched a critique of the ideologies of cultural modernization. They envisioned, framed, and designed a process of reform that was rooted in the existential situation of the masses—in everyday experience, not universal ideals—and that took place outside the formal bounds of institutionalized politics. At the center of their thinking was also the terrible knowledge they alone possessed of nuclear annihilation; Japan as ruins, as gaping emptiness, was their ultimate subject. Because they conflated the treaty with the possibility of atomic warfare, opposition to the treaty was essentially a humanist, antinuclear appeal.

Early postwar photojournalism emerged as part of this tremendous social unrest. After the suppression of the war years—when amateur photographic groups were banned, leading journals were shut down, and photojournalists were engaged to serve the war effort—the immediate postwar period saw a proliferation of photographers and publishers dedicated to photo reportage. Their intellectual mandate was to document social realities with "fearless objectivity," to use the camera as an instrument of truth that would counter the perceived distortions of history. New magazines such as *Sun Photo News* (*San shashin shinbun*), published by Mainichi Newspapers, soon dominated the industry with such slogans as "Photographs convey the truth."[6] Working within a social realist framework, the postwar photojournalists focused on images of atomic-bomb survivors, victims of industrial pollution, and rural poverty.

The work of Ken Domon (1909–1990) arose from this milieu. A radical who had once been imprisoned, Domon was instrumental in founding the Shudan Photo Group, a collective that held annual exhibitions in the early 1950s with Western photographers whose work expressed social commitment, including Margaret Bourke-White, Bill Brandt, Henri

Cartier-Bresson, and W. Eugene Smith. Working in Hiroshima and the Chikuho coal mines, Domon achieved national acclaim for his startling portraits of children damaged by war and exploitative labor conditions.[7] In the Hiroshima hospitals devoted to atomic-bomb survivors (*hibakusha*), he focused close-up on the daily lives of children deformed by radiation (fig. 16). His image of a boy receiving treatment on keloid scars offers an immediate experience, compelling both empathy and revulsion, as if the viewer were confronting the actual scene. Clinical, even dispassionate, Domon rejected deliberate artfulness to establish a legacy of evidence. His objective documentary style forged the *Riarizumu*

Shashin Undō (realistic photography movement), which strongly influenced the history of postwar photojournalism.

The debates on photographic realism influenced several photographers who would later found VIVO, including Ikkō Narahara (b. 1931; a.k.a. Ikko) and Kikuji Kawada (b. 1933; fig. 17). Like Ken Domon, Narahara and Kawada trained their cameras on the dark side of modern Japanese social reality. Narahara's series *Human Land, Island without Green, Gunkanjima* (1954–57) documents a coal-mining island near Nagasaki. His cropped, uncentered, close-up portrait of a half-naked miner emerging from the pitch-blackness, drenched in filth and sweat, captures the social conditions with a straight realism similar to Ken Domon's (fig. 18). But here the subject's psychological presence adds layers of

visual meaning, beyond raw description, to the image. In another photograph from the same series, Narahara suggests the confounding depths of this industrial wasteland by shooting the angular, concrete labyrinth of an apartment structure from above (fig. 19). Narahara's abstract, expressive compositions made his work more personal than journalistic, and when shown in a historic two-part exhibition in 1956, they aroused controversy among the orthodox social realists. Domon's objective realism would become its limitation, and he was among the first to declare that the period of "objective documentary" was over. Narahara's *Gunkanjima* thus heralded a shift in postwar photography from objective toward subjective realism, anticipating aspects of the 1960s style that would define the new Japanese photography.

VIVO and the New Japanese Photography

The pivotal figure in the emerging school was Tōmatsu, whose series recording the fragmentary relics of traditional Japan, the forgotten lives of Nagasaki's Catholic *hibakusha,* and the disjunctive culture of the American military bases caused a sensation in the late 1950s and early 1960s. Tōmatsu was trained in the conventions of photojournalism, in which individual pictures were subject to a larger, coherent narrative, but he gradually rejected journalistic illustration and refused commercial jobs. As he matured, his subject became less a critical document of Japan's postwar social conditions than an existential essay on everyday life amid the ruins of war and the irrationality of loss. An introspective perception, expressionist style, and psychic urgency mark his pictures. Tōmatsu's images of the Nagasaki atomic-bomb survivors, for example, convey less information than Ken Domon's of Hiroshima and yet have far more pathos (fig. 20). By employing an abstract, even surreal style to frame his composition of a woman's diseased arm combing her hair, face entirely lost in shadow, Tōmatsu universalizes

fig. 16 | Ken Domon
From the series *Hiroshima,* 1957
Collection of the Ken Domon Museum of Photography

fig. 17 | Kikuji Kawada
Japanese National Flag, from the series *The Map,* 1960–65
Collection of the Tokyo Metropolitan Museum of Photography

the particular terror of her condition, emphasizing the power of art over journalism, *humanité* over ideology.

The VIVO photographers first showed together in a historic series of three shows, *The Eyes of Ten* (*Jūnin no me*), which was organized by critic Tatsuo Fukushima and held at the Konishiroku Gallery in Tokyo from 1957 to 1959.[8] The ten included Hosoe, Kawada, Narahara, Tōmatsu, and Akira Tanno, who then separately formed VIVO, from the Esperanto word for "life." They gathered as an agency with the aim to promote innovation through their work as magazine photographers. The editor of *Camera*

fig. 18 | Ikkō Narahara
From the series *Human Land, Island without Green, Gunkanjima,* 1954–57
Collection of the Tokyo Metropolitan Museum of Photography

fig. 19 | Ikkō Narahara
From the series *Human Land, Island without Green, Gunkanjima,* 1954–57
Collection of the Tokyo Metropolitan Museum of Photography

fig. 20 | Shōmei Tōmatsu
Woman Suffering from an Atomic Disease, from the series *11:02 Nagasaki,* 1960–66
Collection of the Tokyo Metropolitan Museum of Photography

Mainichi, Shōji Yamagishi (1928–1979), became a passionate champion of their work and emerged as their most important advocate both within Japan and abroad.

The VIVO artists all were born in the 1930s and raised under Japan's imperialist regime, and came of age amid war, defeat, and devastation. They emerged in the mid-1950s as youths who, disappointed in institutionalized politics and resisting blanket Americanization, were dedicated to the possibility of art to transform Japan's socially entrenched statism. Most of all, their subject was postwar Japan—its modernity, its identity, and its wartime past, which was silenced but not gone. As Tōmatsu reflected: "In Nagasaki, I witnessed not

only the vestiges of war, but a postwar without end. I once believed that 'ruins' were cities reduced to ashes. Nagasaki taught me that ruins can also be found in the human soul."[9]

Like the earlier photojournalists, the VIVO photographers were concerned with the condition of manual laborers, the ghostly vestiges of native culture existing in the shadows of urban sprawl, and the effects of Japan's Americanization. What distinguishes their work from that of the earlier generation is their obsession with how to describe immediate experience: their pictures are not comments on experience, but experience itself; not records of the uncanny, but uncanniness itself. Exploiting the violent, cruising, Beat style of William Klein's *New York* (1956), the VIVO artists aimed to express, rather than merely document, the visual and existential discord that pervaded everyday life. However short-lived VIVO was as an agency, the

name itself has come to signify this larger phenomenon associated with Tōmatsu and Yamagishi, and spanning the 1960s.

Daidō Moriyama emerged at the end of VIVO's formal activity and ultimately forged a far more innovative and independent style. But long before he had a camera of his own, he spent months studying Tōmatsu's contact sheets in an effort to analyze the master's iconography, method, and style. In his first published series, *Japan: A Photo Theater* (*Nippon gekijō shashinchō,* 1968), Moriyama demonstrated certain affinities. Like Tōmatsu, he found his subjects in urban back alleys, among raucous theater troupes, and around the Yokosuka naval base. Tōmatsu's famous image of a man shoveling mud in

the aftermath of a typhoon (fig. 21) shares with Moriyama's *Shinjuku Station* (pl. 17) a concern with the bizarre underworld of Japanese street life. Both figures are dehumanized, their forms cropped to exaggerate the awkwardness of their extreme condition. Tōmatsu's picture of a traditional street vendor (fig. 22) also compares neatly with Moriyama's *Actress, Tenjō Sajiki, Tokyo* (pl. 11). Both images represent a haunted, grotesque realism caught in a momentary flash of time. But whereas Tōmatsu's composition sets the performer's face in a formal grid of abstract line and shadow, Moriyama's presentation is more promiscuous, accidental, and, ultimately, terrifying. Eschewing artistry, Moriyama delib-

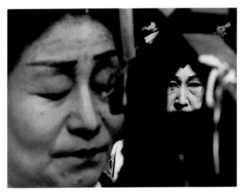

erately seeks an anonymous approach to shooting the present as immediately as he experiences it.

In contrast to Tōmatsu, Eikoh Hosoe's sense of theater enabled him to transcend the documentary ethic of his photographic education. Hosoe's 1959 encounter with dancer Tatsumi Hijikata, founder of the Ankoku Butoh movement, inspired his investigation of sexual debauchery and death as a means of uncaging a primal energy at the core of man's physical being. Hijikata believed that this energy was suppressed and forgotten by the mechanisms of modern society. The outcome of their collaboration, *Kamaitachi* (1968), presents Hijikata's phantasmagorical performance set in the rural landscape of northern Japan (fig. 23). Hosoe continued to explore the forbidden erotic theater of the naked male body with Yukio Mishima in their celebrated project,

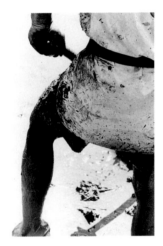

fig. 21 | Shōmei Tōmatsu
Aftermath of a Typhoon, Nagoya, from the series *Nippon,* 1959
Collection of the Tokyo Metropolitan Museum of Photography

fig. 22 | Shōmei Tōmatsu
Sandwich Men, Tokyo, from the series *Nippon,* 1962
Collection of the Tokyo Metropolitan Museum of Photography

Ordeal by Roses (*Barakei;* fig. 24). Set in Mishima's rococo-style house in Tokyo, this cumulative photographic portrait presents the bodybuilder-author, clad in *fundoshi* (traditional male loincloth), in hallucinatory poses suggesting bondage and death. Mishima recalled: "The world to which I was abducted under the spell of [Hosoe's] lens was abnormal, warped, sarcastic, grotesque, savage, and promiscuous. . . . It was, in a sense, the reverse of the world we live in, where our worship of social appearances and our concern for public morality and hygiene create foul, filthy sewers winding beneath the surface."[10]

The theatrical, the occult, and the erotic—themes deeply connected to the larger avant-garde culture of the 1960s—would also characterize Moriyama's work. He focused on the uncanny realms of Japanese modernity, where dark and ancient customs erupt back into daily life, unsettling normalcy. Moriyama was fascinated with the aberrant as a subversive way to represent Japan by what is officially hidden. Having assisted Hosoe on the *Ordeal by Roses* production, Moriyama began his independent work with the poet and dramatist Shūji Terayama in 1964.[11] In the tradition of Antonin Artaud, whose dark images of pestilence and defiant posturing had assumed cult status in the Tokyo underground, Terayama agitated for "subversion through theatrical imagination" by staging spectacles peopled with dwarfs, giants, naked women, deformed men, and live grotesqueries of all descriptions. Drawing on the legacies of Dada, Surrealism, and existential thought in the Japanese avant-garde, his plays also drew freely upon native Japanese folklore as well as juvenile literature, television, and film. Exhibiting an eclecticism that anticipates the postmodern sensibility, Terayama's clash of traditional and popular culture expressed the crisis of modernity in 1960s Japan. The eccentric figures that populate Moriyama's *Japan: A Photo Theater* were regulars on Terayama's legendary Tenjō sajiki

stage, and the dramatist contributed an absurdist prose-poem as the book's preface. Through Terayama, Moriyama invoked a universe of terror, of splits in appearance, of the irrational and fantastic—all signs of an unofficial world that resisted being effaced.

Moriyama's preoccupation with what he has called "this grotesque, scandalous and utterly accidental world of humanity,"[12] remained central to his art. Unlike Hosoe, whose theatricality was achieved by literally staging his subjects (Hijikata, Mishima) in artificial, mythological roles aimed to shock, Moriyama found his theatricality erupting naturally at the periphery of urban landscapes—in the Yokosuka

by riding through Shinjuku in a patrol car late at night and shooting what he saw through the car window. Like the photographs of Weegee, whom Moriyama admires, the *Accident* series "suggests a criminal atmosphere in the most banal, everyday environment . . . [in scenes of] the inextricable decadence of humanity."[13] Central to Moriyama's strategy with *Accident* was also the practice of using advertising billboards, movie posters, police placards, and other types of reproduced images, which create visual density in the urban landscape, as elements of his photographs. "The plurality of images was part of my own singular reality," Moriyama has written, "and I presented them as such."[14] The appropriation that came to mark Moriyama's style further expressed his vision of the kitsch voyeurism that so pervades modern city life. Theatricality as a sign of modernity's debauched conditions hence became the subject of Moriyama's art, fulfilling the postwar photojournalistic ideal of shooting evidence of history gone awry.

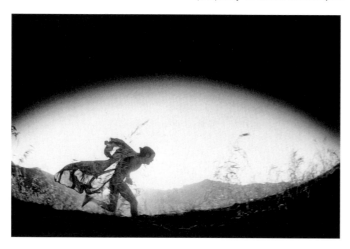

fig. 23 | Eikoh Hosoe
Kamaitachi (performance by
Tatsumi Hijikata), n.d.
Collection of the Tokyo Metropolitan
Museum of Photography

fig. 24 | Eikoh Hosoe
From the series *Ordeal by Roses
(Barakei)*, 1961
Collection of the Tokyo Metropolitan
Museum of Photography

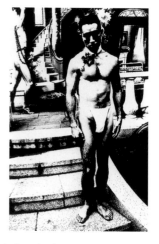

bars, at Tokyo's strip joints, and backstage in cheap downtown Kabuki theaters. His cabaret performer caught with false breasts exposed (cat. no. 26) or his wailing folk singer (pl. 6) do not symbolize a primitive, aestheticized otherness; they are rather a form of diaristic anti-art whose realism lies in a professed lack of artistry or intervention. Another important photographer who focused on erotic theatricality situated in the everyday was Masahisa Fukase (b. 1934; fig. 25), whose *Homo Ludence* series has a similar disturbing effect.

Moriyama's theatricality operates on several levels. In the lurid spectacles that make up the *Accident* series (pls. 65–66), for example, a Warholian decadence geared to voyeurism pervades. Here Moriyama aimed to capture a carnivalesque violence

Another Country

Daidō Moriyama emerged at a time when debates on photography and its relationship to objective or subjective realism dominated the discourse. Many lesser photographers were quick to emulate the styles associated with each school, hastening the ascendancy of orthodox styles. Moriyama's critical importance in the history of postwar photography is that he was among the first to break through the formal and ideological constraints of each approach to forge an expressionist style that was wholly his own. Rather than locating realism in either the objective or subjective realm, in static subjects of photography, Moriyama found realism in the act of taking a photograph itself. In a revealing essay, "The Camera

as a Means of Confirming the Self," he describes his method and concept:

I brush aside words and ideas, and focus on photography as a means of expressing a message that is both physiological and phenomenological. Without that framework, my approach is very simple—there is no artistry, I just shoot freely. For example, most of my snapshots I take from a moving car, or while running, without the finder, and in those instances one might say that I'm taking the pictures more with my body than with my eyes. I think that the process gives my photos more a sense of place and existence, more atmosphere. . . . Whether it's the perception of a certain object, or the atmosphere of a situation, if one always thinks about the composition of the picture, one will lose the freshness of the moment, and little by little the photos reveal their contemplated and formatted nature. . . . [My] photos are often out of focus, rough, streaky, warped etc. . . . But if you think about it, a normal human being will in one day perceive an infinite number of images, and some are focused upon, others are barely seen out of the corner of one's eye. The blurry photos too can be related to real life. A person's line of vision will often change over the course of a day—there's no way for it to be perfectly still and gradually shift from one thing to another. In fact, it is more normal to move around and for one to only have a rough sense of one's surroundings. I do not mean to give excuses for my photos, but perhaps this is the underlying structure, the crucial origins of my photographic style. For me, photography is not the endeavor to create a two-dimensional work of art, but by taking photo after photo, I come closer to truth and reality at the very intersection of the fragmentary nature of the world and my own personal sense of time. To dif-

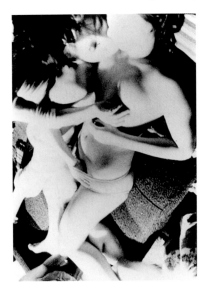

fig. 25 | Masahisa Fukase
Shinjuku, 1968, from the series
Homo Ludence, 1971
Collection of the Tokyo Metropolitan
Museum of Photography

ferentiate subjective and objective photography is nonsense. The exploration of the possibilities of photography is, in the end, inseparable from the individual's explorations of the possibilities of life.[15]

Ultimately Moriyama's originality lies in his insistence on photography as a kind of action art focused on recording the fragmentary substance of time itself. Informed by the intellectual and cultural concerns of the Japanese postwar avant-garde, with its pervasive existential and nihilistic bent, he expunged its overdetermined nostalgia and politics to forge a far more immediate—and unmediated—art. To Moriyama, early postwar photographers such as Ken Domon and Shōmei Tōmatsu were finally limited by their own doctrinaire dedication to narrative, a romantic belief in the possibility of art to serve an ideological end.[16]

In the early 1970s, after years of training his thirty-five-millimeter camera on city scenes, Moriyama traveled to the rural village of Tōno, in northern Japan. To Moriyama and other artists and intellectuals of his age, Tōno was known as the subject of a literary classic that was the founding work of Japanese folklore studies, *The Tales of Tōno (Tōno monogatari).* The tales, compiled as oral history in 1910 by the pioneering ethnologist Kunio Yanagita, recount episodes of murder, incest and grotesque births, ghosts and mountain apparitions, deities and monsters—the surviving numinous of an older world that had seemingly escaped the rational systems of the modernizing state. Through Yanagita's influential work, Tōno itself came to represent an authentic yet disappearing Japan, an arcadia inextricably linked to the afterlife and threatened by effacement. Yukio Mishima, writing on *The Tales of Tōno* shortly before his ritual suicide in 1970, stated, "*The Tales of Tōno* speaks, coldly, of innumerable deaths."[17]

The culmination of Moriyama's conceptual methodology as a photographer was his 1974 exhibition of *The Tales of Tōno* (pls. 71–74).[18] His choice of Tōno

as a subject was informed in part by his affinity for Yanagita's treatment of his elusive topic. Yanagita compiled the *Tales,* told to him by a local storyteller, as a series of "present-day facts" (*genzai no jijitsu*)—an approach Moriyama follows on his own expedition to record Tōno village.[19] Yanagita's 119 tales are brief and episodic, fragmentary and anti-narrative, structured overall without beginning or end, like a collage, anticipating Moriyama's own cinematic survey of contemporary Tōno's village life. Moriyama's random shots are cropped and paired in fragmented juxtapositions of, for example, a futon quilt hung out to air and the leathery face of an old farm woman (pl. 71). The debates over whether Yanagita's *Tales* were "scientific" (an unmediated record of spoken language) or "literary" (an interpretation shaped by the conventions of written language) also relate to Moriyama's own dilemma between objective and subjective, photojournalism and art photography. Ultimately the works of Yanagita and Moriyama achieve the status of both "document" and "art." But Moriyama is emphatic that his is not a literal illustration or lyrical evocation of Yanagita's work and even states that "the present reality of Tōno and Yanagita's Tōno are incompatible in almost all respects."[20] Rather, in his focus on shooting the "visible present" as he experiences it, Moriyama seeks not Yanagita but what Yanagita sought: he concludes that "photography might as well be folklore itself."[21]

Over and over, Moriyama seeks out the immediacy of time and place by surrendering to the power of site, what he calls "the original landscape" (*genkei*). In his writings on *The Tales of Tōno,* he argues for the direct experience of existence that site itself evokes. To Moriyama, the photographer who disregards the formal aspects of his trade and concentrates on time and place can uniquely express this reality in the modern era. Integral to Moriyama's understanding of landscape, however, is an abiding sense of the ephemeral, the incomplete, and memory. Empty streets, a person's face in a doorway, stray dogs—these are all elements of a marginalized landscape that he wants to recover.

This desire to return to "the original landscape," he writes, causes a sort of "personal reincarnation" (*rinne tenshō*), a recognition of some facet of the self, lodged in the past, which is aroused by an unexpected encounter with the image of a place. Moriyama invokes the classical Japanese aesthetic precept, *ichi-go ichi-e* (one time, one meeting), to suggest what he calls "the tragic nature of human existence," which comes from the "paradox of this reincarnation and the return to the original landscape."[22] It is as if his photographs were constructed as a double exposure—one aspect reflecting the information of a passing moment (images of contemporary Japan), the other penetrating into the elusive meaning of Japanese cultural identity (evocations of premodern Japan). Rooted in the particularities of postwar Japan, his photographs aim for, and achieve, universal emotional resonance. Far more complex than straight objective or subjective viewing, Moriyama's art creates a landscape wherein the real and the illusory, history and memory all coexist. It is a realm of consciousness that Moriyama calls "another country."

Notes

Unless otherwise noted, all translations from the Japanese are by Miwako Tezuka, Joseph Sorensen, C. Miki Wheeler, or Christine Shippey, adapted by the author.

1. From 1959 to 1961 Moriyama worked with Takeji Iwamiya, an Osaka photographer known for large-format landscape work and especially for his studies of Japanese gardens.

2. Daidō Moriyama, letter to Sandra S. Phillips, undated [1998].

3. Gendai no me featured photography and essays, and Moriyama's fetus series (pls. 95–96) was first published there. Among Nakahira's most influential writings and photographic anthologies are: Mazu tashikarashisa no sekai o suterō (First, throw out verisimilitude) (Tokyo: Tabatake Shoten, 1970); Aratanaru gyōshi (A new gaze) (Tokyo: Shōbun-sha, 1983); and Adieu a Okinawa: Shashin genten (Okinawa: The starting point of photography).

4. Daidō Moriyama, letter to Sandra S. Phillips, undated [1998].

5. Daidō Moriyama, interview with author, Tokyo, July 1998.

6. See Edward Putzar, Japanese Photography, 1945–1985 (Tucson, Ariz.: Pacific West, 1987), 8. Other photo magazines that were influential in the 1950s and 1960s were Asahi Camera and Camera Mainichi. Iwanami Photo Library, under the editorial supervision of Yōnosuke Natori from 1950, was also significant.

7. Ken Domon's series of these subjects were published as the following: Hiroshima (Tokyo: Kenkō-sha, 1958); Children of Chikuho Coal Mines (Tokyo: Patoria-shoten, 1960); and Rumie's Daddy Is Dead (Tokyo: Kenkō-sha, 1960). His Hiroshima work was also featured with Shōmei Tomatsu's work in Nagasaki in the Hiroshima-Nagasaki Document (Tokyo: Gensuikyō, 1961).

8. Tatsuo Fukushima, an organizer of the avant-garde arts group Democrat, which was active in the early 1950s in Tokyo, was a proponent of such existentialist writers as Sartre and Camus. The other photographers who were featured in The Eyes of Ten included Shun Kawahara, Yasuhiro Ishimoto, Masaya Nakamura, Akira Sato, and Toyoko Tokiwa (the only woman in this group).

9. Shōmei Tōmatsu, "Genjidai no kurisuto" (Christ in the nuclear age), in Nagasaki 11:02: August 9, 1945: Photographs by Shōmei Tōmatsu, trans. Linda Hoaglund (Tokyo: Shinchōsha Photo Musée, 1986), unpaginated.

10. Yukio Mishima, preface to Ordeal by Roses, in Eikoh Hosoe: Photographs, 1960–1980 (Rochester, N.Y.: Dark Sun Press, 1952), unpaginated.

11. Terayama initially approached Moriyama to commission him to record his theatrical activities (Moriyama, interview with author, Tokyo, July 1998).

12. Daidō Moriyama, "Jikokakunin no shudan toshite no kamera" (The camera as a means of confirming the self), in Shashin to no taiwa (A dialogue with photography) (Tokyo: Seikyūsha, 1985), 19.

13. Moriyama, "Sakuhin Kaisetsu" (Commentaries on works), in Shashin to no taiwa (A dialogue with photography), 22.

14. Ibid., 24.

15. Moriyama, "Jikokakunin no shudan toshite no kamera," 19.

16. See Moriyama's criticism of Domon and Tōmatsu as doctrinaire (kyōjyō-teki) in Daidō Moriyama, Shashin yo sayōnara (Farewell photography) (Tokyo: Shashin Hyōronsha, 1972).

17. Cited in Marilyn Ivy, Discourses of the Vanishing: Modernity, Phantasm, Japan (Chicago and London: University of Chicago Press, 1995), 66. For Ivy's discussion of The Tales of Tōno, see 66–140. See also J. Victor Koschmann, Ōiwa Keibō, and Yamashita Shinji, International Perspectives on Yanagita Kunio and Japanese Folklore Studies (Ithaca, N.Y.: Cornell University China-Japan Program, 1985).

18. The exhibition was held at the Nikon Salon in Tokyo.

19. For Moriyama's rationale for undertaking Tōno, see his essay, "Naze Tōno nanoka?" (Why Tōno?), in Tōno monogatari (Tokyo: Asahi Sonorama, 1976), 140–72.

20. Ibid., 159.

21. Ibid., 161.

22. Ibid., 167.

memories of a dog—conclusion : Osaka DAIDO MORIYAMA

Translated by Linda Hoaglund.
Originally published as "Inu no kioku—shūshō: Osaka,"
in *Asahi Graph* 24 January 1997.

Excerpt 1

For better or worse, I became involved with photography because of a broken heart. I was twenty.

At the time I was a kid, but I was already a freelance graphic designer of sorts. When I was seventeen, I had dropped out of the night school at Osaka Municipal School of Industrial Art to become an assistant at a small Osaka design firm. Two years later, after my father died unexpectedly, I began working for myself, setting up shop in my home in Ibaragi. My father had owned a life insurance company, and he left me a legacy of influence and contacts. Though I was a newcomer, I had more than enough work: posters, calendars, pamphlets, window displays. . . . Work poured in through the sales offices of large printing companies. The attendant design fees were a bit inappropriate for such a youngster. For the most part, I worked all night, slept in the early morning, rose after noon to wrap up the job, and picked up the next night's work in the early evening. Although I sometimes caught a movie or picked up books or records, I rarely saw friends and was unversed in the adult ways of spending money.

One day I chanced to meet a girl who would obsess me completely. She worked on the design team of a display company in Kitahama and worked with me on a storefront display. Although I am extremely shy, I can be bold, and late that spring, my heart resolved, I invited her to a coffee shop and asked if she would go out with me. She promised I could have my answer in one week's time. Although she looked young, she was older than I. When we met again, she agreed to go out with me.

I was in seventh heaven, flush and eager to try my wings. For the next three months I saw her once a week and flew to my heart's content, squandering my design fees in the process. Just after the summer turned, her behavior suddenly changed. It seemed to me that she was avoiding my calls at work. I may have been a dopey kid, but that much I

could figure out. When I could no longer reach her by phone, I visited her office, but she refused to see me on the grounds that she was too busy. Desperate, I resorted to waiting for her at the train station. Although I had been meeting her every Saturday, I had never asked for her home number or address, but I did remember the name of her station. One Saturday toward the end of August, I waited at the Okamachi Station on the Takarazuka line. Assuming she'd work until noon, I expected her anytime after one o'clock and resolved to wait, no matter how long. To escape the scorching heat, I stood in the shade of a tree across from the station and kept watch over the ticket gate. By two o'clock more than a dozen trains had passed, and I was fairly well fed up. Then she popped into view, wearing a yellow dress. Stilling my pounding heart, I approached and spoke to her. She turned toward me and halted, her expression clearly registering shock and confusion. Then her face hardened, and she turned and quickly walked away. Running around in front of her, I suggested we go to a coffee shop to talk.

"You're a pain," she cracked, and there was a harshness in her eyes I'd never seen before.

Flinching briefly, I sharpened my own tone and shot back, "Can't you at least hear what I have to say?"

She cut me off, bursting forth with, "I'm getting married in the fall, so it's best I don't see you. And don't call me at work anymore."

Twenty-year-old kid that I was, I could hardly manage a peep in response to this flat-out rejection. I stood in a daze, speechless at first, then managed only to mumble, "What did I do?"

"No, it's not like that. I'm sorry; it's my fault. Thanks for everything," she offered. She flashed a smile as she said, "Good-bye." Barely able to echo her farewell, I stood there like a dope.

The upshot was that I hadn't a clue about the real story and had simply followed her lead. I was left only with the riddle of feminine creatures and the realization that, for reasons obscure to me, my short-lived love of three months was over.

I have no memory of where I spent the remainder of that long summer evening, but I probably wound up in Umeda, in a bar behind Sonezaki.

Looking back, I suspect that what we had was less a love affair than a one-sided passion, but my heart was truly broken, and I lost all interest in my design work. Design work requires one to sit at a desk, and as I sat drawing, day and night, my eyes wandered to the shadows of people passing on the street, and I would become disgusted with everything. The radio adjacent to my desk blared music at all hours and seemed only to play songs about romance this and romance that, and if I played a record, it too went on about love this and love that. There was plenty of work if I wanted it, but in those days typesetting was not readily available. On a calendar, for example, I had to write a year's worth of dates by hand, a task more onerous than I could face. I was sick of tawdry designs for cinnamon candy packages. I could only sigh at the memory of the brisk work pace I had maintained during my romance.

Of course, I couldn't quit work entirely, but I accepted only graphic jobs such as posters and pamphlets. Often these projects required photographs, and through someone's introduction I became a regular at the photo studios of Takeji Iwamiya, the most famous photographer in western Japan. It was of course out of the question that Iwamiya himself would take on the kind of photographs I needed, but he had several able assistants who handled my work. Gradually I grew so accustomed to the atmosphere at the studio and so friendly with his assistants that I began stopping by for no reason. The wounds from my love affair had not yet healed, but my encounter with the world of photography liberated me from my reclusive life. It seemed to offer another dimension, a nimble physical experience

closer to sports or the stage than the desk work I had known.

Excerpt 2

Thirty-five years have passed since I left Osaka. I cannot help but be self-conscious on the eve of my return.

In January of 1996, exactly a year ago, I went to Osaka to make a television program. The trouble was that I wasn't going as a cameraman to shoot Osaka. Instead, I would be the subject filmed by someone else for Nippon Television's program "The World of Art." The director obviously imagined that I would be snapping photographs in various locations, perhaps on the northern island of Hokkaido—vaguely romantic and full of local color. But as soon as they proposed the show, I promptly insisted on Osaka. For the past few years my nearly obsessive nostalgia about Osaka has infused my routine in Tokyo. Without a moment's consideration, I knew that Osaka was the place I had to go.

And so we went. My job was to wander around the various sections of the city at will, snapping photos. The television crew was to capture me taking photographs against the backdrop of Osaka. I toured all my old haunts: Umeda, Sonezaki, Nakanoshima, Midōsuji, Doshōmachi, Shinsaibashi, Dōtonbori, Sennichimae, Nanba, Ginbashi, Kyōbashi, Tsuruhashi, Tennōji, Shinsekai, Janjan Yokochō, Tobita, Nankō. Carrying only my Olympus Miu, I prowled the downtown neighborhoods and the back alleys near the markets, taking pictures as I went. The TV crew trailed me, following my gaze. When I take photographs, my body inevitably enters a trancelike state. Briskly weaving my way through the avenues, every cell in my body became as sensitive as radar, responsive to the life of the streets.

So we prowled the streets of Osaka for three whole days, and by the third night we were nearly through. After a quick drink with the crew, I wandered the night alone, back toward my hotel. I did not have my camera, and I walked idly, following my whims. As I crossed the large pedestrian bridge near Osaka Station, streams of light confronted my gaze, and I felt an urgent thrust rising through my body. It was like a sharp flash of electricity coursing through me. If I were to give it words, I would say: "I have no choice. . . . I have to shoot this. . . . I can't leave this place for another's eyes. . . . I have to shoot it. . . . I have no choice." An endless, murmuring refrain.

Even after I returned to the hotel, took a shower, drank a scotch and soda at the bar, and returned again to my room to stare at the TV, my thoughts never strayed from that refrain. Thus came my long-overdue decision to create a photographic series on Osaka.

Right before we returned to Tokyo the following day, we shot one final scene in which the reporter and I chatted briefly on the pedestrian bridge in front of Shin Osaka Station. The previous night's refrain still rang in my ears, and I told her of my decision. Just as William Klein has his New York, I should have my Osaka. Starting last May, I began to photograph the city.

There is a long, thin building near the western approach to the Ebisu Bridge, which spans the Dōtonbori River. The first and second floors of the building are occupied by the Ebisu Bridge Häagen-Dazs shop. The area is a thriving section of Osaka, and all day long people cross the bridge in an unceasing stream. As you approach, you are greeted by the strains of a mysterious little melody that blankets the neighborhood from just before noon until midnight. It is the theme song played by the Ebisu Bridge Häagen-Dazs shop. I've been coming to Osaka repeatedly ever since last summer to take pictures for this collection. Each time I come, I head straight for Ebisu Bridge, hear the music, sigh with relief, and flash a wicked grin. I think to myself, "Osaka, here I am." The song has a mildly intoxicating effect on

me. The orchestration is as odd as the melody is mysterious, combining the timbre of a music box with the sounds of a fife and drum corps and the echo of a circus band. As I hear it, again and again, it inspires in me a strange nostalgia. A nostalgia not for the past, but perhaps for the future. Comical, lyrical, and somehow pathetic, it is a weird and lovely tune. Knowing how I had fallen for this piece of music, a friend of mine took the trouble to record its strains from the top of the bridge. For me, this is the ultimate recording, filled with the noise of the streets and the voices of Osaka's people. I often play this melody in my Tokyo workshop, as though I'm in Osaka. It soothes me some when I'm irritated or put out. Late at night I play the tape, and my thoughts turn to Osaka, to the photographs I have not yet taken, and then back to my Osaka again.

shomei tomatsu : the man and his work DAIDO MORIYAMA

Translated by Linda Hoaglund.
Originally published as "Tōmatsu Shōmei: Hito to sono sakuhin,"
in *Photo Art* (Tokyo: Shashin Sōgō Hyakka, 1976).

It must have been about fifteen years ago. I was not quite twenty-two and knew as much about photography[1] as a lamb. After frittering away nearly a year in Osaka as an apprentice to Takeji Iwamiya, I left for Tokyo, driven by my passion for the world of VIVO, a tempest that, in my imagination, could have silenced a crying child. Carrying in my breast pocket only a letter of introduction from my master, I took the Tōkaidō railway all the way to Tokyo, hunched tense and sleepless in a corner of the third-class car. Writing this, I am appalled by its resemblance to the climax of a trashy novel. The truth is that I was both anxious and ecstatic. I had aimed my sights at Tokyo and an assistantship at VIVO.

In Tokyo I strode down the Ginza, radiant in green tweeds and black mambo pants, bound for VIVO's studio in Tsukiji, no matter whether it proved to be a fortress of Young Turks or a den of demons. There I found Eikoh Hosoe himself, a photographer whose work I knew well. Quickly, I drew the letter from my pocket and presented it to him. At the time he was only twenty-eight. This youthful genius sported thick-rimmed glasses and a roomful of presence. He skimmed the letter, crossed to the back of the room, where several others were gathered, and began arguing with them in a hushed voice. Now I realize that they must have been wrangling over who would give me the bad news. Sensing that something was wrong, I sank toward despair. Then Eikoh Hosoe called me, "Hey, you, Moriyama, come along." He walked out of the office, down a winding alley between two small buildings, to a cavernous basement restaurant.

Stranded between a cold cup of coffee and my own frozen gaze, Hosoe picked up again, though a bit more formally, "It's Moriyama, right? VIVO's breaking up in a week. I know you have an introduction from Iwamiya. I'm very sorry. If only you'd come a little sooner. But it's too late now. It's just too bad, really too bad."

He spoke in sympathetic tones, like the amateur-hour host Masao Koga gently critiquing a contestant, mercilessly shattering all my dreams. In the darkness of the restaurant, my rainbow-hued visions of Tokyo dissolved. I panicked, groping for something—anything—I could say to buy time, to keep him from saying, "Well, that's it," but came up mute, speechless. Hosoe was warm, and instead of rising to leave, he casually asked me about Osaka. It was then that Shōmei Tōmatsu, whose recalcitrant features I recognized from the pages of a photography journal, lumbered out of the darkness, like a bull. He was thirty-three.

He settled directly in front of me and ordered a mixed grill and a lemonade with great deliberation. With his swarthy complexion, small but sharp eyes, dark attire, stocky build, and rounded shoulders, his presence was overpowering. When Hosoe introduced us, his lowered voice registered annoyance, not charm. He shot me a piercing look and uttered, "I'm Tōmatsu."

Hosoe briefly told my story. Without looking up, Tōmatsu issued his harsh verdict: "Too bad. Time to go back to Osaka." After this, he turned his full attention to battle with the large piece of meat before him. At first I thought, "He's so extraordinary." In the next moment, "What a shithead. All he does is stuff his face."

So went my memorable first encounter with the photographer Shōmei Tōmatsu. I do well to remember that it may have been a cursed day, for thenceforward I made my life among a gang of misfit photographers.

Eikoh Hosoe was positively dreamy compared with the harsh, dry Tōmatsu. Determined to take advantage of this, I jabbered at Hosoe about whatever came to mind. I paid absolutely no attention to Tōmatsu, who devoured his meal intently, down to the last slice of broiled pineapple.

"I can do anything. I will do anything. At Iwamiya's studio I was one of the best at developing and printing. I don't care if there's no more VIVO. Can't you help me? Won't you help me? Won't you do something? Please." I harangued Hosoe, knowing it was my last chance.

Tōmatsu trained his small, cold eyes on me as if to say, "What a line." But then Hosoe finally relented: "OK. If you really think you've got what it takes, now that VIVO's finished, I'll need an assistant. You want to try working with me for a while?"

I nearly fainted, overcome with happiness and excitement. Tōmatsu's expression softened almost unrecognizably into a quick, thin smile. "Good for you," he declared.

Thus I achieved the glory of assisting Eikoh Hosoe, who was already a star at twenty-eight. Despite my dubious knowledge of film processing and even the basics of operating a camera, I threw myself into this new world, giving it everything I had.

Having turned the studio over to Akira Sato, the other members of VIVO—Akira Tanno, Ikkō Narahara, Kikuji Kawada, Shōmei Tōmatsu, and Eikoh Hosoe—rented a one-room apartment in Kōjimachi that would serve as their joint office and clubhouse. They named the new space after the apartment itself, Studio 43. Narahara, who traveled constantly for one reason or another, turned up there infrequently. Kawada stayed cooped up at home, rarely making an appearance. Tanno popped in toward evening, prattled on about various things, and quickly vanished again. Hosoe, as the hottest cameraman of the day, was off rushing from meeting to meeting with publishers. I was left alone with the telephone and Tōmatsu, who even then refused fashionable assignments, commuting to Studio 43 day after day with exceeding regularity. As we were together every day, Tōmatsu and I gradually got to know each other. I found him half intimidating, half gentle. In his spare time he told ribald stories, full of salacious details, rendering me speechless. When I

had nothing better to do, he drafted me into games of "come hither,"[2] which he had picked up along the way. Ignoring my protests, he pressed me into game after game, blackmailing me out of my last yen on a daily basis. I remember how thrilled I was when he treated me, penniless as I was, to a film or a drinking session, as though we were best friends.

In the meantime, late at night, I was secretly examining Tōmatsu's meticulously organized contact sheets, which he had brought to Studio 43 and pronounced off limits . . . "Dropouts," "Asphalt," "NAGASAKI," "Fear Mountain," "The Occupation," "Home," "Combinart." My nocturnal scrutiny of these lucid photographs left a profound impression on my dovelike sensibility. I was drawn increasingly into Shōmei Tōmatsu's world and into the world of photography. I was deeply influenced by Tōmatsu, even devoted to him. But, somewhere beyond that devotion, I was also preparing for a powerful rebellion.

After three enjoyable years I left my assistantship with Hosoe for many reasons. Starting from scratch, without any assignments or even the firm resolve to take photographs, to say nothing of a camera to shoot them with (having acquired only a wife), I became what they call a freelance photographer. Naturally, in the days that followed, nothing happened. In the end, my mother bought me a camera to celebrate my independence.

In those days, if I ran into Tōmatsu, he would hire me, asking me to help him out with his work. At times he passed along assignments shooting on film sets. Even though I carried in my breast pocket a collection of snapshots taken in defiance of Tōmatsu, I was grateful for the work he provided me, and my feelings vacillated. Later, as I began to get assignments of my own from magazines, I ran into Tōmatsu on the street only occasionally, and we gradually grew more distant.

Now that I was taking my own photographs, I had the impertinence to develop my own views about photography. They were diametrically opposed to Tōmatsu's weary, axiomatic pronouncements, reminiscent as they were of divine revelations . . .

"Moriyama, photography is haiku."

"Photography is the art of limitless choices."

I began to view Tōmatsu's newly published photographs as conceptual and rarely "got" the sociological assumptions implicit in his images. Still, the Tōmatsu I carried, in some central place inside, nagged at me. Some time had passed when I saw his collection *The Pencil of the Sun.* It baffled me. Especially the photographs of Southeast Asia. The series of photographs is so raw, and close to the heart of several controversies, that I will leave it for now. But I must add that I am faintly annoyed by the transcendent lucidity in the light and hue of those Southeast Asian images, which, as landscapes of enlightenment, have about them something of the stench of death.

It is obvious that my meeting with Shōmei Tōmatsu was definitive. There is no question that our encounter has given great meaning and power to the nascent photographer I was, as well as to the active photographer I have become. Frankly, it was a fortunate meeting. Yet, no matter how preoccupied I am with Tōmatsu, like anyone else, he can only be himself, and I can only work my own terrain. This is the point of departure for all encounters between two people. Shōmei Tōmatsu is self-disciplined and faithful, a cosmopolitan repulsed by indulgence. He is a mature adult possessed of a rigor I cannot hope to equal. I am someone of many weaknesses. I build myself bit by bit, relying too much on others. Given Tōmatsu, given his photographs, perhaps I, who can only be considered his opposite, was allured. Human relationships are endlessly fascinating.

No doubt even the apparently unflappable Tōmatsu must suffer anguish. When I see Tōmatsu, who's seen it all, the epitome of cool, I think of the word *déraciné.*[3] By this I don't mean the pose of the

outsider so popular with the young. The word *déraciné* sums up Tōmatsu, a man whose nature conceals a kind of loneliness.

When Shōmei Tōmatsu sets a goal, he is as quick as a monkey, applying tremendous focus and initiative to his work. While he is obviously focused on his immediate purpose, it seems to me that he also aims at some totality beyond himself, like the proverbial Don Quixote or Captain Ahab. He dares to stare down existence itself.

Déraciné refers to those who know more than they care to about things they cannot afford to believe in. This is why once, when I was drunk, I observed that, among all photographers, Shōmei Tōmatsu is the only one who has nearly achieved enlightenment.

I know of no other than Tōmatsu, who, knowing everything there is to know about fleeting moments of sadness or kindness, about bitter aftertastes and evil itself, can blithely laugh it all off. This is why, when Tōmatsu occasionally reveals a profound weakness, a rote quality, I cannot help but see it as a sign of relative strength. Once, standing at a bar smoking his pipe, he said, "If I had seven lives, I'd be a photographer in every one." Tōmatsu is a relentless hunter in search of absolute love (photography).

Once, just once, I'd like to have it out with him over and over and over again.

I'll finish off by offering Tōmatsu a line from one of my favorite poems:

> The Lonely Hunter
> *But my heart is a lonely hunter*
> *That hunts on a lonely hill*
> – Fiona Macleod

How exasperating that this has turned into a kind of love letter after all . . .

Notes

1. Photojournalism. In the Japanese original, Moriyama writes "photography world" and transliterates it as "journalism." Trans.
2. "Come hither": an obscene version of a traditional Japanese card game usually played by geisha to entertain their clients. Trans.
3. The French term *déraciné* (literally, "uprooted"), which appears in the original Japanese text, was used by the writer Hiroyuki Itsuki beginning in the early 1970s to refer to a certain outlaw, *étranger* quality of gaze or perspective. Trans.

PLATES

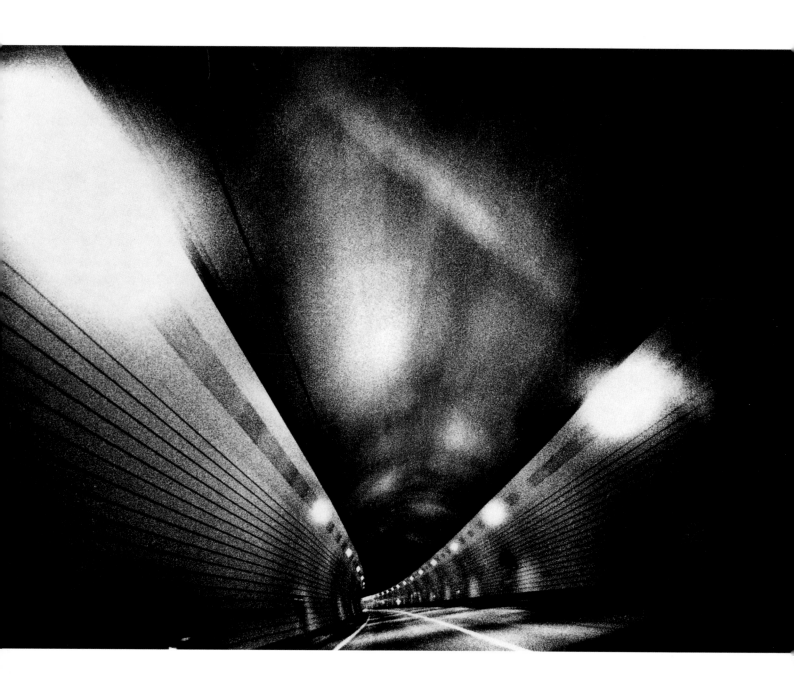

1 | *Tomei Expressway*, c. 1968
Cat. No. 49

2 | *Shibuya*, 1966
Cat. No. 22

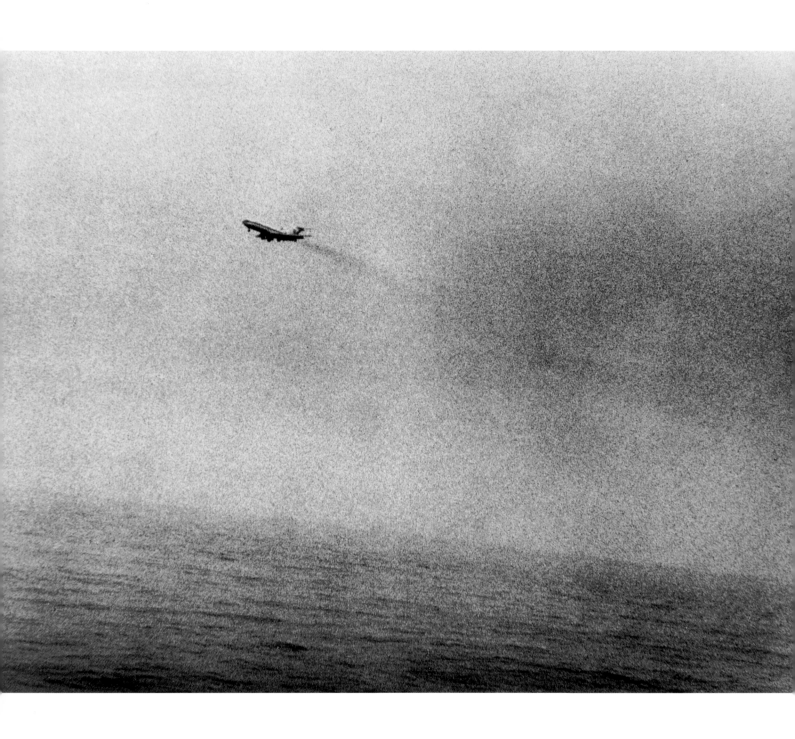

3 | *Kawasaki*, c. 1966
Cat. No. 24

4 | *Zushi*, 1965
Cat. No. 11

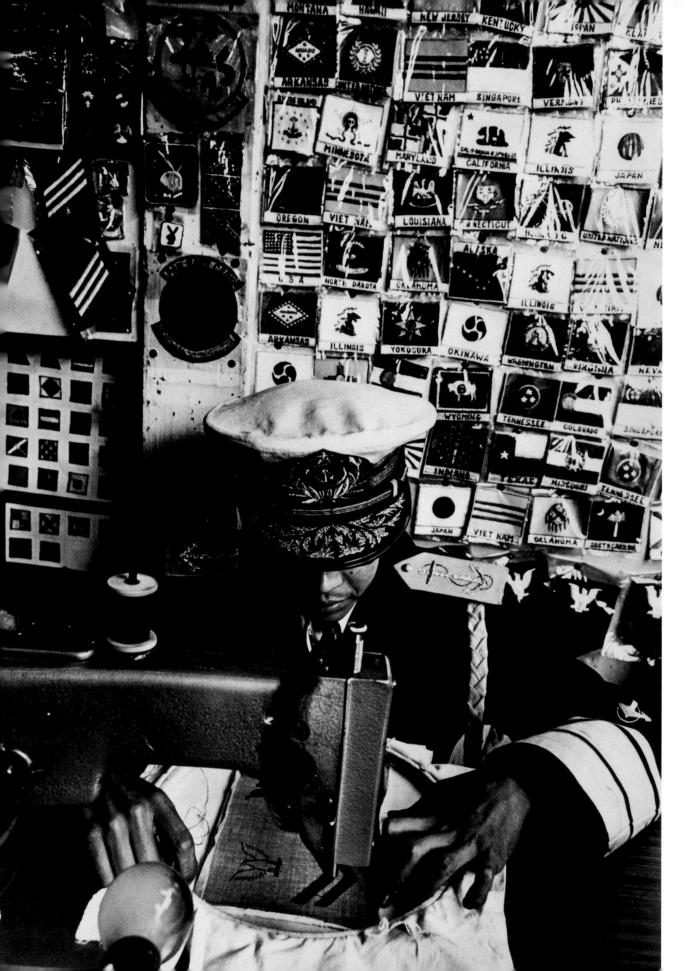

5 | *Yokosuka*, 1965
Cat. No. 10

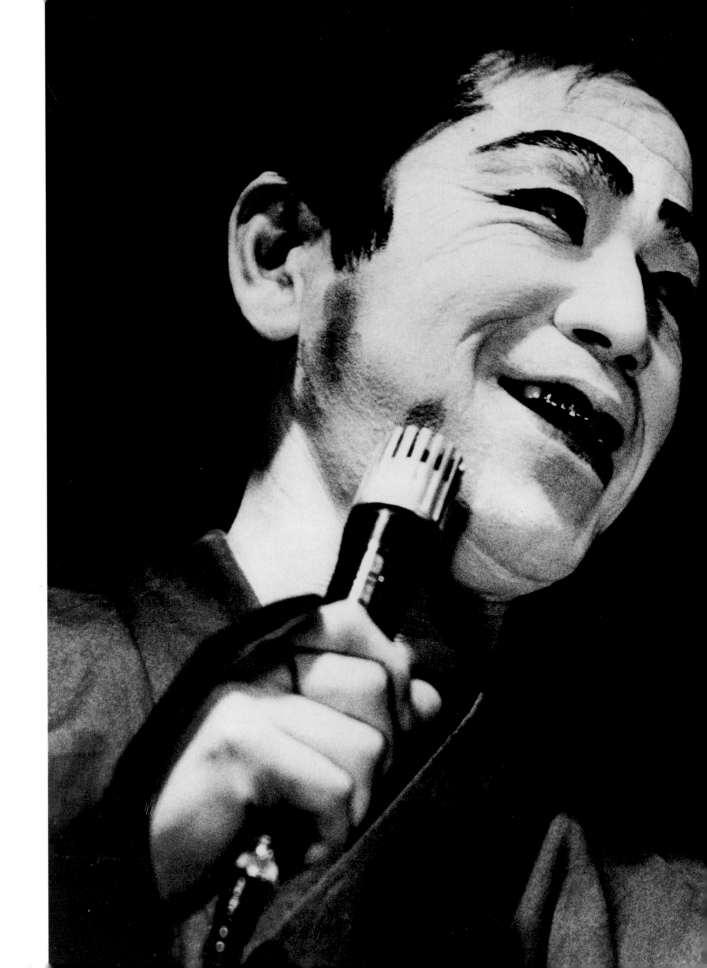

6 | *Kita-Senju*, 1966
Cat. No. 17

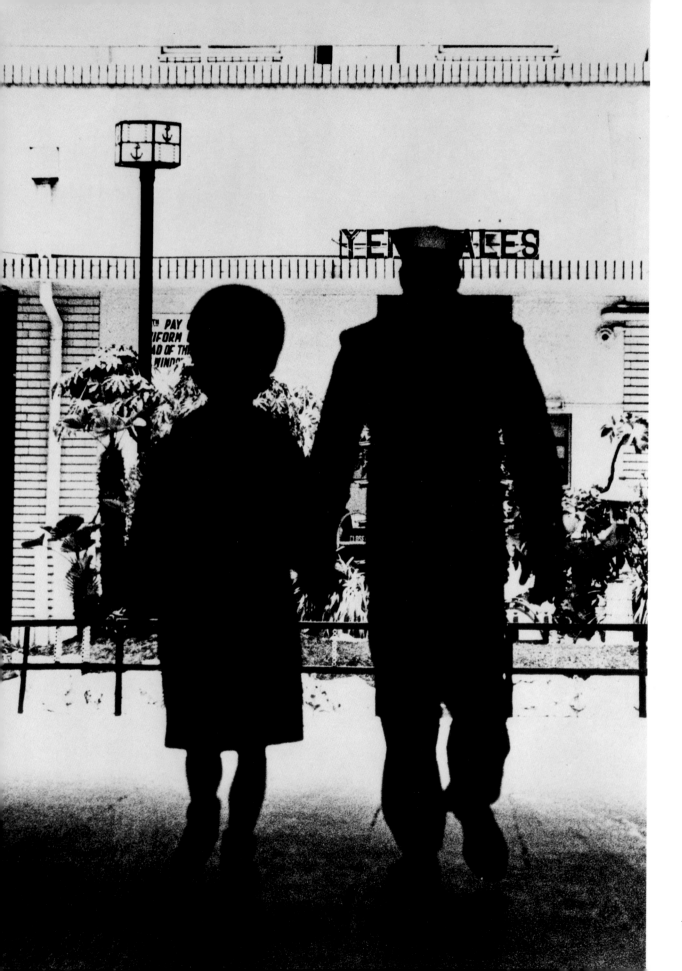

7 | *Yokosuka*, 1965
Cat. No. 6

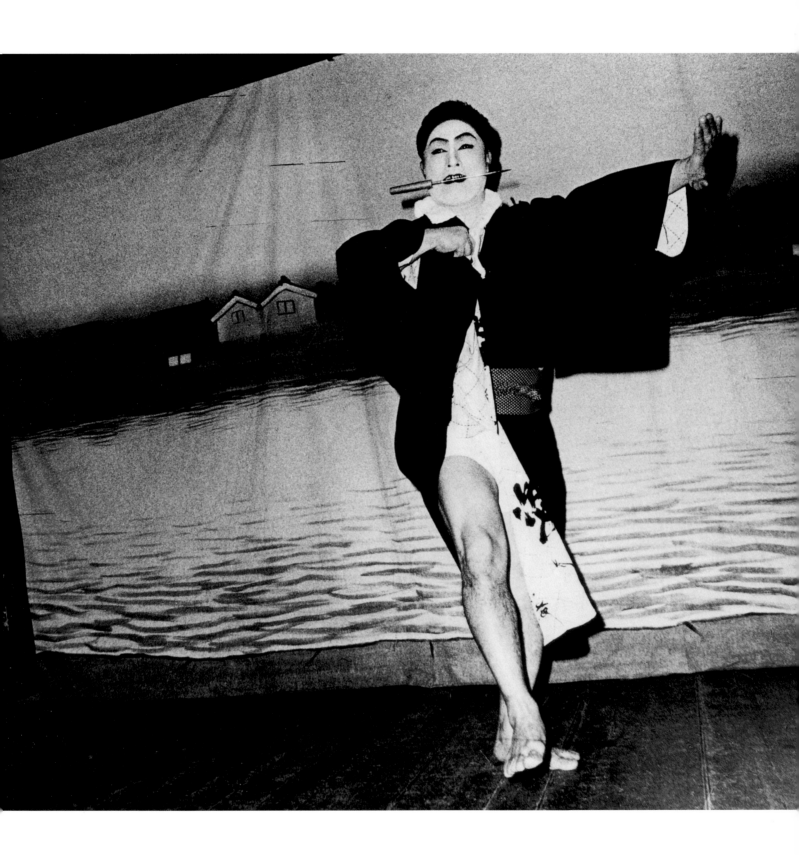

8 | *Kita-Senju*, 1966
Cat. No. 19

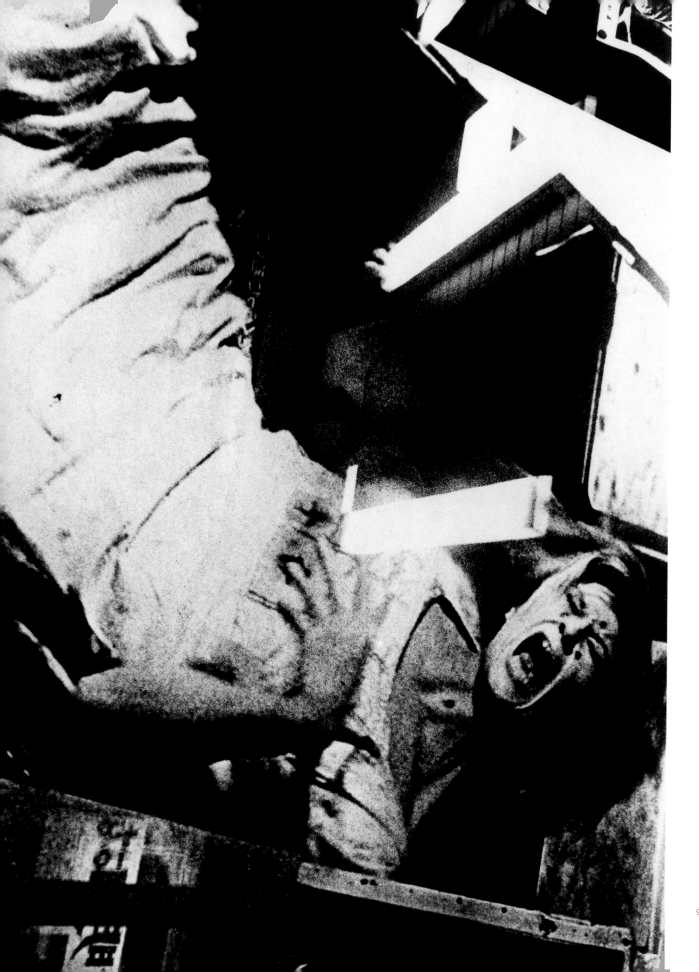

9 | From the film *Bonnie and Clyde*, 1967
Cat. No. 29

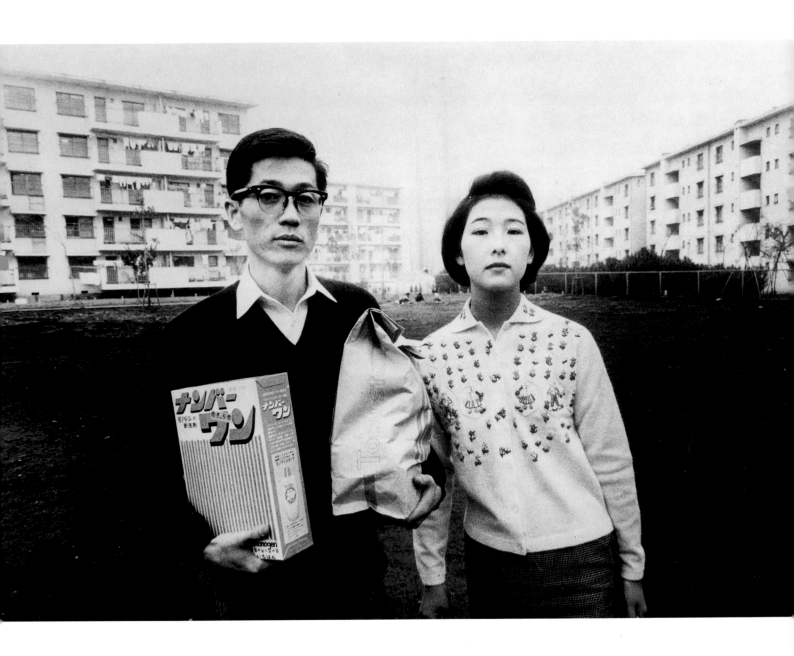

10 | *Housing Development, Tokyo*, 1967
Cat. No. 31

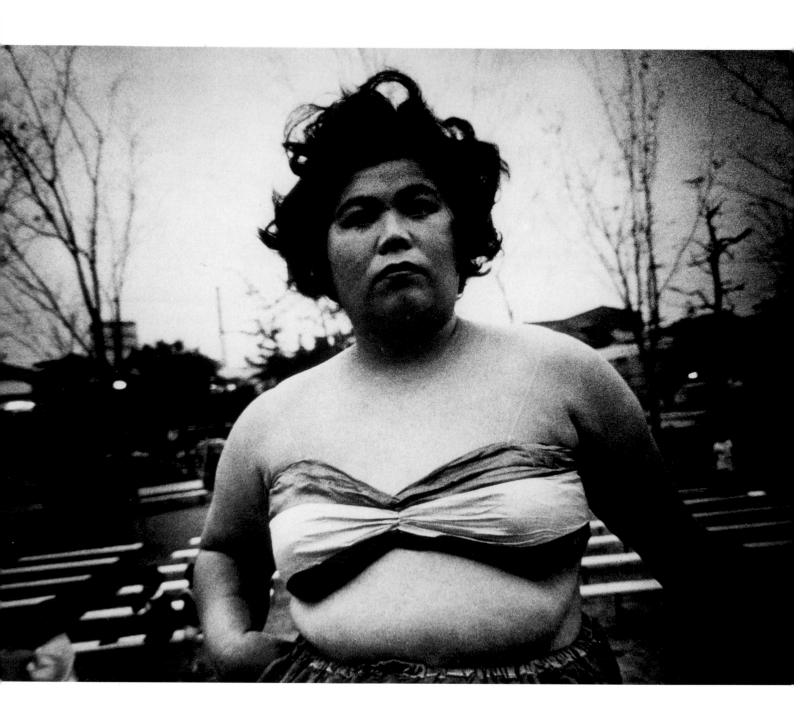

11 | *Actress, Tenjō Sajiki Theater*, 1967
Cat. No. 27

| *Hanafuda Card Game in Her Room*, 1966
Cat. No. 14

13 | *Shibuya,* 1967
Cat. No. 33

14 | *Hiratsuka,* 1966
Cat. No. 16

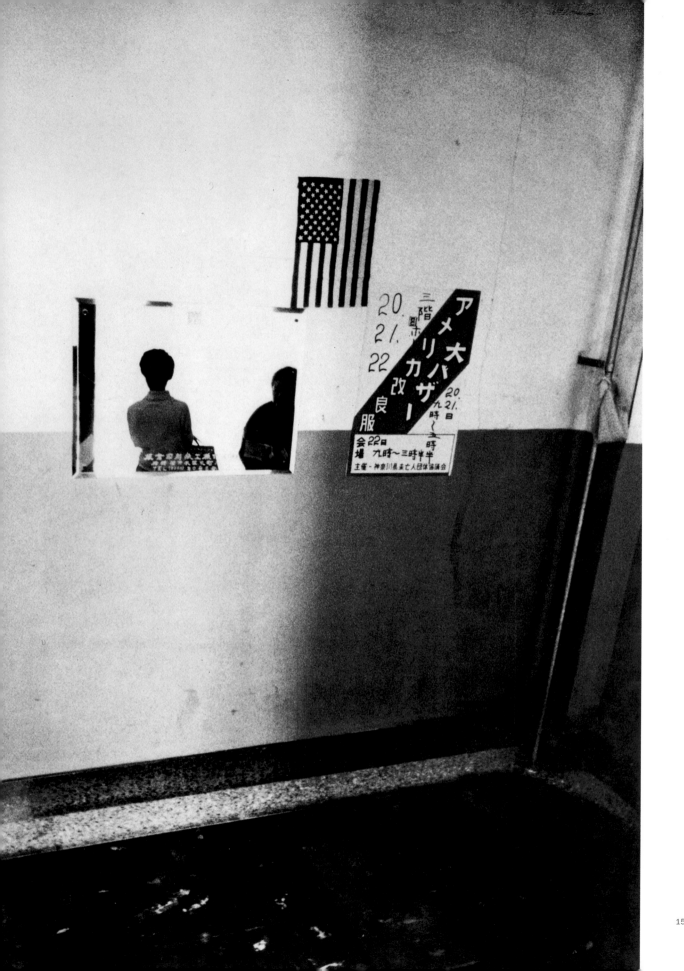

15 | *Yokosuka,* 1965
Cat. No. 9

16 | *"Computer Age."* 1966
Cat. No. 13

17 | *Shinjuku Station*, 1965
Cat. No. 5

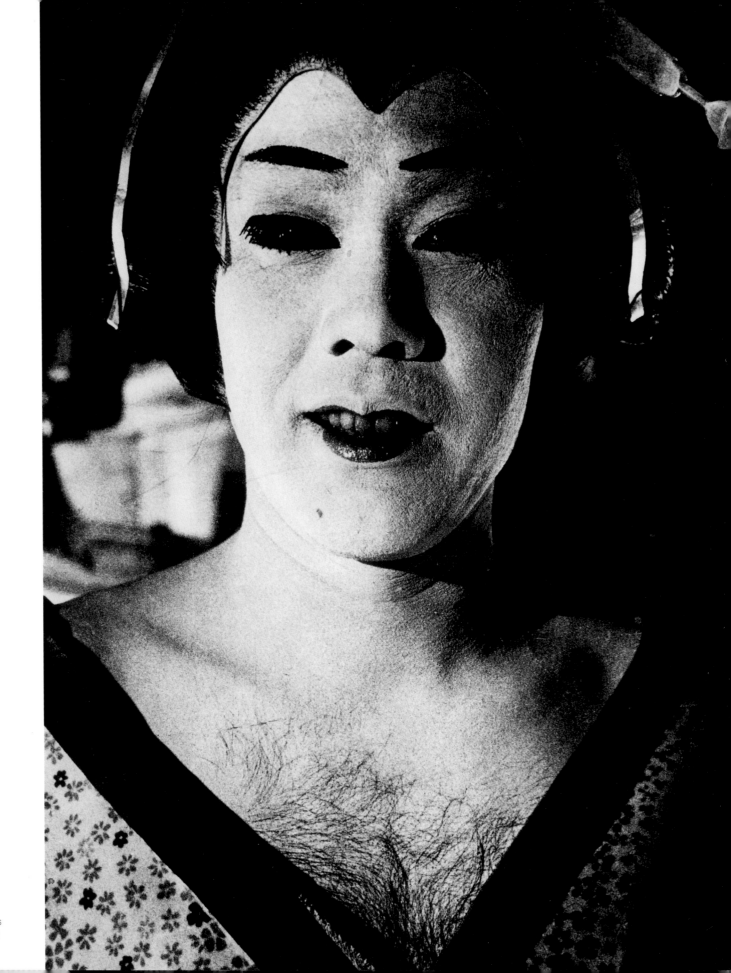

18 | *Actor*, 1966
Cat. No. 12

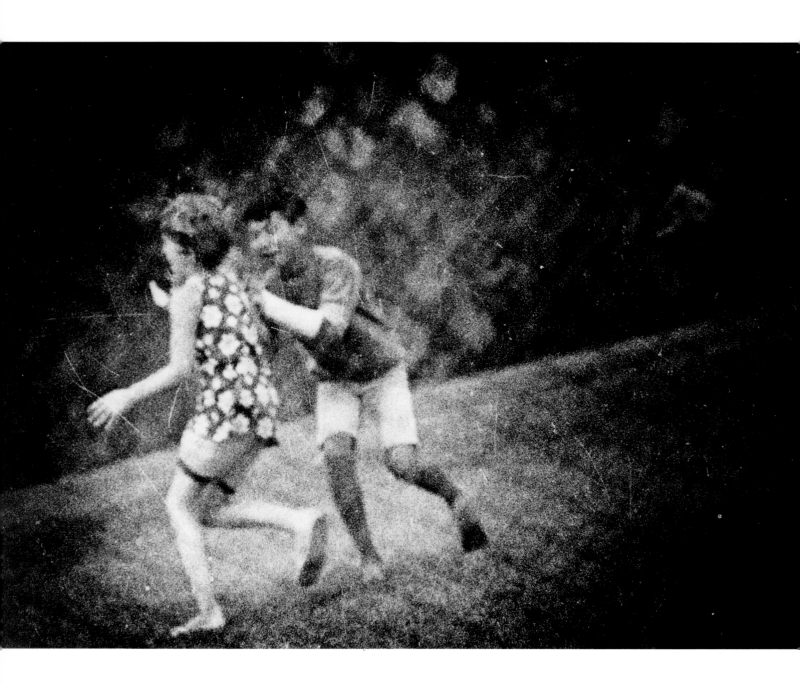

19 | *Route 16, Yokota,* 1969
Cat. No. 110

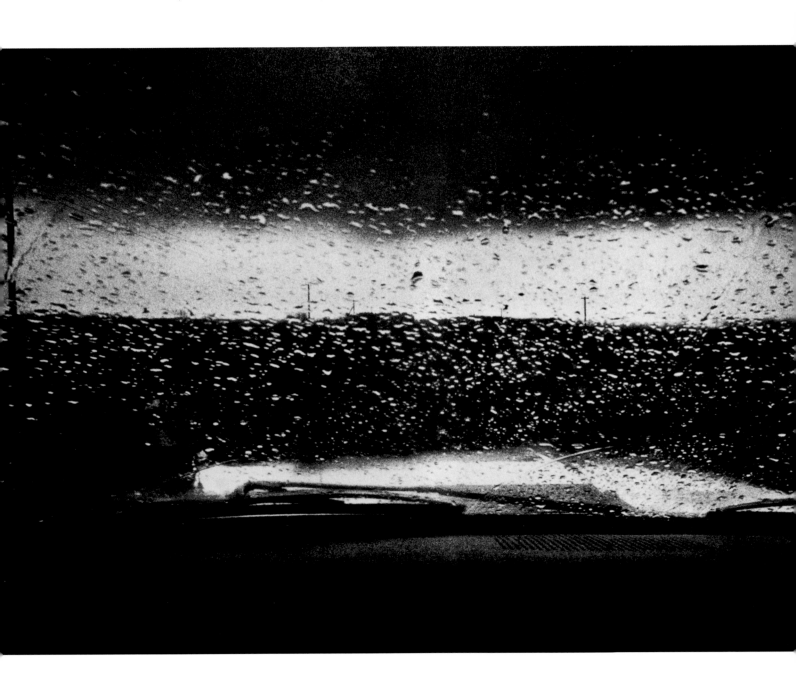

20 | *Kushiro, Hokkaido,* 1971
Cat. No. 128

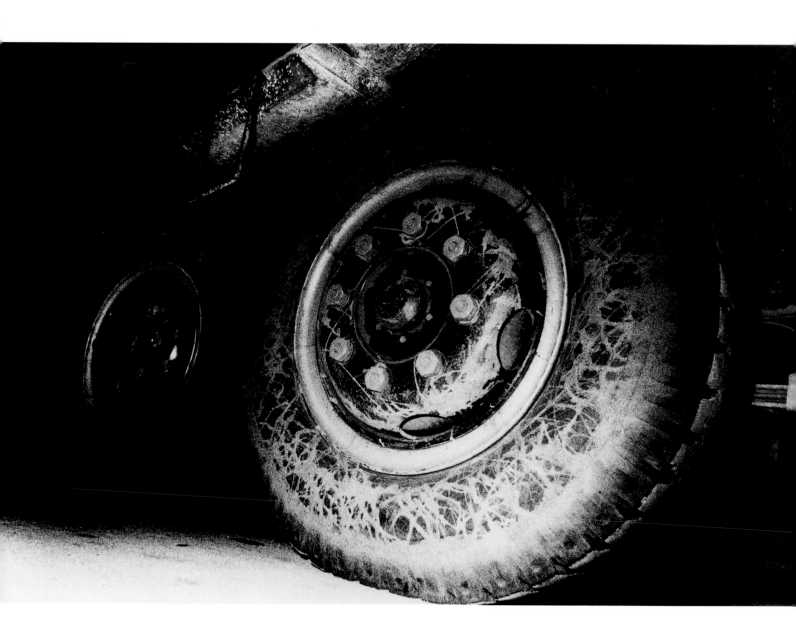

21 | *Tire, Yokkaichi*, 1968
Cat. No. 47

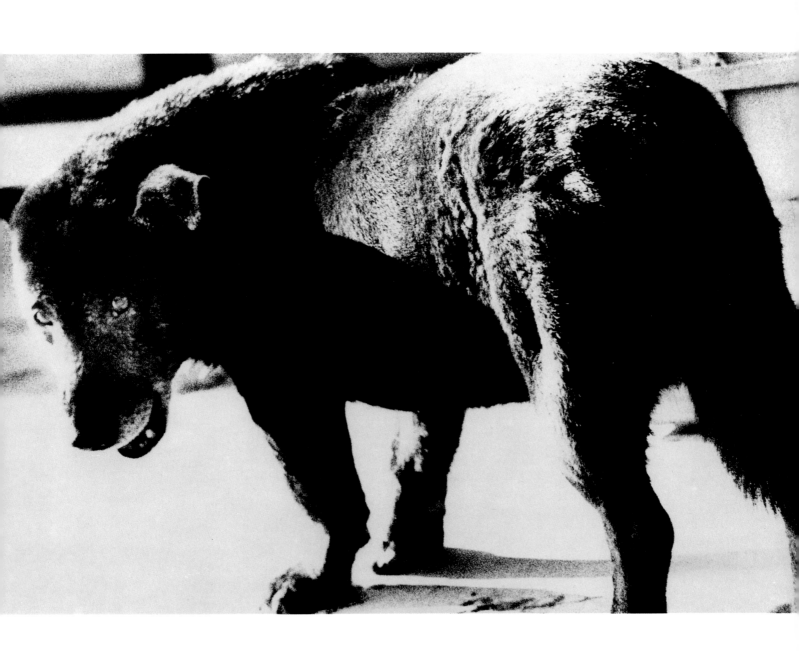

22 | *Stray Dog, Misawa, Aomori, 1971*
Cat. No. 133

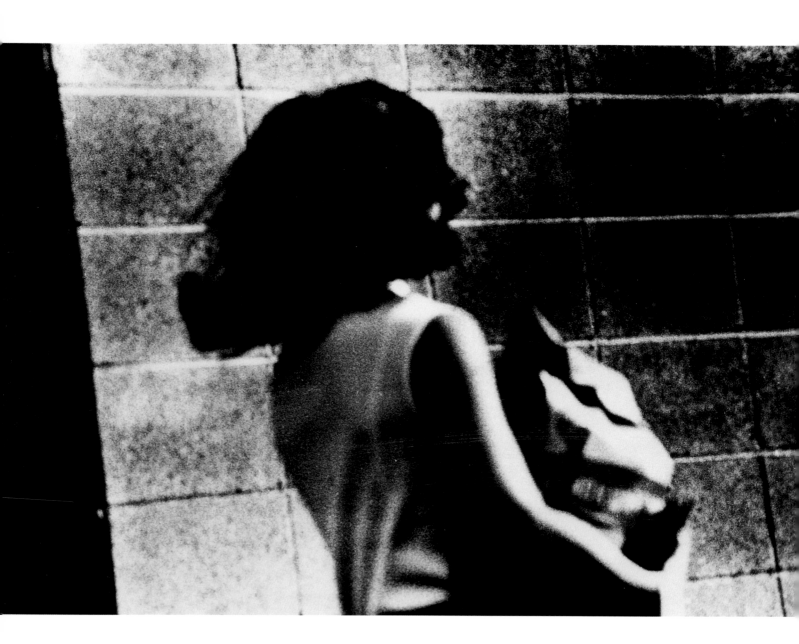

23 | *Route 16, Kanagawa, 1969*
Cat. No. 107

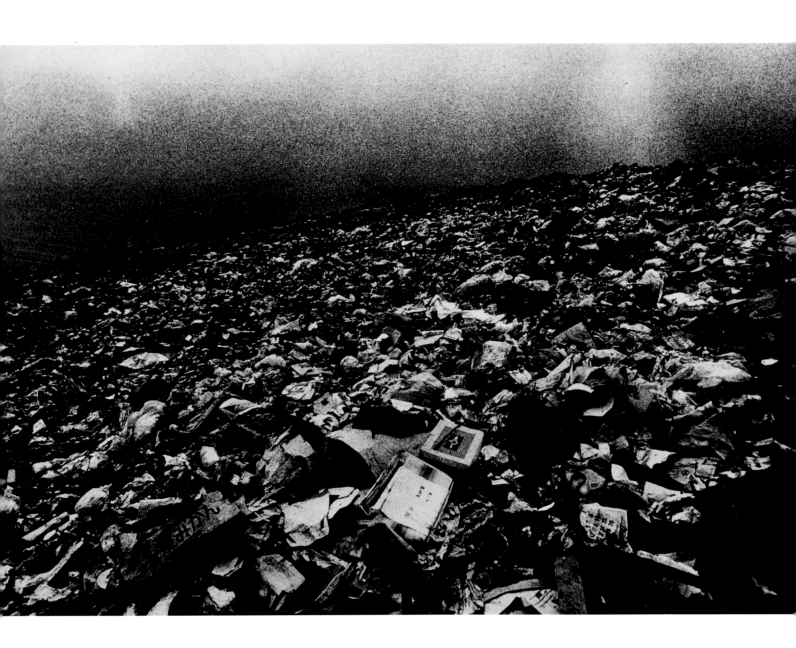

24 | *Yumenoshima, Tokyo,* 1966
Cat. No. 23

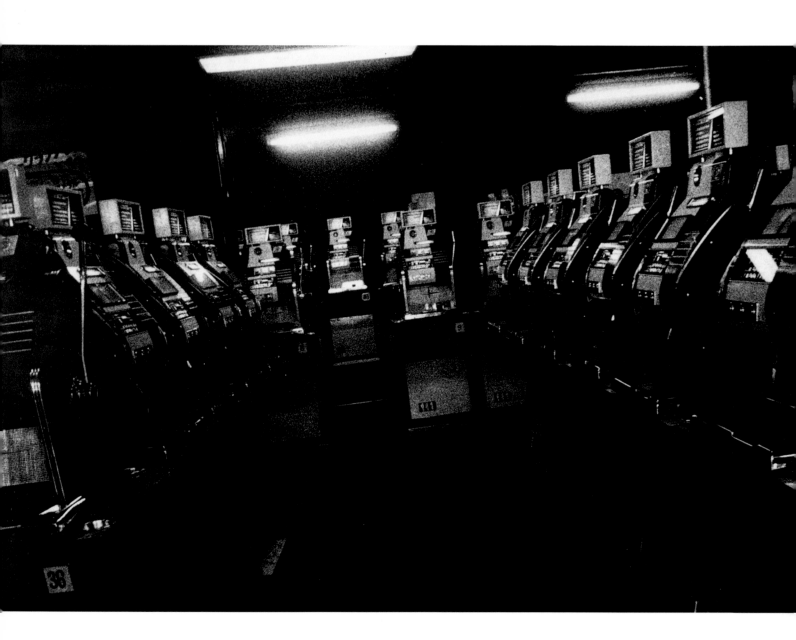

25 | *Game Center, Yokohama*, 1972
Cat. No. 139

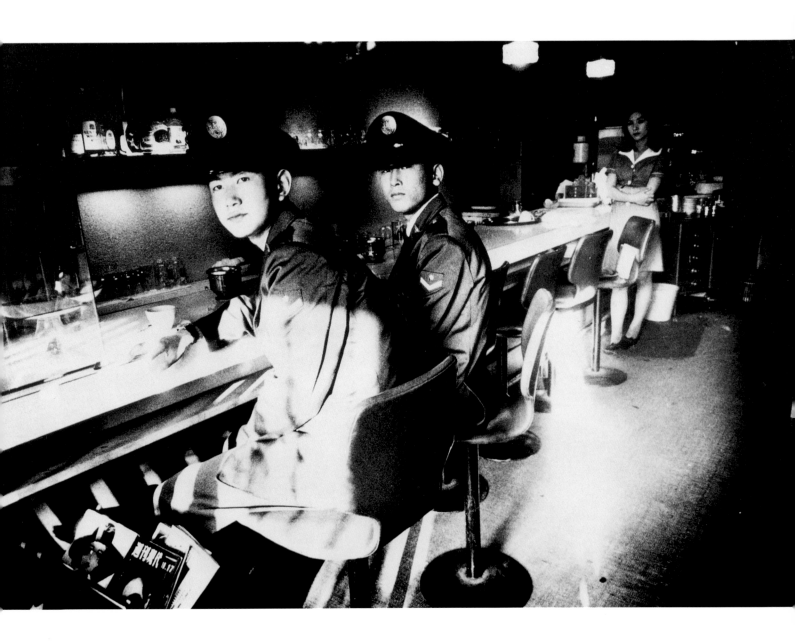

26 | *Coffee Shop, Hamamatsu, 1968*
Cat. No. 39

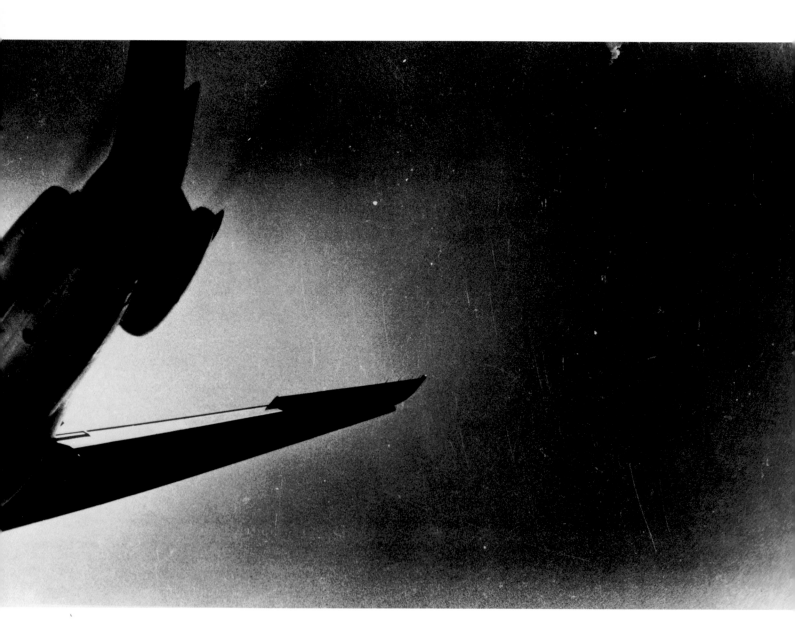

27 | *American Base, Route 16, Yokota, 1969*
Cat. No. 77

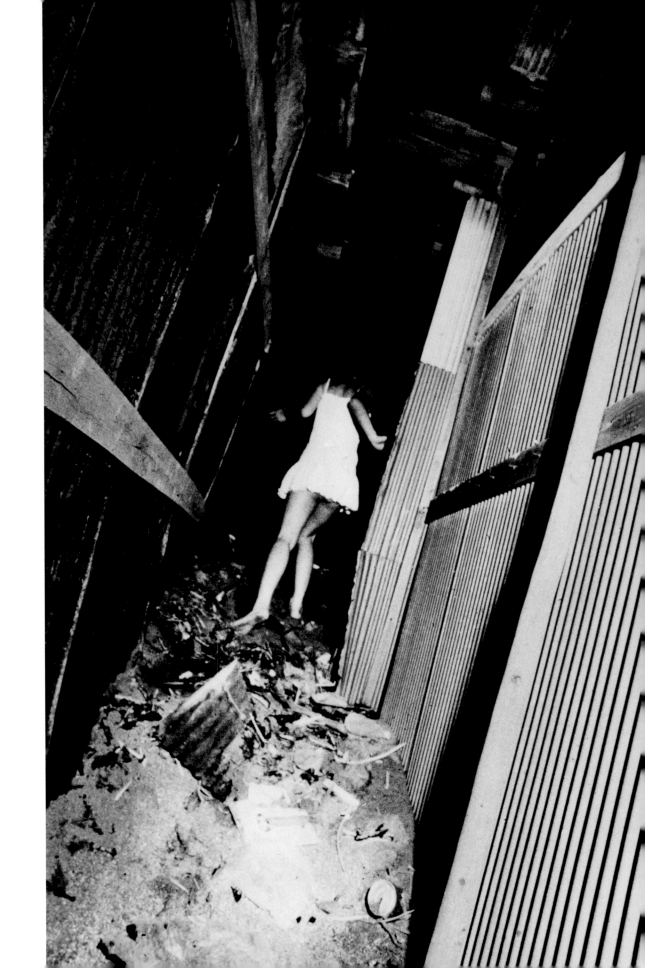

28 | *Yokosuka,* 1970
Cat. No. 124

29 | *Shinjuku*, 1969
Cat. No. 114

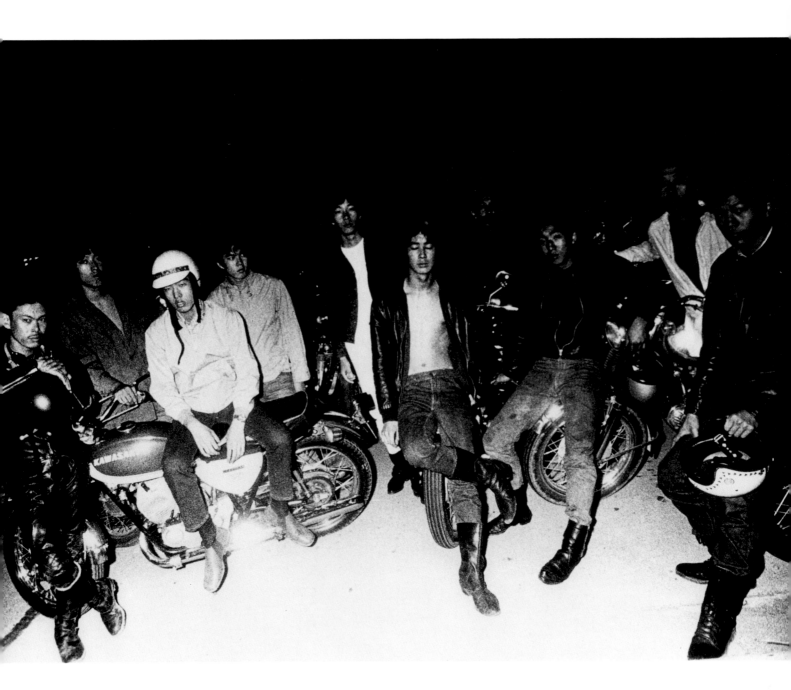

30 | *Bikeriders, Yokohama*, 1970
Cat. No. 120

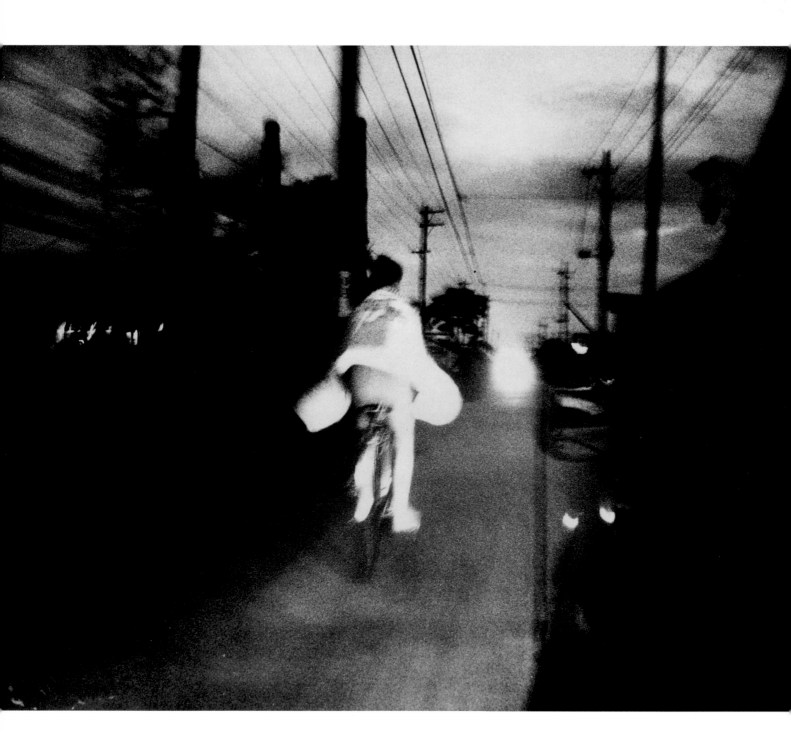

31 | *Route 16, Tachikawa, 1969*
Cat. No. 109

32 | *Scandal*, 1969
Cat. No. 112

33 | *Misawa, Aomori,* 1971
Cat. No. 129

34 | *Stripper,* 1968
Cat. No. 45

35 | *Room, Tokyo*, 1969
Cat. No. 104

36 | *Setagaya, Tokyo,* 1969
Cat. No. 113

37 | From the film *Bonnie and Clyde,* 1969
Cat. No. 89

38 | *Brigitte Bardot Poster, Aoyama, 1969*
Cat. No. 84

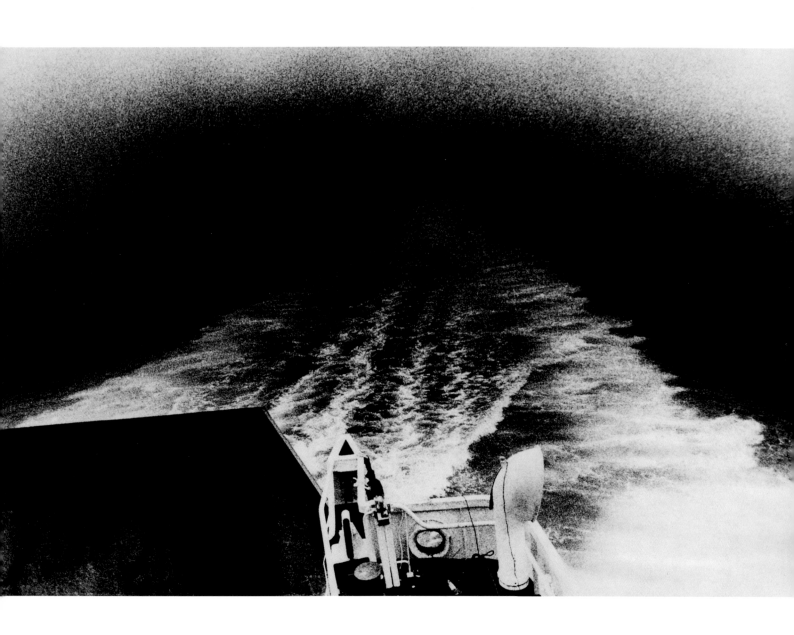

39 | *Ferry, Inland Sea*, 1970
Cat. No. 121

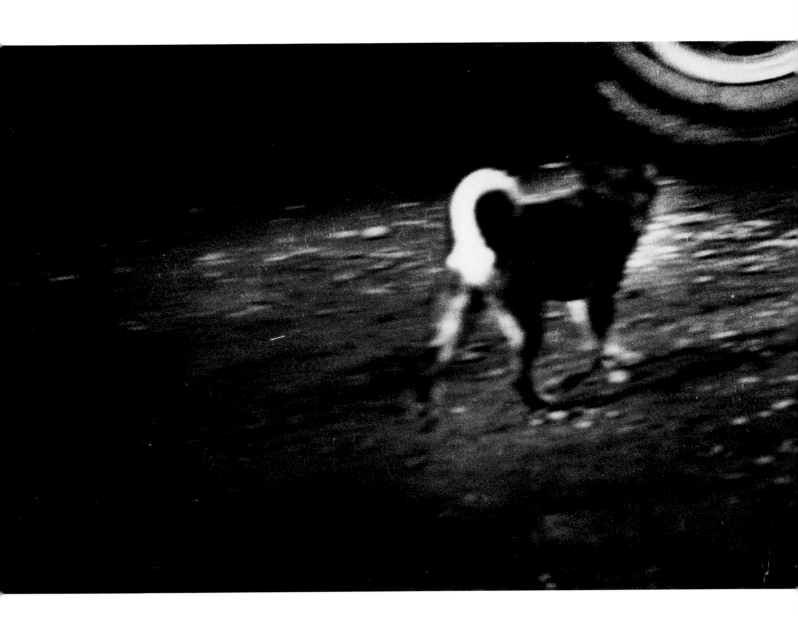

40 | *Route 16, Saitama*, 1969
Cat. No. 108

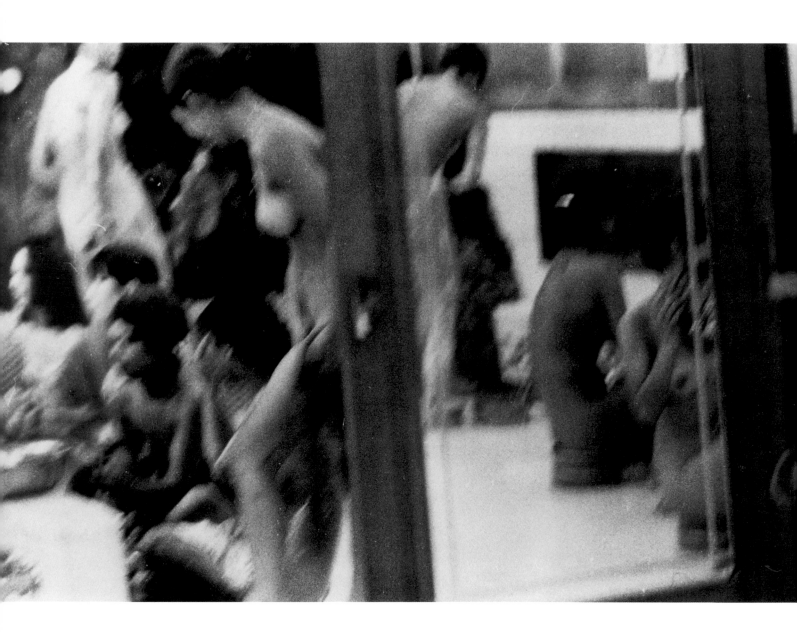

41 | *Public Baths, Shinjuku,* 1966
Cat. No. 21

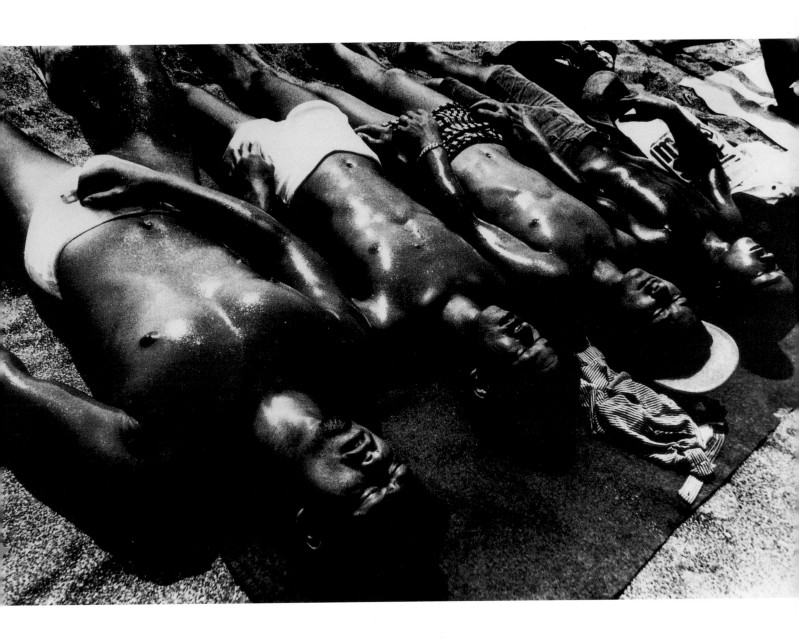

42 | *Hayama*, 1966
Cat. No. 15

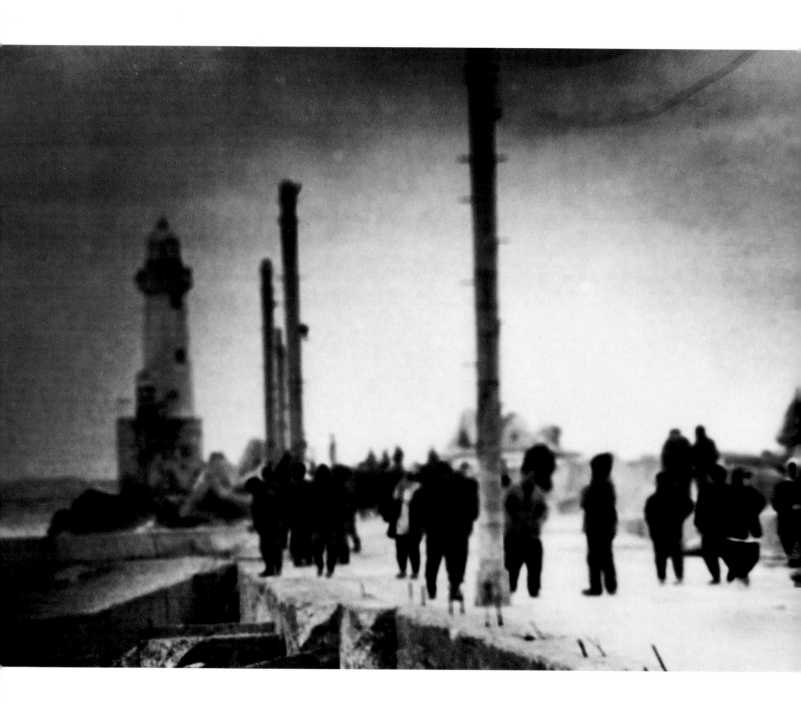

43 | *Accident at Sea, Chōshi, Chiba,* 1969
Cat. No. 75

44 | *Accident at Sea,*
Chōshi, Chiba, 1969
Cat. No. 76

45 | *Dam Site Construction from Film Screen, Nagano*, 1971
Cat. No. 126

46 | *Sunset, Osaka*, 1970
Cat. No. 122

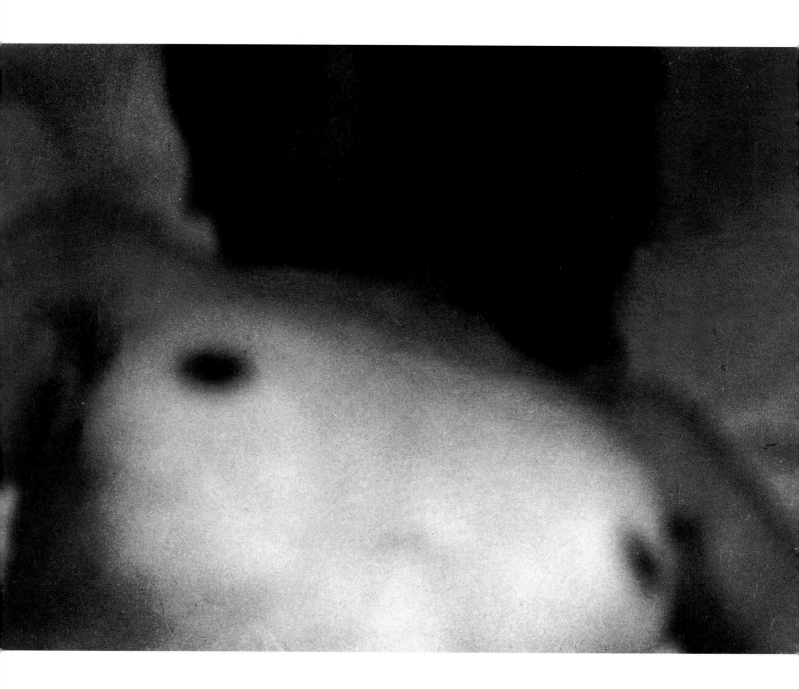

47 | *Hotel, Shibuya,* 1969
Cat. No. 91

48 | *Osaka*, c. 1973
Cat. No. 143

49 | *Hotel, Shibuya*, 1969
Cat. No. 99

50 | *Hotel, Shibuya*, 1969
Cat. No. 102

51 | *Aoyama*, 1969
Cat. No. 79

52 | *Aoyama*, 1969
Cat. No. 80

53 | *Hotel, Shibuya,* 1969
Cat. No. 97

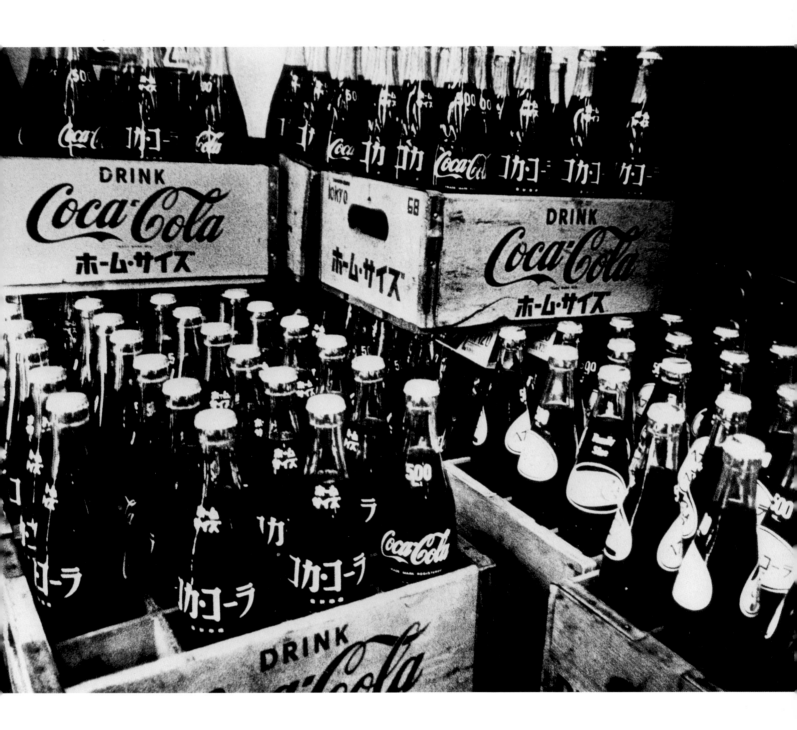

54 | *Aoyama*, 1969
Cat. No. 81

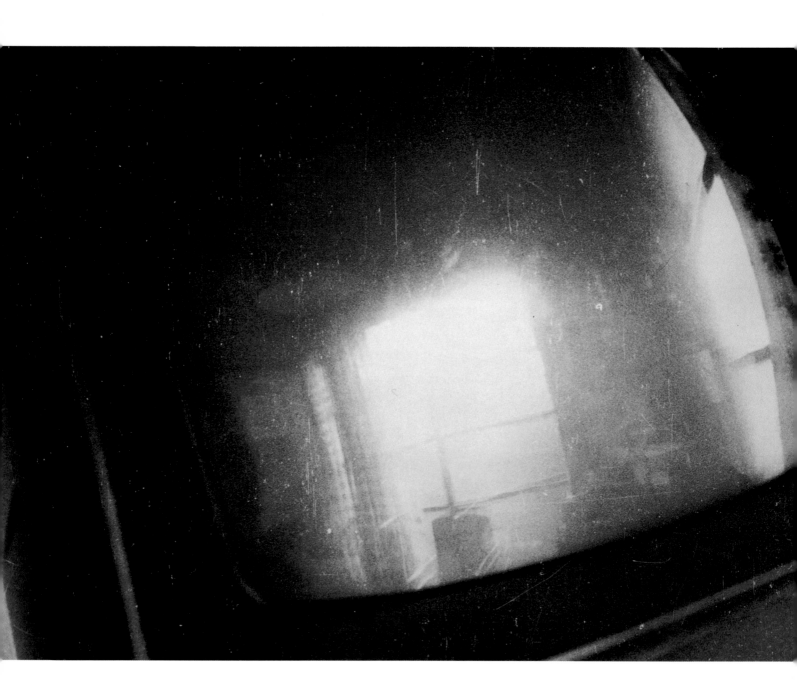

55 | *Television*, 1968–70
Cat. No. 67

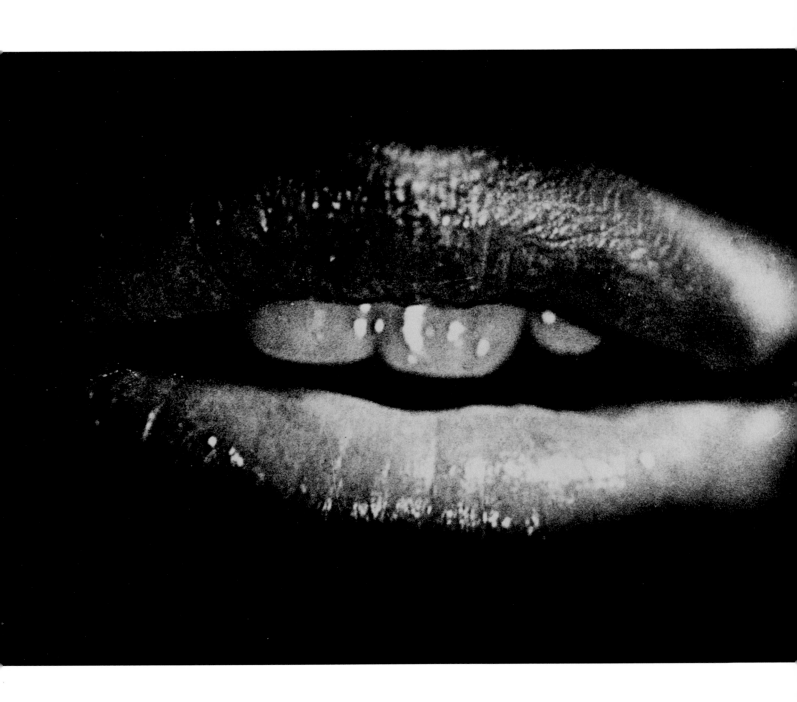

56 | *Lips from a Poster*, 1975
Cat. No. 159

57 | *In the Train*, 1968–70
Cat. No. 56

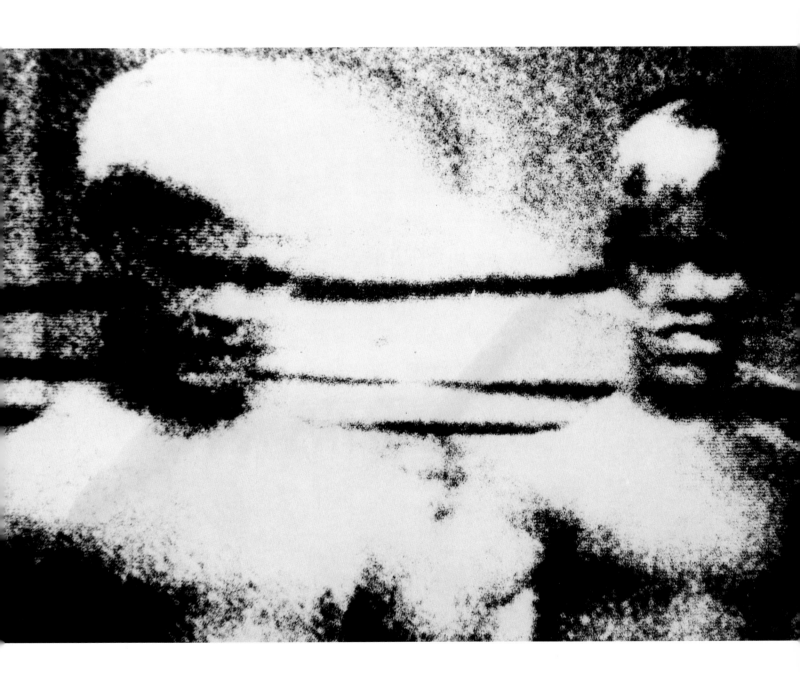

58 | *Professional Midget Wrestling, Television, 1968–70*
Cat. No. 59

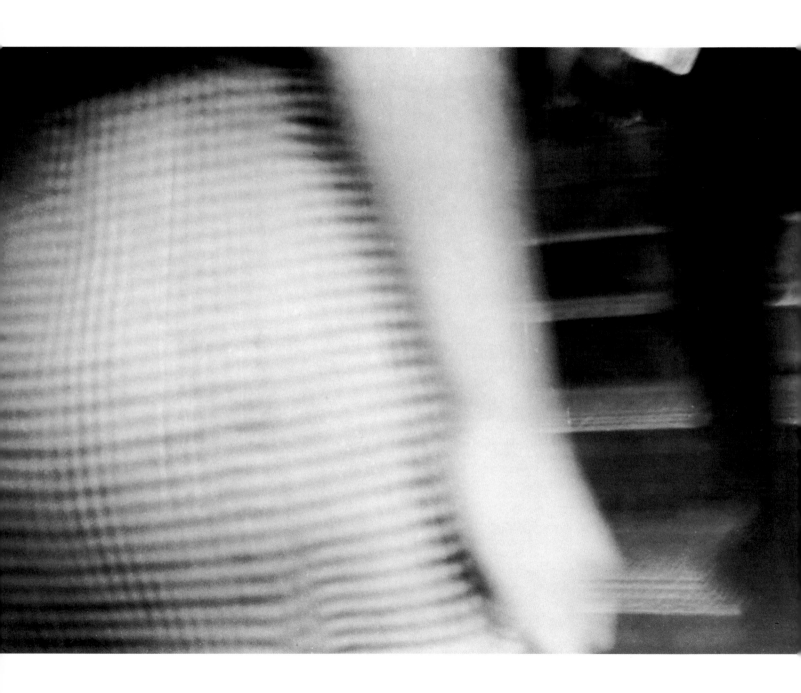

59 | *Street*, 1968–70
Cat. No. 63

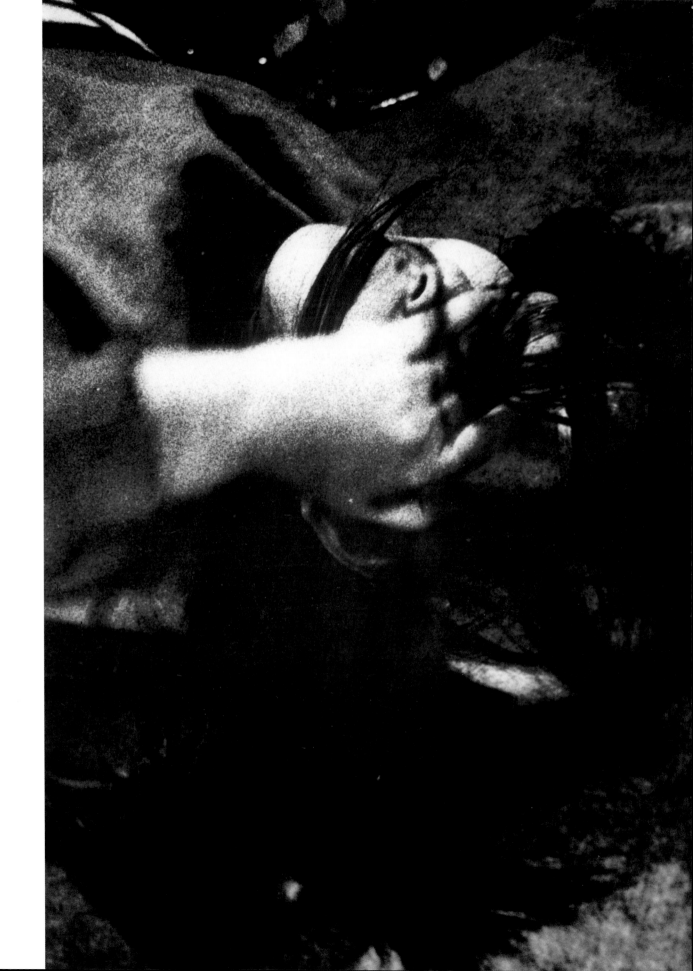

60 | *Woman on Street,*
Tokyo, 1970
Cat. No. 123

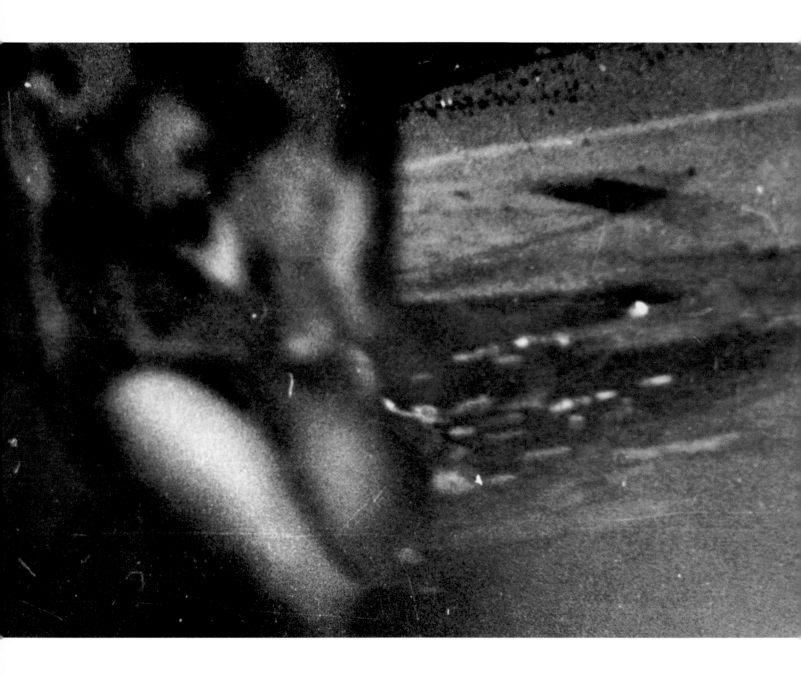

61 | *Subway*, 1968–70
Cat. No. 66

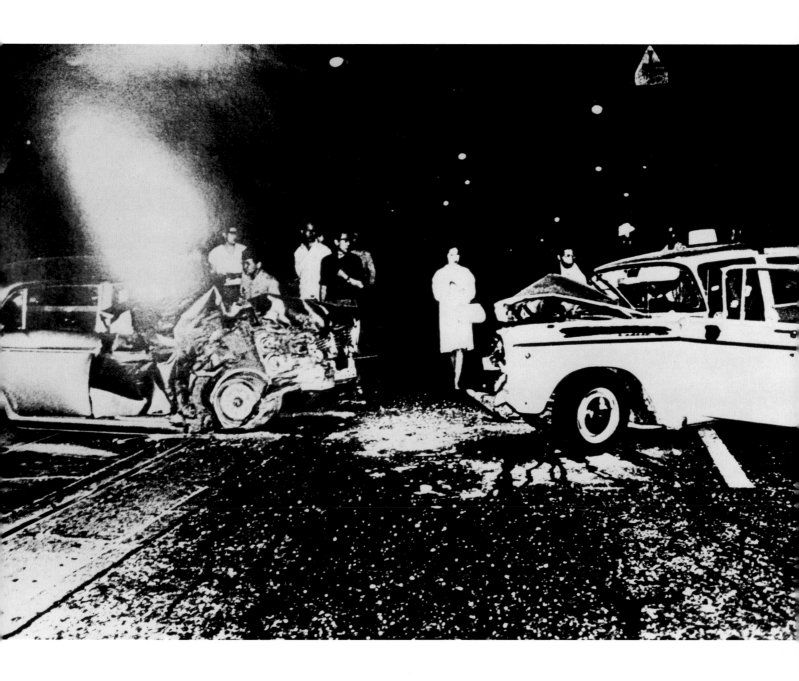

62 | *Police Safety Poster*, 1969
Cat. No. 103

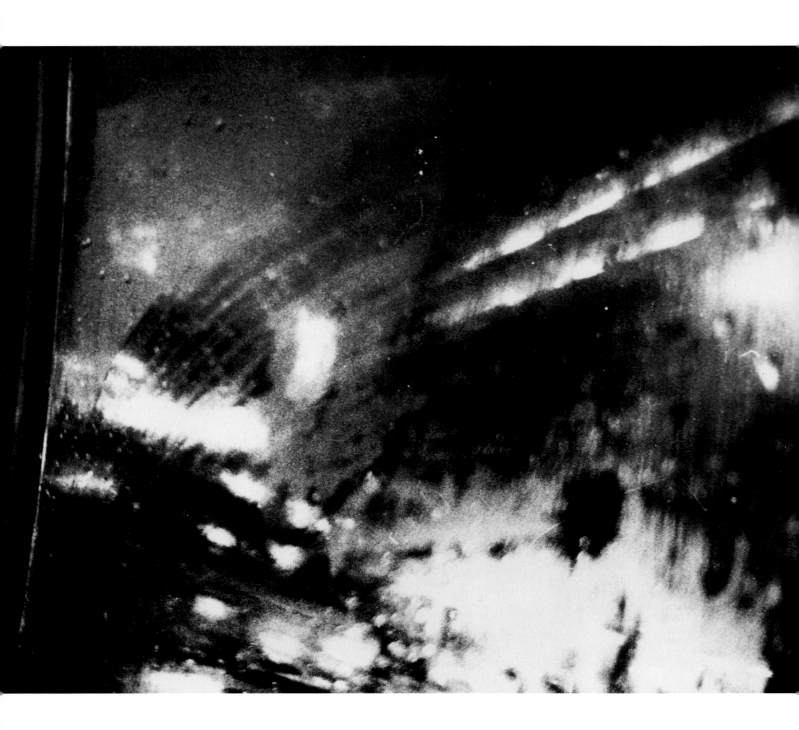

63 | *Tokyo, Night,* 1968–70
Cat. No. 69

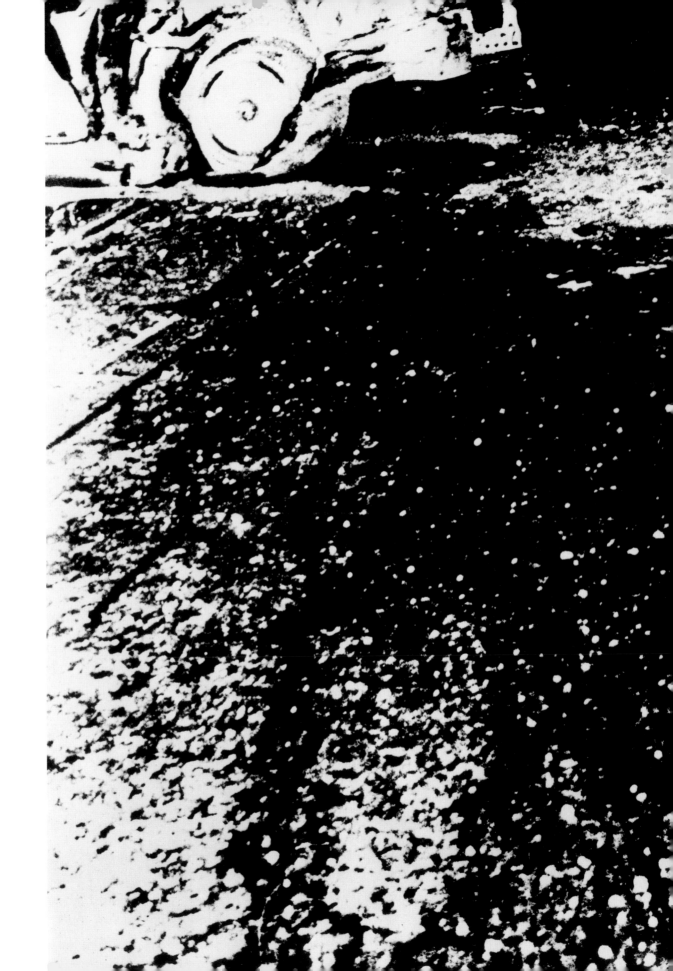

64 | *Detail from Police*
Safety Poster, 1969
Cat. No. 87

65 | From the series
Accident, 1969
Cat. No. 71

66 | From the series
Accident, 1969
Cat. No. 72

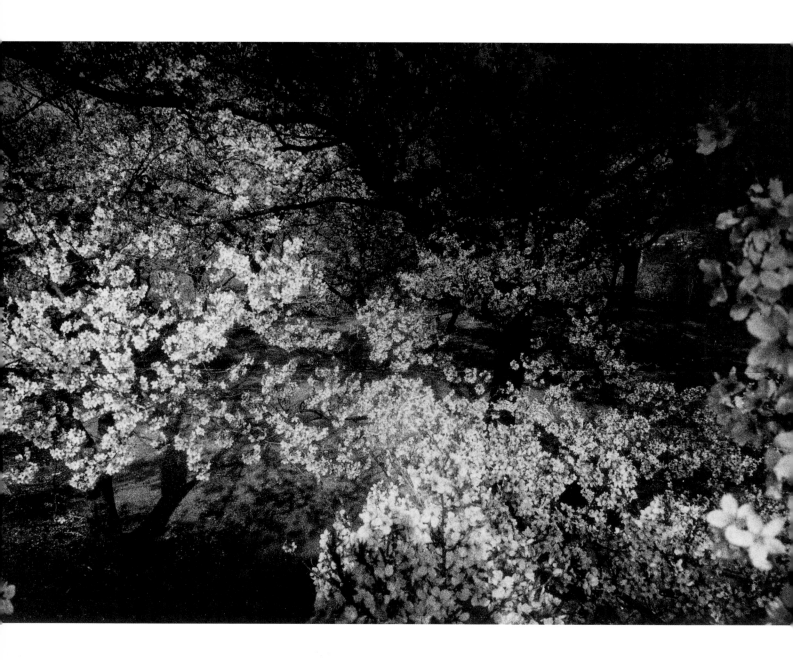

67 | *Cherry Blossoms, Nagano,* 1972
Cat. No. 138

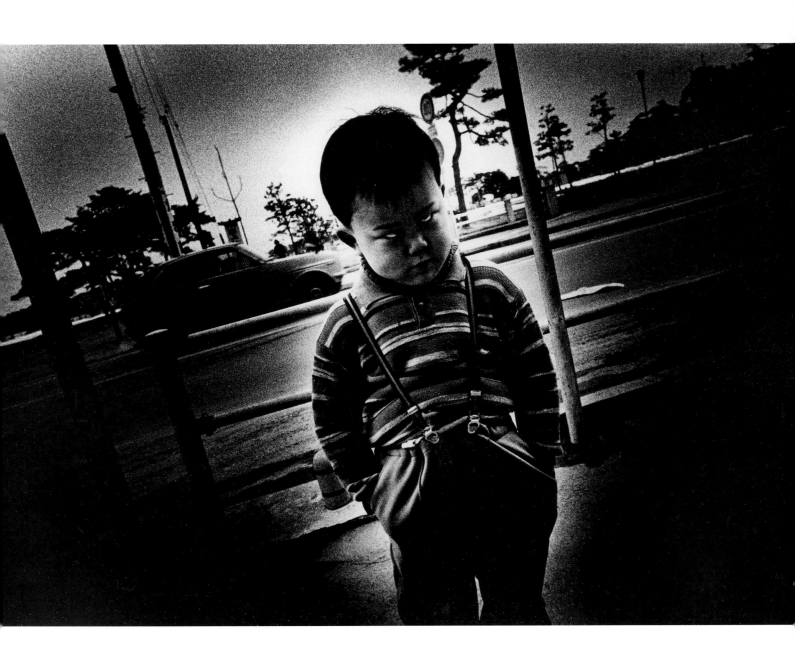

68 | *Matsushima, Miyagi,* 1974
Cat. No. 145

69 | *Miyajima, Hiroshima, 1974*
Cat. No. 146

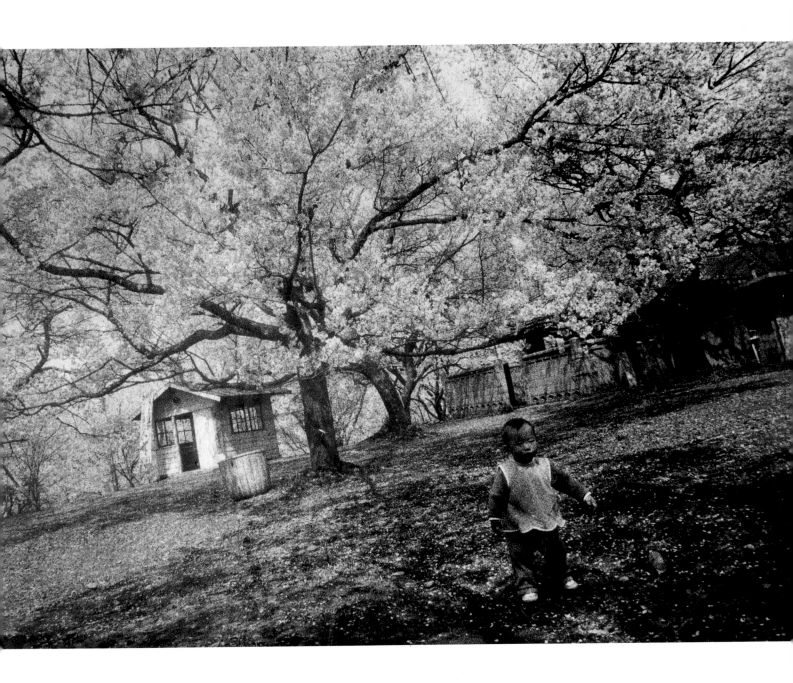

70 | *Cherry Blossoms, Nagano*, 1972
Cat. No. 136

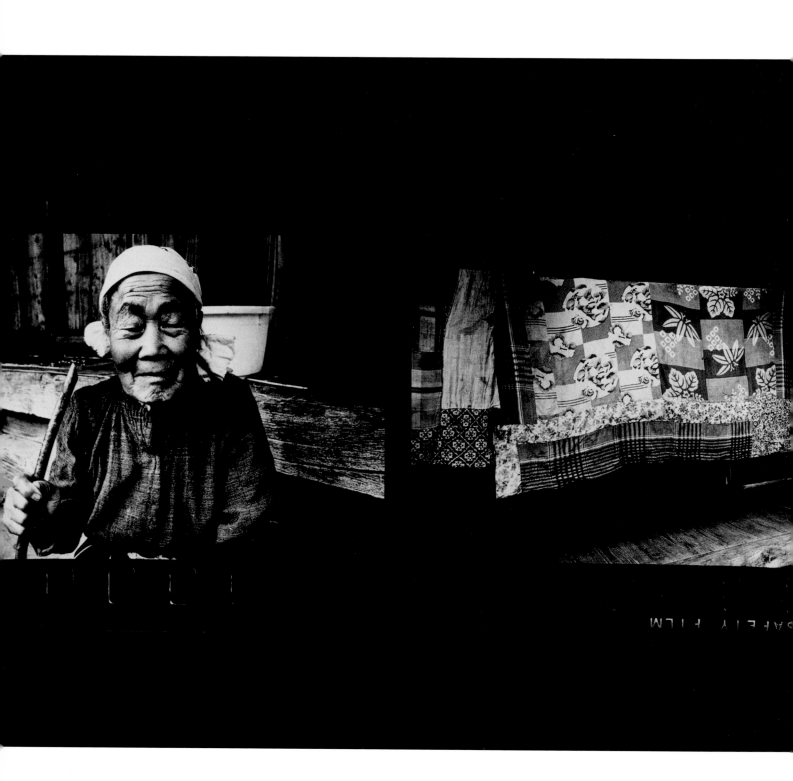

71 | From the series *The Tales of Tōno*, 1974
 Cat. No. 148

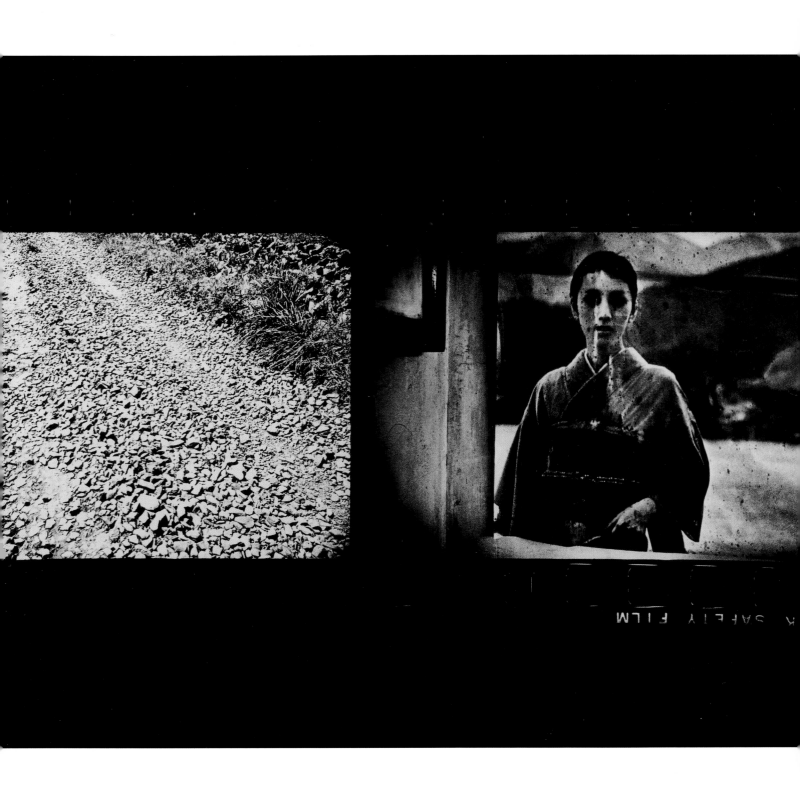

72 | From the series *The Tales of Tōno*, 1974
Cat. No. 156

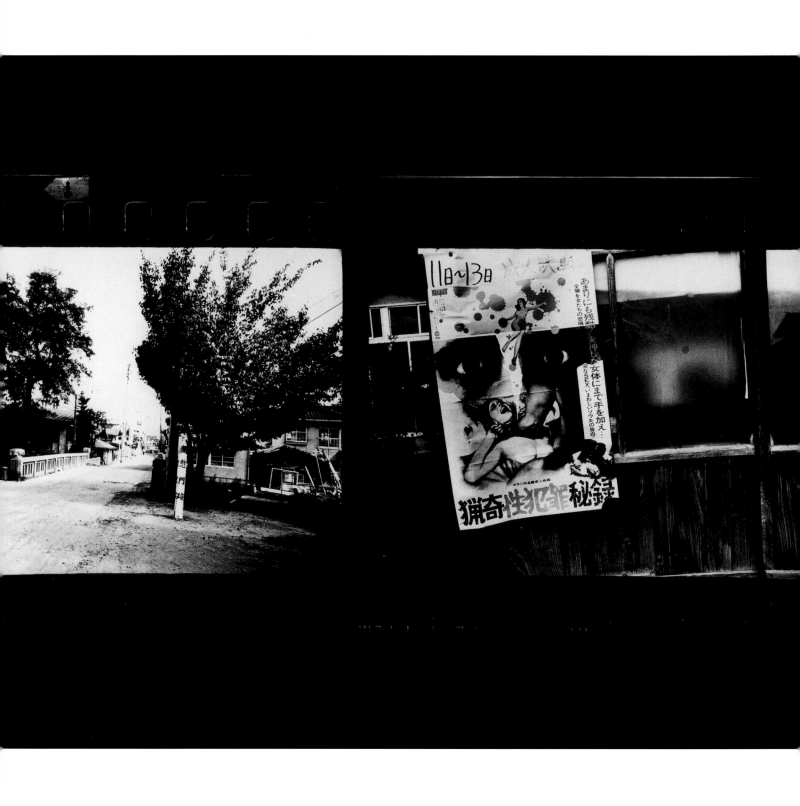

73 | From the series *The Tales of Tōno*, 1974
Cat. No. 157

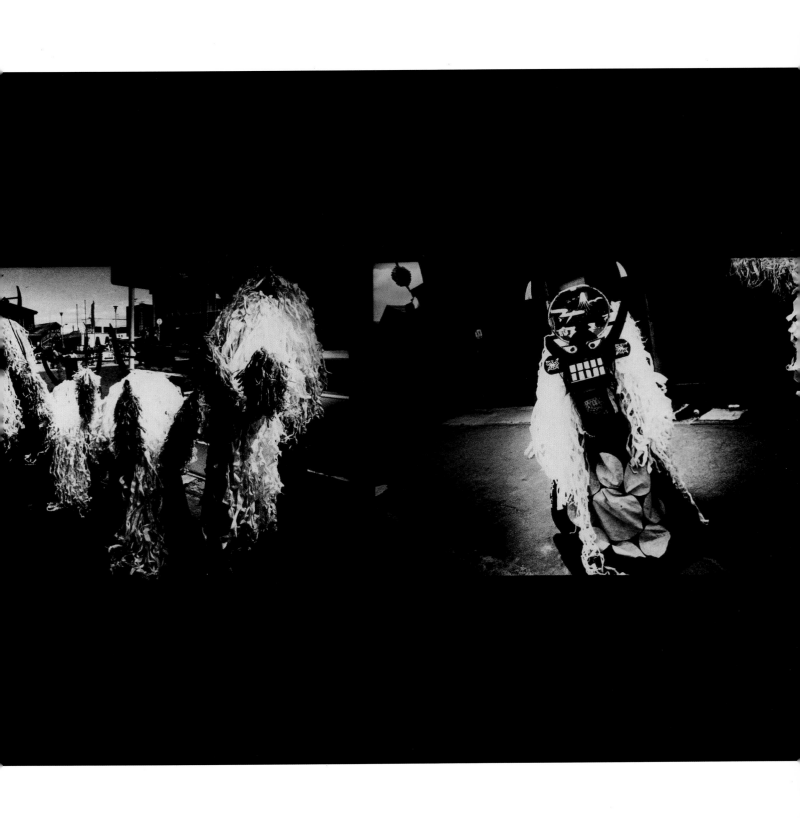

74 | From the series *The Tales of Tōno*, 1974
Cat. No. 152

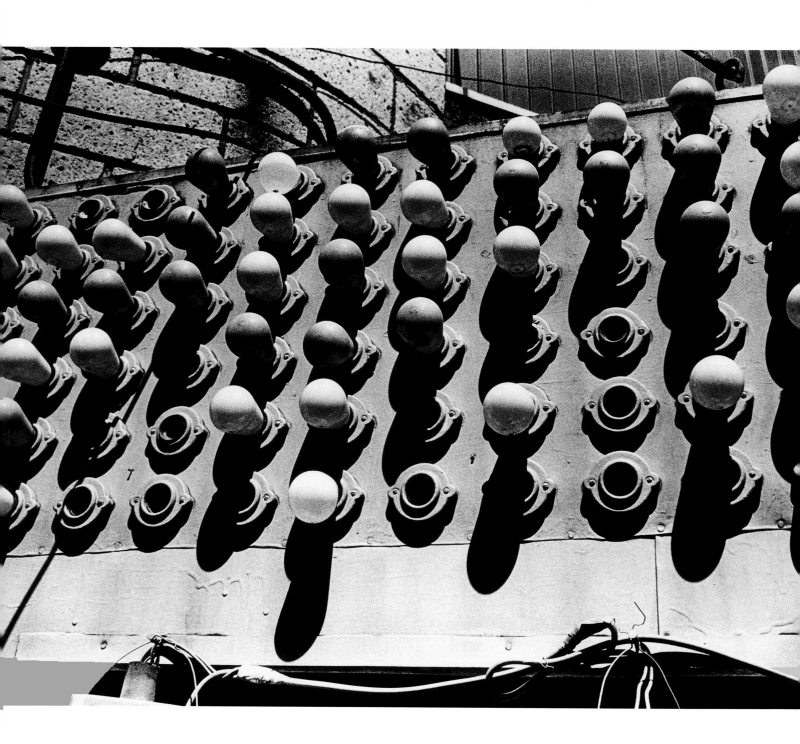

75 | *Yokohama*, 1982
Cat. No. 175

76 | *Shibuya*, c. 1981
Cat. No. 173

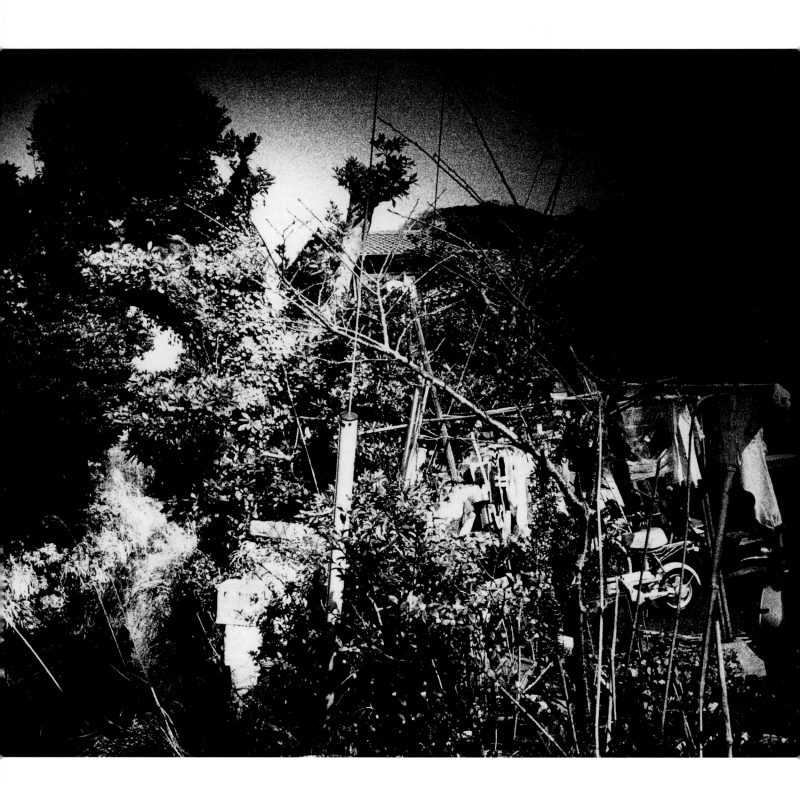

77 | *Kamakura*, 1981
Cat. No. 163

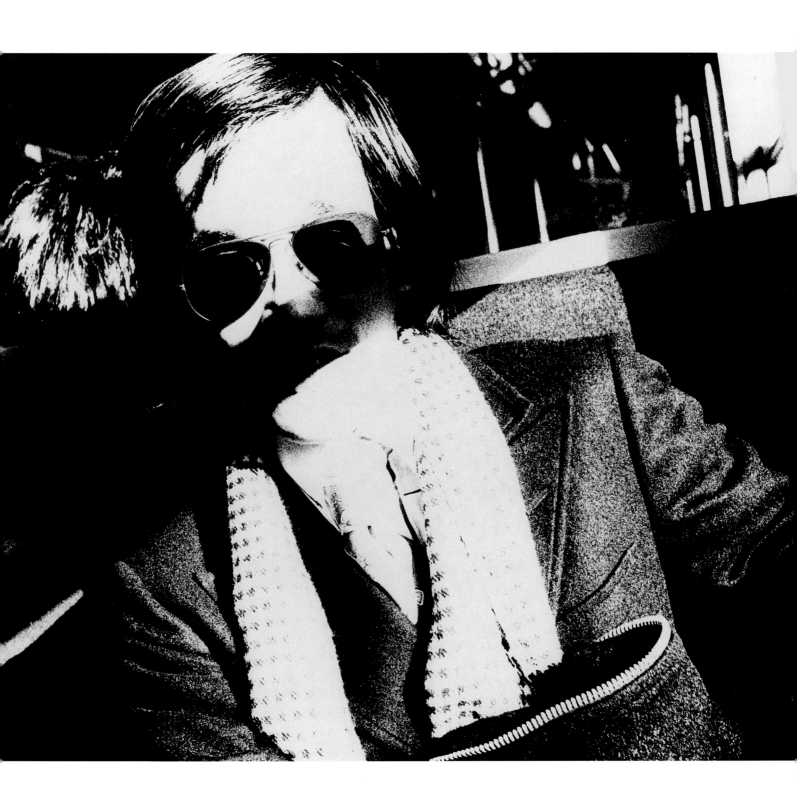

78 | *A Man in the Train, Yokosuka Line,* 1981
Cat. No. 164

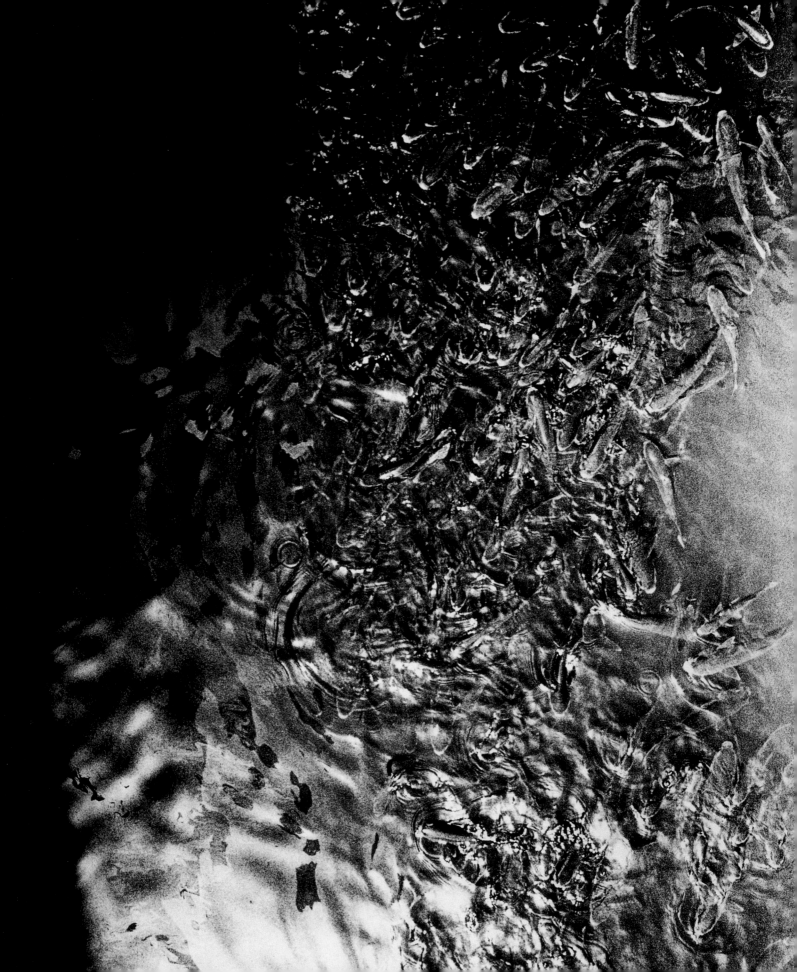

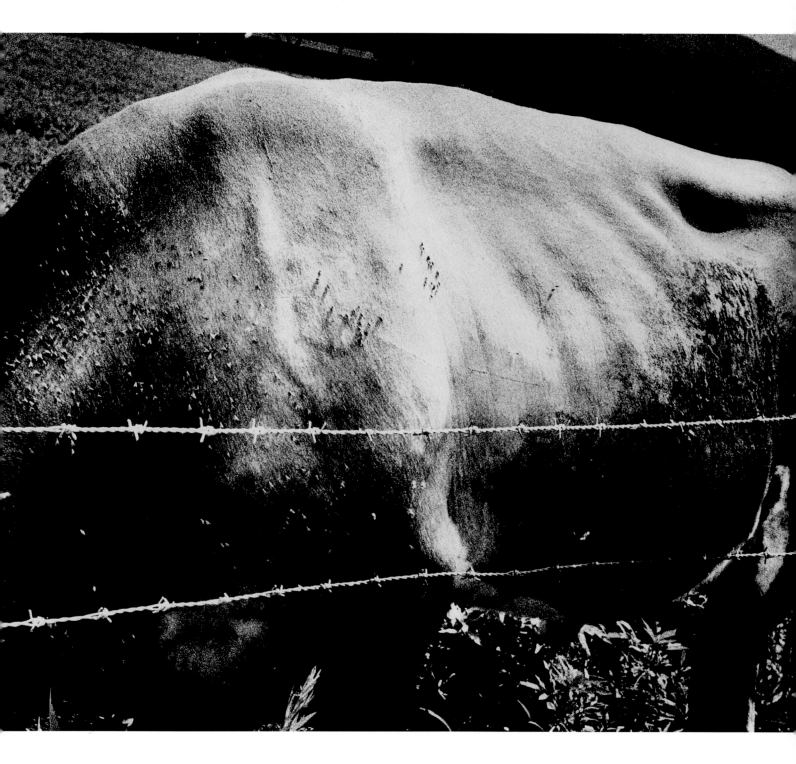

79 | *Shimoda, Shizuoka*, 1992
 Cat. No. 186

80 | *Nagano*, 1981
 Cat. No. 165

81 | *Shibuya*, c. 1990
Cat. No. 185

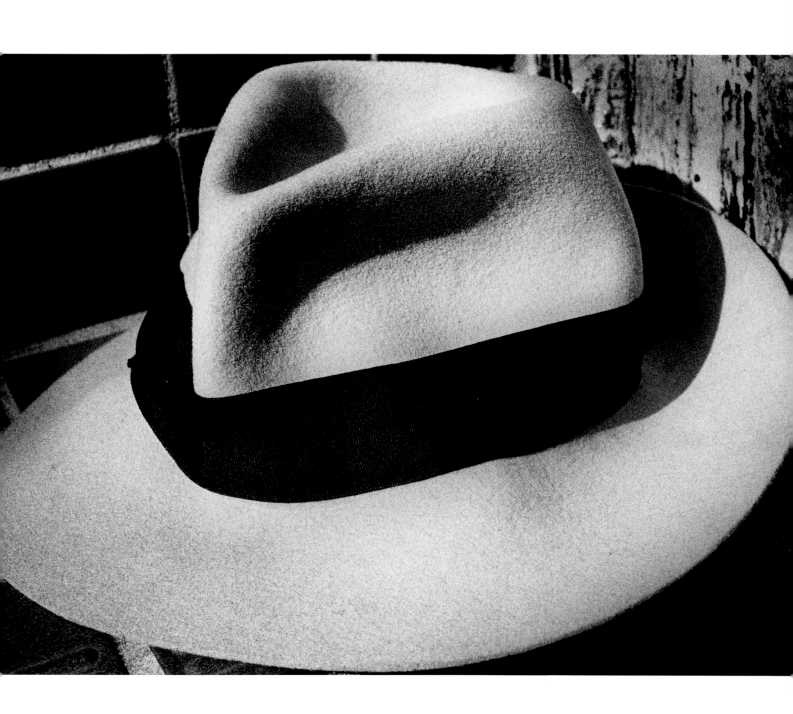

82 | *Shibuya*, 1981
Cat. No. 167

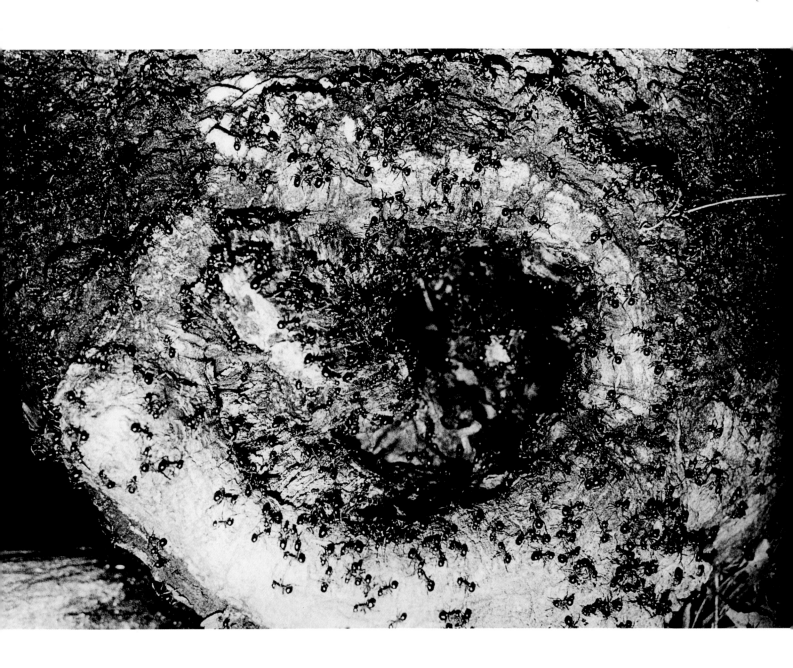

83 | *Yamanashi*, 1987
Cat. No. 183

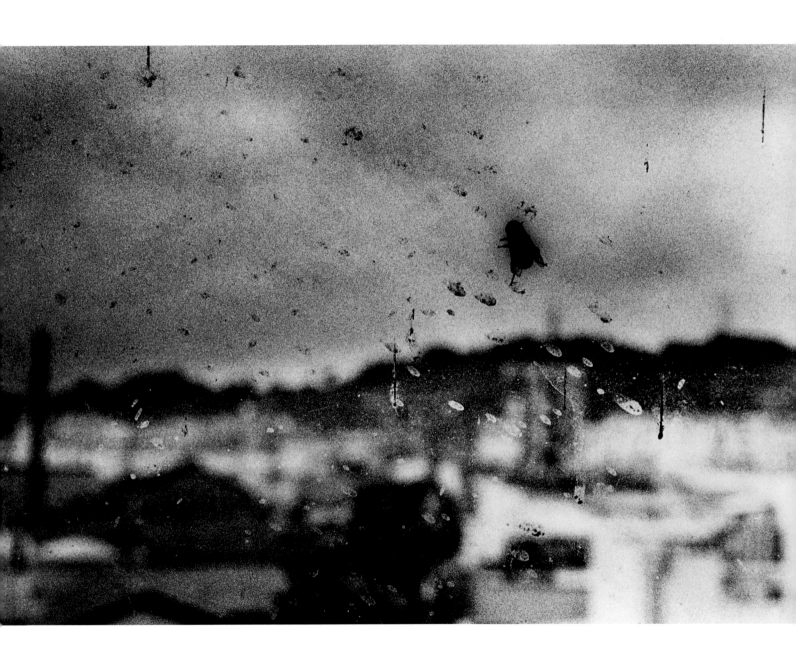

84 | *Suwa, Nagano, 1982*
Cat. No. 174

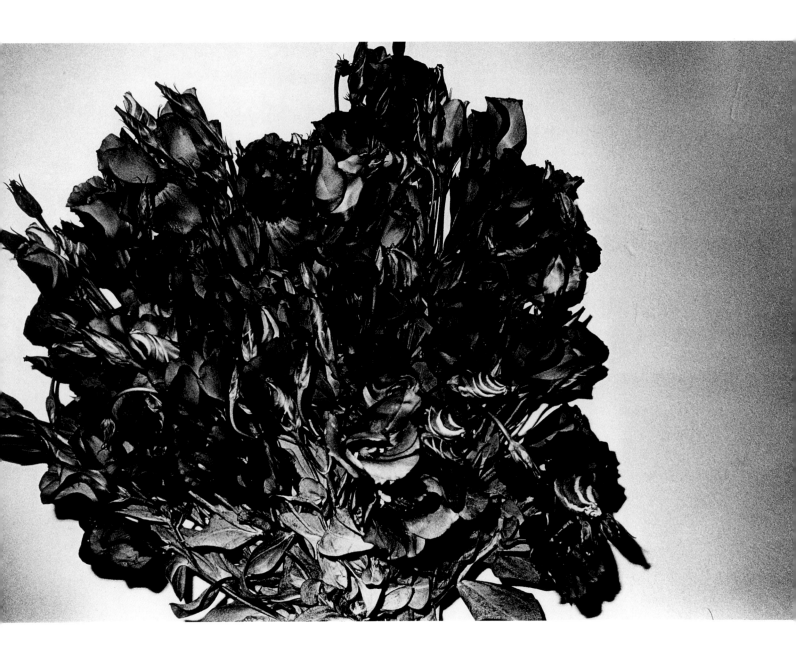

85 | *Shibuya*, 1988
Cat. No. 184

86 | *Tokyo*, 1981
Cat. No. 170

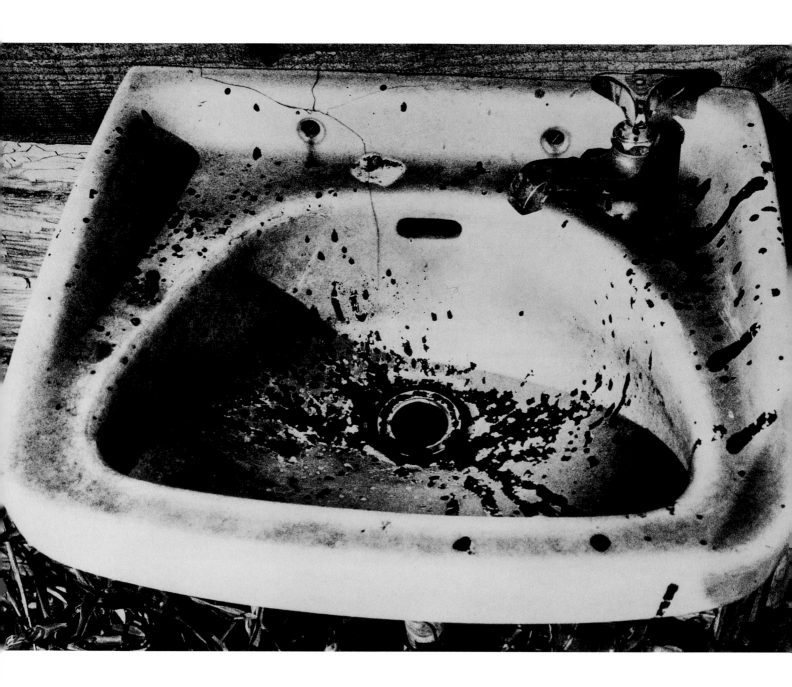

87 | *Gotokuji,* c. 1985
Cat. No. 181

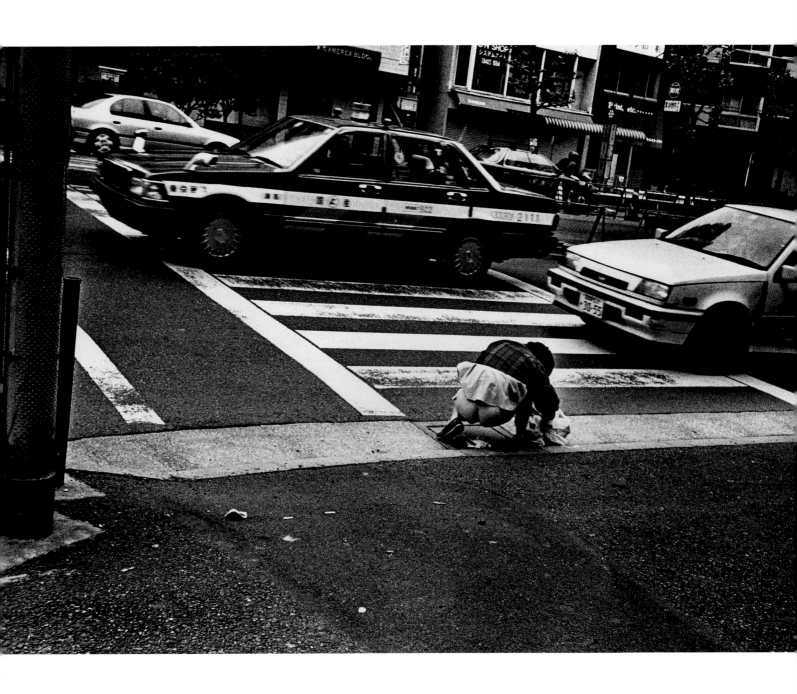

88 | *Monzen-naka-chō, Tokyo,* 1993
Cat. No. 188

89 | *A Place in the Sun—Sakuragaoka, Shibuya*, 1983
Cat. No. 179

90 | *Osaka*, 1996
Cat. No. 196

91 | *Osaka*, 1996
Cat. No. 192

92 | *Osaka*, 1996
Cat. No. 199

93 | *Osaka,* 1996
Cat. No. 193

94 | *Osaka,* 1996
Cat. No. 194

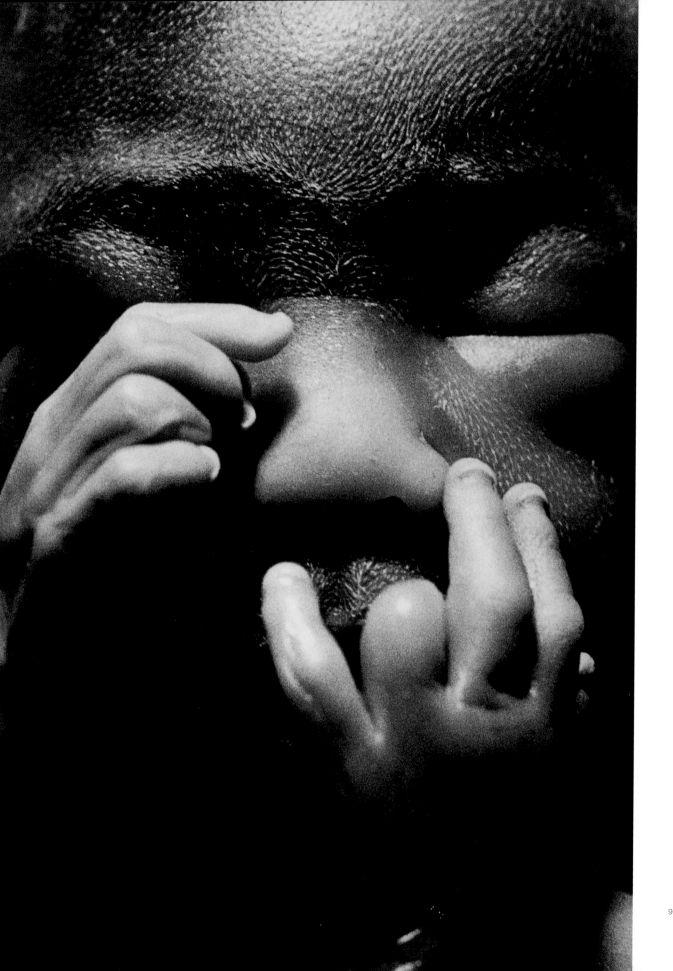

95 | From the series
Pantomime, 1964
Cat. No. 2

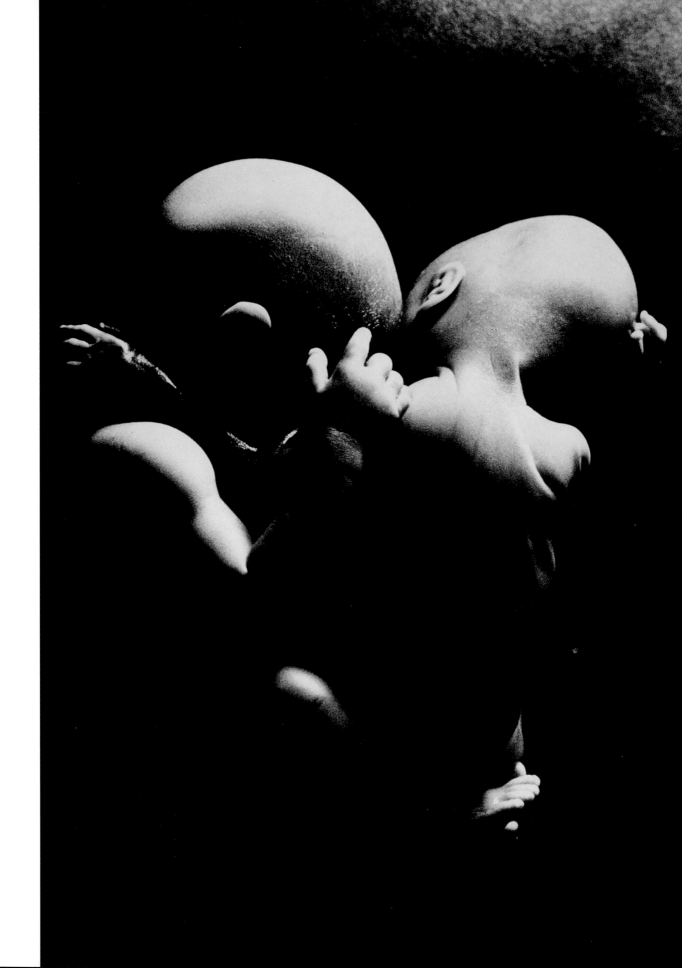

96 | From the series
Pantomime, 1964
Cat. No. 1

CHRONOLOGY

Based on the chronologies
by Tetsuro Koike in *Shashin to no taiwa*
and *Shashin kara / Shashin e*.
Translated and adapted by Miwako Tezuka.

1938–45 (Shōwa 13–20) On October 10, 1938, Daidō (Hiromichi) Moriyama is born to Hyōe (father) and Miki (mother) Moriyama in Ikeda-chō (now Ikeda-shi), Osaka. His twin bother, Ichidō (Kazumichi), dies at the age of one. Daidō is a sickly child and is temporarily left in his grandfather's care in Shimane Prefecture.

1945–58 (Shōwa 20–33) Moriyama's family endures the hardships of the immediate post–World War II period among the ruins behind Osaka Station. His father's job as a salesperson for Sumitomo Life Insurance Company requires the family to move to various places, including Hiroshima, Tokyo, and Kyoto. Consequently, Moriyama attends five grade schools and two junior high schools. At the age of thirteen, he takes his first pictures with a toy camera, called "Start." At seventeen, Moriyama transfers from a high school in Kyoto to the design department of the Osaka Municipal School of Industrial Art. During the day he works at a design firm, designing wrapping paper. He eventually drops out of school but continues to work as a graphic designer while enjoying the urban life in nearby Kobe. After his father dies in a train accident in September 1958, Moriyama begins working as a freelance graphic designer in Hirano-chō, Osaka.

1959 (Shōwa 34) Moriyama begins studying photography under Takeji Iwamiya. Every morning he takes pictures of the Kobe cityscape before going to Iwamiya's studio. He manages to support himself by taking a part-time job at a shabby photo-developing shop. Around this time, Moriyama discovers William Klein's *New York* and Shōmei Tōmatsu's *Occupation* (*Senryō*) and *House* (*Ie*), all of which have a profound impact on him.

1961 (Shōwa 36) Moriyama moves to Tokyo, hoping to join the eminent photographers' group VIVO, whose members include Tōmatsu. The group is about to dissolve, but Eikoh Hosoe takes Moriyama on as an assistant. Moriyama begins working at Studio 43 in Kōjimachi, where some of the former VIVO members congregate. There he spends considerable time with Tōmatsu, whose works make a lasting impression. Moriyama assists in the production of Hosoe's series *Ordeal by Roses* (*Barakei*).

1963 (Shōwa 38) On April 2, Moriyama marries Michiko Sugiwara, a secretary at Studio 43. Moriyama turns freelance and moves to Zushi, in Kanagawa Prefecture. He works for the quarterly newsletter of the National Essence Society (Kokusui-kai).

1964 (Shōwa 39) In late winter Tōmatsu introduces Moriyama to Takuma Nakahira, then an editor of a prominent magazine, *Gendai no me* (The modern eye). Moriyama also becomes acquainted with Hideo Kinoshita, editor of *Asahi Graph,* and the poet and dramatist Shūji Terayama and begins publishing his photographs in *Asahi Graph*, *Asahi Journal*, and *Asahi Camera*. Around this time, Nakahira decides to take up photography as a career. Moriyama and Nakahira develop a close friendship, exchanging opinions and vigorous criticism of their works.

1965 (Shōwa 40) In early summer, Moriyama and his wife and first daughter, Yuko, move to Fujisawa, in Kanagawa Prefecture, where Nakahira also resides with his new wife. While frequenting the nearby American naval base of Yokosuka, Moriyama develops his snapshot style. He brings his photographs of Yokosuka to Shōji Yamagishi, editor of *Camera Mainichi*. After their meeting, the monthly magazine becomes Moriyama's main outlet for publication.

1966 (Shōwa 41) Both Moriyama and Nakahira are virtually unemployed. They spend their days discussing the work of other photographers yet are unable

to fulfill their passion for photography. Moriyama's first collaboration with Shūji Terayama is a series, *The Underpinnings of Show Biz: A Postwar History of Sideshows (Shō no teihen: Misemono no sengoshi)*, in the magazine *Haiku*. A collaborative work by Moriyama, Terayama, and Nakahira—*There Is a Battlefield in the City (Machi ni senjō ari)*—is serialized in *Asahi Graph*.

1967 (Shōwa 42) In December, Moriyama receives the newcomer's award from the Japan Photo Critics Association (Nihon Shashin Hihyōka Kyōkai). His award-winning photographs of local entertainers are praised for their exploration of indigenous subject

matter, but Moriyama is dissatisfied with this interpretation. Around this time, Moriyama obtains a catalogue of an Andy Warhol exhibition and becomes interested in the concepts of reproduction and repetition.

1968 (Shōwa 43) Moriyama's acclaimed photographic series *Japan: A Photo Theater (Nippon gekijō shashinchō)*, with text by Shūji Terayama, is published by Muromachi Shobō. On October 21, International Antiwar Day, Moriyama witnesses street scenes in Shinjuku that change his way of thinking and acting in later years. Inspired by Jack Kerouac's *On the Road*, he begins taking landscape photographs from moving vehicles. On November 1, the quarterly photography magazine *Provoke* begins publication. The founding members include Takuma Nakahira,

Takahiko Okada, Yutaka Takanashi, and Kōji Taki. Moriyama joins the group with the second issue.

1969 (Shōwa 44) As Moriyama begins to receive more attention, a number of photography magazines feature his series, including *Accident* in *Asahi Camera*. On March 10, a dialogue between Moriyama and Takuma Nakahira appears in the second issue of *Provoke*. Unlike other *Provoke* members, especially Nakahira, Moriyama appears to keep his distance from political issues.

1970–71 (Shōwa 45–46) *Asahi Camera* features Moriyama's work on its cover for the entire year. On March 31, despite Moriyama's objections, *Provoke* dissolves and ceases publication. Moriyama's exhibition *Scandal*, at Plaza Dick, presents blown-up images of flashy magazine advertisements and receives much attention from the public. His activities include many television appearances and newspaper advertisements. In late 1971, when he travels to New York for the first time with Tadanori Yokoo, Moriyama encounters the works of Weegee at the Museum of Modern Art and is fascinated by them.

1972–73 (Shōwa 47–48) Moriyama's second daughter, Asako, is born and his book *Hunter (Kariudo)* is published. In *Farewell Photography (Shashin yo sayōnara)*, published in April 1972, Moriyama takes his out-of-focus, coarse-grain style to extremes. Consequently, he begins to experience a slump and often turns to alcohol and drugs. He is compelled to face his personal emotions, yet this only causes unsatisfactory results in his work. Around this time, Moriyama and Nakahira lose contact.

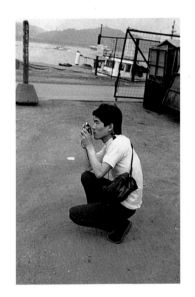

fig. 26 | Takayuki Komori
Daidō Moriyama, 1969
Takayuki Komori Collection

fig. 27 | Shōmei Tōmatsu
Two photographs from the series *Tōmatsu's Photo Diary*, which appeared in *Camera Mainichi* 3, 1968. The left shows guests arriving at a party honoring Daidō Moriyama and Ikkō Narahara, among others. The right shows the weekly editorial meeting of JSP, of which Koji Taki was a member. Collection of the Tokyo Metropolitan Museum of Photography

1974 (Shōwa 49) On April 22, Workshop Photography School (Wākushoppu Shashin Gakkō) is established by Moriyama, Nobuyoshi Araki, Masahisa Fukase, Eikoh Hosoe, Shōmei Tōmatsu, and Noriaki Yokosuka. From March 27 to May 19, twenty-six works by Moriyama are shown in *New Japanese Photography* at the Museum of Modern Art, New York. The show's curators, Shōji Yamagishi and John Szarkowski, highlight Tōmatsu and Moriyama as Japan's most important photographers. Moriyama's solo exhibition, *The Tales of Tōno* (*Tōno monogatari*), is realized this year. Although some see the exhibition as evidence of Moriyama's regionalist sentiment, he displays a stronger interest in crowded Tokyo street scenes. Around this time, Moriyama begins experimenting

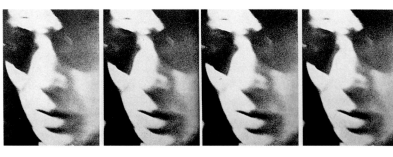

with mechanical reproduction methods such as photocopy and silkscreen and he publishes *Another Country in New York* ([*Mon hitotsu no huni*] *Nyūyōku*).

1975–78 (Shōwa 50–53) In April 1975 Moriyama is appointed a full-time lecturer at Tokyo Vocational School of Photography (Tokyo Shashin Senmongakkō). In June 1976 he opens a photography gallery, CAMP, in Shinjuku, where he also holds a weekly class for about nine months, beginning in June 1977. In April 1977 Moriyama participates in the exhibition *Neue Fotografie aus Japan* at the Municipal Museum in Graz, Austria. In fall of this year Takuma Nakahira is suddenly struck by an illness that causes partial speech and memory loss. Although series of exhibitions and lectures indicate his commercial success, Moriyama still feels uneasy about his approach to photography. In summer

1978 he retreats to Sapporo, Hokkaido. His depression and artistic slump exacerbate his drug use. Works from this difficult period (1976–78) are compiled in *Japan: A Photo Theater II* (*Zoku nippon gekijō shashinchō*). During this time he rediscovers the work of Joseph-Nicéphore Niépce (1765–1833) and Nakaji Yasui (1903–1942).

1979–80 (Shōwa 54–55) Moriyama's work continues to be shown in and outside Japan (New York, Venice, Austria). On July 20, 1979, Shōji Yamagishi dies. Losing his best supporter and disillusioned with the photographic medium itself, Moriyama falls deeper into drug addiction and depression. On May 8, 1980, he pays a visit to William Klein in Paris. Despite his personal crisis, Moriyama is widely regarded as the central figure in Japanese photography of the late 1960s and the early 1970s.

1981 (Shōwa 56) In March, Moriyama withdraws from CAMP. *The Daibosatsu Pass* (*Daibosatsutōge*), published in the December issue of *Asahi Camera,* finally gives him the motivation to overcome his anguish and to work consistently.

1982–85 (Shōwa 57–60) Recovering from his long slump, Moriyama spends most of his time working on new series and serving as a juror for photo competitions (*Nihon Camera* black-and-white competition in 1983, the Rokkor Club competition in 1985). For the 1982 series *Inu no toki* (The time of the dog) he travels to Ikeda and shoots ten rolls of film in three days, after which he returns on short visits to take more photographs. On June 1, 1983, Moriyama receives the photographer of the year award from the Photography Society (Shashin Kyōkai). Two compilations of his numerous writings are also published: *Inu no kioku* (Memories of a dog) in 1984 and *Shashin to no taiwa* (A dialogue with photography) in 1985.

fig. 28 | Kōji Taki
Portrait of Daidō Moriyama, from *Provoke 3,* 1969
Collection of the San Francisco Museum of Modern Art. Library

1986 (Shōwa 61) Moriyama continues to travel frequently for various projects, mainly for *Shashin Jidai,* which becomes his sole outlet for publication after *Camera Mainichi* folds in April 1985. Moriyama's long photo essay *How to Take a Beautiful Picture* (*Utsukushii shashin no tsukurikata*) begins appearing in the December issue of *Shashin Jidai* and continues until the February 1988 issue. Beginning in April and continuing for one year, *Fotografia japonesa contemporanea,* a group exhibition organized by the Spanish government, presents fifty-five Japanese photographers, including Nobuyoshi Araki, Eikoh Hosoe, and Moriyama.

FIFTEEN PHOTOGRAPHERS TODAY

fig. 29 | Exhibition poster for *Fifteen Photographers Today,* 1974
Collection of the National Museum of Modern Art, Tokyo

fig. 30 | Naoki Mori
Daidō Moriyama, 1977
Takayuki Komori Collection

1987 (Shōwa 62) Moriyama opens a gallery, Room 801, in Shibuya. From September 1 to October 24 he is one of twelve photographers represented in the exhibition *Empathy: Contemporary Japanese Photographers '87* at the Visual Studies Workshop in Rochester, New York. The guest curator, photographer Akira Matsumura, describes Japanese photography as characterized by intense emotionalism, which he contrasts to the idealism or philosophical conceptualism of its Western counterpart. In *Nihon kindai shashin no seiritsu* (The development of modern Japanese photography), Toshiharu Itō cites the work of Moriyama and Nobuyoshi Araki as the culmination of Japanese modernism, based on a purely Japanese aesthetic.

1988 (Shōwa 63) *Shashin Jidai* ceases publication with the April issue. Moriyama begins a new series, *Nakahira Takuma e no tegami* (A letter to Takuma Nakahira), in *Bungei* and reestablishes contact with Nakahira. At this time, younger photographers such as Hōichi Hara begin to cite Moriyama as a source of inspiration. In July, Room 801 is renamed Foto Daidō. Moriyama begins spending more time in Paris, searching for a new site of exploration and contemplation.

1989 (Shōwa 64/Heisei 1) From January 6 to February 12 the Yamaguchi Prefectural Museum holds an exhibition entitled *11-nin no 1965–75* (Eleven photographers from 1965 to 1975). Moriyama's series *Hunter* (*Kariudo*), as shown in the exhibition, is denied a contextual reading, and the focus is shifted to the photographer's methodology. In May, Moriyama organizes a one-person show for Nakahira, *Abayo X* (Adieu à X), at Foto Daidō. From September 17, Moriyama participates in *Internationale Foto–Triennale* in Esslingen, Germany, as the sole representative from Japan.

1990 (Heisei 2) Although participation in major exhibitions has become routine for Moriyama, *Shashin no kako to genzai* (The past and the present of photography), from September 26 to November 11 at the National Museum of Modern Art in Tokyo and Kyoto, holds a special meaning for him as it also includes works by Nakaji Yasui, whom Moriyama holds in very high regard.

1991 (Heisei 3) In the summer Osamu Wataya of the fashion company Hysteric Glamour visits Moriyama. Wataya proposes publishing Moriyama's work as a series, *Daidō Hysteric,* which is realized two years later. In *Shashin to bunmei ni kansuru esseishū* (Selected essays on photography and civilization), Shirō Kawakami criticizes *Provoke,* and Moriyama in

particular, for merely insisting on a methodology conceived in opposition to that of Ken Domon while regressing to painterly expression.

1992 (Heisei 4) From March 6 to 29, the Fukui Prefectural Museum presents *1960-nendai Nihon no poppu ten* (Japanese Pop Art in the 1960s), which includes two hundred monochrome prints from *Japan: A Photo Theater* and other works by Moriyama from the late 1960s and 1970s. Moriyama is the only photographer included in this show.

1993–95 (Heisei 5–7) *Tokyo: Daidō Hysteric,* no. 4, of 1993, and the following year's *Tokyo: Daidō Hysteric,*

no. 6, reveal Moriyama's new approach, which denies lyricism and emotionalism. In this series, as in his earlier experiments with silkscreen, Moriyama also re-examines the essence of photography as reproduction. Working intensely on this project, Moriyama uses up to five hundred rolls of film for each publication, and eventually his cameras break down from overuse. His antilyrical, antinarrative style is manifested again in the exhibition *Shashin-toshi Tokyo / Photo City Tokyo* (Tokyo Metropolitan Museum of Photography, January 21 to March 31, 1995). In fall 1994 Moriyama joins the gallery Place M, in Shinjuku, which becomes his regular exhibition space. In the January 1995 issue of *Asahi Camera,* Kōtarō Iizawa describes Moriyama and his *Japan: A Photo Theater* as "a new legend in Japanese photographic expression."

fig. 31 | *Daidō Moriyama,* c. 1990s
Collection of the Tokyo Metropolitan
Museum of Photography

1996 (Heisei 8) The newspaper *Nihon Keizai Shimbun* features Moriyama's photo essay *Utsusareta onnat-achi* (Women in photographs) from October 15 to 31.

1997 (Heisei 9) *Moriyama Daidō Kariudo/Hunter: For Jack Kerouac* is republished by Taka Ishii Gallery, Tokyo. From June through August, his solo exhibition *Polaroid Polaroid* is held at the Polaroid Gallery, Tokyo. On January 24 Moriyama's new series, *Memories of a Dog—Conclusion* (*Inu no kioku—shūshō*), begins appearing monthly in *Asahi Graph.*

EXHIBITION HISTORY

Compiled by Miwako Tezuka.

Solo Exhibitions

1970 • *Scandal,* Plaza Dick, Tokyo

1974 • *Tōno monogatari* (The Tales of Tōno), Ginza Nikon Salon, Tokyo

• *Moriyama Daidō Printing Show,* Shimizu Gallery, Tokyo

1975 • *Ōka* (Cherry blossoms), Mato Grosso, Tokyo

1976 • *Goshogawara,* Ginza Nikon Salon, Tokyo

• *Moriyama Daidō shashin ten* (Daidō Moriyama photo exhibition), Shadai Gallery, Tokyo

• *Yō ga attara kuchibue o* (Whistle if you need me), CAMP, Tokyo

1977 • *Tokyo: Aminome no machi* (Tokyo: The city of webs), Ginza Nikon Salon, Tokyo

1978 • *Tsugaru kaikyō,* CAMP, Tokyo

• *Niigata-shi,* CAMP, Tokyo

1980 • *Daidō Moriyama,* Gallery Form, Graz, Austria

1981 • *Hikari to kage* (Light and shadow), Nagase Photo Salon, Tokyo

• *Moriyama Daidō shashin ten* (Daidō Moriyama photo exhibition), Zeit-Photo, Tokyo

1982 • *Hikari to kage: Shūshō* (Light and shadow: The last chapter), Konishiroku Photo Gallery, Tokyo

1986 • Solo exhibition, Room 801, Tokyo (eight solo exhibitions between 1986 and 1988)

1990 • *Moriyama Daidō shashin ten* (Daidō Moriyama photo exhibition), Zeit-Photo, Tokyo

1992 • *Moriyama Daidō: 1970-nendai no kiseki* (Daidō Moriyama: Works from the 1970s), Il Tempo, Tokyo

1993 • *Moriyama Daidō: Shashin insutareishon ten* (Daidō Moriyama: A photo installation), Watarium Museum, Tokyo

• *Daidō Moriyama: Vintage Photographs,* Laurence Miller Gallery, New York

1994 • *Moriyama Daidō shinkan shashinshū ten* (Daidō Moriyama: New photo catalogue exhibition), Watarium Museum, Tokyo

1995 • *Peeping Out,* Place M, Tokyo

• *Imitation,* Taka Ishii Gallery, Tokyo

1996 • *Polaroid Polaroid,* Polaroid Gallery, Tokyo

Group Exhibitions

1968 • *Nihon shashin hihyōka kyōkai shinjinshō jushō kinen ten* (Commemorative exhibition of the newcomer's award winners), Ginza Nikon Salon, Tokyo

1974 • *New Japanese Photography,* Museum of Modern Art, New York

• *15-nin no shashinka ten* (Fifteen photographers today), National Museum of Modern Art, Tokyo

1975 • *Nihon gendai shashinshi ten* (A history of contemporary Japanese photography), Seibu Museum, Tokyo

1977 • *Neue Fotografie aus Japan,* Municipal Museum, Graz, Austria

1979 • *Japan: A Self-Portrait,* International Center of Photography, New York

• *Self-Portrait: Japan,* part of the larger exhibition *Photography/Venezia '79,* Venice

1982 • *20-seiki no shashin: Ngūyōku kindai bijutsukan korekushon ten / The Twentieth-Century Photography from the Museum of Modern Art,* Seibu Museum, Tokyo

1983 • *Gendai nihon no bijutsu 2—fūkei to no deai* (Contemporary Japanese art 2—An encounter with landscape), Miyagi Museum of Art, Miyagi

1984 • *Gendai 6-nin no shashinka* (Six contemporary photographers), Ikebukuro Seibu Art Forum, Tokyo

1985 • *Black Sun: The Eyes of Four,* Museum of Modern Art, Oxford; Serpentine Gallery, London; Philadelphia Museum of Art

• *Paris-New York-Tokyo,* Tsukuba Photo-Museum, Ibaraki

1986 • *Fotografia japonesa contemporanea,* Circulo de Bellas Artes, Madrid; Diputacion de Valencia Sala Parpallo, Valencia; Ayuntamiento de Barcelona Casa Elizalde, Barcelona; Museo de Bellas Artes de Bilbao Arte Ederren Bilboko Museoa, Bilbao

1987 • *Empathy: Contemporary Japanese Photographers '87,* Visual Studies Workshop, Rochester, New York

1988 • *Japanese Contemporary Photographers,* Prague

1989 • *Internationale Foto-Triennale,* Esslingen, Germany

• *11-nin no 1965–75: Nihon no shashin wa kaeraretaka* (Eleven photographers from 1965 to 75: Did Japanese photography change?), Yamaguchi Prefectural Museum of Art, Yamaguchi

• *Orientarizumu no kaiga to shashin* (Paintings and photographs of orientalism), Nagoya World Design Exposition '89, White Museum, Nagoya

1990 • *Fotofest '90,* Houston, Texas

• *Foto Biennale Rotterdam '90,* Rotterdam

• *Tokyo: Toshi no shisen / Tokyo: A City Perspective,* Tokyo Metropolitan Museum of Photography

• *Shashin no kako to genzai* (The past and the present of photography), National Museum of Modern Art, Tokyo; National Museum of Modern Art, Kyoto

• *Sengo shashin to tōhoku / Photography and Climatology,* Miyagi Museum of Art, Miyagi

• *Shashin ni yoru dokyumento Toyama '90 / Photography Contest Document, Toyama,* Museum of Modern Art, Toyama

1991 • *Beyond Japan,* Barbican Art Gallery, London

• *Nihon no shashin 1970-nendai / Japanese Photography in the 1970s,* Tokyo Metropolitan Museum of Photography

1992 • *1960-nendai nihon no poppu ten / Japanese Pop Art 1960s,* Fukui Art Museum, Fukui

1994 • *Place M ōpuningu 3-nin ten* (Place M opening three-person exhibition), Place M, Tokyo

1995 • *Shashin toshi Tokyo / Photo City Tokyo,* Tokyo Metropolitan Museum of Photography

• *Tokyo kokuritsu kindai bijutsukan to shashin 1953–1995* (National Museum of Modern Art, Tokyo, and photography, 1953–1995), National Museum of Modern Art, Tokyo Film Center, Tokyo

SELECTED BIBLIOGRAPHY

Compiled by Miwako Tezuka.
Entries are arranged chronologically.

Exhibition Catalogues and Related Materials

IN ENGLISH

- *New Japanese Photography.* Exhibition brochure.
 New York: Museum of Modern Art, 1974.
- Yamagishi, Shōji, ed. *Japan: A Self-Portrait.* Trans.
 Hiroaki Sato and Philip Yampolsky, New York:
 International Center of Photography, 1979.
- *Photography: Venice '79.* New York: Rizzoli, 1979.
- Holborn, Mark. *Black Sun: The Eyes of Four:
 Roots and Innovation in Japanese Photography.*
 New York: Aperture, 1986.
- ———. *Beyond Japan: A Photo Theater.* London:
 Barbican Art Gallery and Jonathan Cape, 1991.

BILINGUAL (ENGLISH AND JAPANESE)

- Szarkowski, John, and Shōji Yamagishi, eds. *New
 Japanese Photography / Nyū japanīzu fotogurafī.*
 New York: Museum of Modern Art, 1974.
- Yokoe, Fuminori. *Nihon no shashin 1970-
 nendai—tōketsu sareta toki no kioku / Japanese
 Photography in the 1970s—Memories Frozen in
 Time.* Tokyo: Tokyo Metropolitan Museum of
 Photography, 1991.
- Sekiji, Kazuko, and Takaaki Yoshimoto. *Shashin-
 toshi Tokyo / Tokyo: City of Photos.* Tokyo: Tokyo
 Metropolitan Museum of Photography, 1995.
- *Japanese Photography: Form In/Out.* Pt. 2. Tokyo:
 Tokyo Metropolitan Museum of Photography, 1996.

Photography Books by the Artist

- *Nippon gekijō shashinchō* (Japan: A photo
 theater). Tokyo: Muromachi shobō, 1968. Reprint,
 with a postscript by Daidō Moriyama, Tokyo:
 Shinchō-sha, Photo Musée, 1995. (The title of
 this book may also be translated as Nippon
 Theater.)
- *Kariudo / A Hunter.* Tokyo: Chūō-kōron-sha, 1972.
- *Shashin yo sayōnara* (Farewell photography).
 Tokyo: Shashin hyōronsha, 1972.
- *Kagerō* (Mayfly). Tokyo: Haga shoten, 1972.

- *Kiroku* (Document). 5 vols. Kanagawa: Privately
 printed, 1972–73.
- (*Mou hitotsu no kuni*) *Nyūyōku / Another
 Country in New York.* Privately printed, 1974.
- *Tōno monogatari* (The tales of Tōno). Tokyo: Asahi
 Sonorama, 1976.
- *Zoku nippon gekijō shashinchō* (Japan: A photo
 theater II). Tokyo: Asahi Sonorama, 1976.
- *Hikari to kage* (Light and shadow). Tokyo:
 Tōjusha, 1982.
- *Nakaji e no tabi* (A journey to Nakaji). Yokohama:
 Sōkyūsha, 1987.
- *Moriyama Daidō, 1970–1979.* Yokohama:
 Sōkyūsha, 1989.
- *San rū e no tegami / Lettre à St. Lou.* Tokyo:
 Kawade shobō shinsha, 1990.
- *Tokyo: Daidō Hysteric,* no. 4. Tokyo: Hysteric
 Glamour, 1993.
- *Color.* Yokohama: Sōkyūsha, 1993.
- *Tokyo: Daidō Hysteric,* no. 6. Tokyo: Hysteric
 Glamour, 1994.
- *Inu no toki* (The time of the dog). Tokyo:
 Sakuhinsha, 1995.
- *Imitation.* Tokyo: Taka Ishii Gallery, 1995.
- *Osaka: Daidō Hysteric,* no. 8. Tokyo: Hysteric
 Glamour, 1997.
- *Moriyama Daidō Kariudo / Hunter: For Jack
 Kerouac.* Tokyo: Taka Ishii Gallery, 1997.
- *Fragments: Representation of Moriyama Daidō
 1964–1998.* [S.l.]: Composite Press, 1998.

Books by the Artist

IN JAPANESE

- *Mazu tashikarashisa no sekai o suterō* (First,
 throw out verisimilitude). By Michiaki Amano,
 Daidō Moriyama, Takuma Nakahira, Takahiko
 Okada, Yutaka Takanashi, and Kōji Taki. Tokyo:
 Tabata shoten, 1970.
- *Inu no kioku* (Memories of a Dog). Tokyo: Asahi
 shinbunsha, 1984.

- *Shashin to no taiwa* (A dialogue with photography). Tokyo: Seikyūsha, 1985.
- *Shashin kara / Shashin e* (From photography / To photography). Tokyo: Seikyūsha, 1995.

Books about the Artist

IN JAPANESE

- Yoshimura, Nobuya. *Gendai shashin no meisaku kenkyū* (Study of the masterpieces of contemporary photography). Tokyo: Shashin hyūronsha, 1969.
- Nishii, Kazuo. *Naze imada Provoke ka: Moriyama Daidō, Nakahira Takuma, Araki Nobuyoshi no tōjō* (Why still *Provoke* now? The emergence of Daidō Moriyama, Takuma Nakahira, and Nobuyoshi Araki). Tokyo: Seikyūsha, 1996.
- Nagano, Shigekazu, ed. *Moriyama Daidō*. Nihon no shashinka (Photographers of Japan), no. 37. Tokyo: Iwanami shoten, 1997.

Articles by the Artist

IN JAPANESE

- Moriyama, Daidō, and Takuma Nakahira. "Shashin to iu kotoba o nakuse" (Abolish the word *photography*). *Design* (April 1969).
- Moriyama, Daidō, and Shōmei Tōmatsu. "Rensai taidan—shashin no naka no 'watashi' o megutte" (Series interview—on "myself" in photography). Parts 1–3. *Camera Mainichi* (October–December 1973): 54–57, 52–61, 68–71.
- Moriyama, Daidō, Kōichi Iijima, and Kōshi Ueno. "Moriyama Daidō hikari to kage" (Daidō Moriyama: Light and shadow). *Camera Mainichi* (November 1981): 155–58.
- "Nakahira Takuma o megutte" (On Takuma Nakahira). *Camera Mainichi* (April 1983): 141–50.
- "Shashin ni totte Zenkyōtō towa nandattanoka" (What the University-wide Joint Struggle Councils meant to photography). *Camera Mainichi* (October 1984): 44–45.

Articles about the Artist

IN ENGLISH

- Holborn, Mark. "Black Sun: The Eyes of Four." *Aperture,* no. 102 (spring 1986): 1–86.
- ———. "Standing in the Shadow." *Artforum* 24 (May 1986): 94–99.
- Matsumura, Akira. "Empathy: Contemporary Japanese Photography." *Afterimage* 15 (November 1987): suppl. 1–8.
- "Forty Years of Aperture: A Photographic History." *Aperture,* no. 129 (fall 1992): 1–79.

IN JAPANESE

- Watanabe, Tsutomu. "Moriyama Daidō: Kininaru shashinka no shōtai" (Daidō Moriyama: Truth about the photographer of the time). In *Gendai no shashin to shashinka: Intabyū hyōron 35-nin* (Contemporary photography and photographers: Interviews and critiques of thirty-five photographers). Tokyo: Asahi Sonorama, 1975.
- Nishii, Kazuo. "Moriyama Daidō no sekai" (The world of Daidō Moriyama). *Camera Mainichi* (November 1976): 50–56.
- Yanagimoto, Naomi. "*Provoke* no jidai: Chi no taihai to shikaku no chōhatsu" (The period of *Provoke:* Corruption of wisdom and provocation of vision). *Camera Mainichi* (October 1984): 55–60.
- Itō, Toshiharu. "Moriyama Daidō." In *Tokyo shintai eizō* (Tokyo image of the body). Tokyo: Heibonsha, 1990.
- Katō, Tetsurō. "Moriyama Daidō." In *Shōwa no shashinka* (Photographers of the Shōwa era). Tokyo: Shōbunsha, 1990.
- Iizawa, Kōtarō. "Moriyama Daidō 1938– / Takanashi Yutaka 1935– / Nakahira Takuma 1938–." In *Photographers*. Tokyo: Sakuhinsha, 1996.
- Fujieda, Teruo. "Sekai o tōkachi ni miru / Looking at the World with Unprejudiced Eyes." *Shashin Eizō* (Photo image), no. 3 (winter 1996): 100–103.

Most of Moriyama's titles refer to the places that are the subjects of his photographs, which are generally urban areas in Japan. Photographs of Tokyo include in their titles names of neighborhoods such as Aoyama, Gotokuji, Iidabashi, Kita-Senju, Otsuka, Setagaya, Shibuya, Shinbashi, and Shinjuku. Other works include in their titles Yokosuka, Misawa, Tachikawa, and Yokota, which were the sites of American military bases in Japan at the time the photographs were made.

Many of Moriyama's photographs initially appeared in magazines and then were later published in book form. They have rarely been presented in galleries as individual works but rather are considered parts of complex series. We have indicated where the photographs listed here were published using the following abbreviations to represent his major books: J for *Japan: A Photo Theater* (1968); H for *Hunter* (1972); F for *Farewell Photography* (1972); T for *The Tales of Tōno* (1976); L for *Light and Shadow* (1982); and S for *Lettre à St. Lou* (1990).

All works are gelatin silver prints unless otherwise indicated.

CATALOGUE OF THE EXHIBITION

1. From the series *Pantomime,* 1964. 9¾ x 7⅛ in. (24.8 x 18.1 cm). Collection of the Tokyo Institute of Polytechnics. Plate 96 [J]

2. From the series *Pantomime,* 1964 9¾ x 7¹⁄₁₆ in. (24.8 x 17.9 cm). Collection of the Tokyo Institute of Polytechnics. Plate 95 [J]

3. From the series *Pantomime,* 1964. 9¾ x 7⅛ in. (24.8 x 18.1 cm). Courtesy of the artist. [J]

4. *Lion's Club Members in Taito-ku, Tokyo,* 1965. 9⅜ x 6¾ in. (23.8 x 17.2 cm). Collection of the Tokyo Institute of Polytechnics. [J]

5. *Shinjuku Station,* 1965. 6⅝ x 8⅞ in. (16.8 x 22.5 cm). Collection of the Tokyo Institute of Polytechnics. Plate 17 [J]

6. *Yokosuka,* 1965. 8⅞ x 6⅝ in. (22.5 x 16.8 cm). Collection of the Tokyo Institute of Polytechnics. Plate 7 [J]

7. *Yokosuka,* 1965. 7 x 10 in. (17.8 x 25.4 cm). Collection of the Tokyo Institute of Polytechnics. [J]

8. *Yokosuka,* 1965. 10 x 7⅛ in. (25.4 x 18.1 cm). Collection of the Tokyo Institute of Polytechnics. [J]

9. *Yokosuka,* 1965. 9¾ x 7 in. (24.8 x 17.8 cm). Collection of the Tokyo Institute of Polytechnics. Plate 15

10. *Yokosuka,* 1965. 9¾ x 7 in. (24.8 x 17.8 cm). Collection of the Tokyo Institute of Polytechnics. Plate 5 [J]

11. *Zushi,* 1965. 6¾ x 8⅞ in. (17.2 x 22.5 cm). Collection of the Tokyo Institute of Polytechnics. Plate 4 [J]

12. *Actor,* 1966. 12³⁄₁₆ x 10 in. (31 x 25.4 cm). Collection of the San Francisco Museum of Modern Art. Fractional gift of Shirley Ross Sullivan, 98.447. Plate 18 [J]

13. *"Computer Age,"* 1966. 6³⁄₁₆ x 8⅞ in. (15.7 x 22.5 cm). Collection of the Tokyo Institute of Polytechnics. Plate 16 [J]

14. *Hanafuda Card Game in Her Room,* 1966. 6¾ x 9 in. (17.2 x 22.9 cm). Collection of the Tokyo Institute of Polytechnics. Plate 12 [J]

15. *Hayama,* 1966. 7⅛ x 10⅞ in. (18.1 x 27.6 cm). Collection of Sandra Lloyd. Plate 42 [H]

16. *Hiratsuka,* 1966. 10⅝ x 6⅞ in. (27 x 17.5 cm). Collection of Carla Emil and Rich Silverstein. Plate 14 [J]

17. *Kita-Senju,* 1966. 9⅝ x 6¹⁵⁄₁₆ in. (24.5 x 17.6 cm). Collection of the Tokyo Institute of Polytechnics. Plate 6 [J]

18. *Kita-Senju*, 1966. 9 x 6¾ in. (22.9 x 17.2 cm). Collection of the Tokyo Institute of Polytechnics. [J]

19. *Kita-Senju*, 1966. 7⅛ x 7⅞ in. (18.1 x 20 cm). Collection of the Tokyo Institute of Polytechnics. Plate 8 [J]

20. *Nude Studio, Shinjuku*, 1966. 9 x 6¼ in. (22.9 x 15.9 cm). Collection of the Tokyo Institute of Polytechnics. [J]

21. *Public Baths, Shinjuku*, 1966. 7⁹⁄₁₆ x 11⁵⁄₁₆ in. (19.2 x 28.7 cm). Collection of the Tokyo Institute of Polytechnics. Plate 41 [H]

22. *Shibuya*, 1966. 6¼ x 9 in. (15.9 x 22.9 cm). Collection of the Tokyo Institute of Polytechnics. Plate 2 [J]

23. *Yumenoshima, Tokyo*, 1966. 7⅛ x 10¹⁵⁄₁₆ in. (18 x 28.8 cm). Collection of Robin Wright Moll. Plate 24

24. *Kawasaki*, c. 1966. 6 x 9 in. (15.2 x 22.9 cm). Collection of the Tokyo Institute of Polytechnics. Plate 3 [J]

25. *Actor*, 1967. 9⅝ x 6¹³⁄₁₆ in. (24.5 x 17.3 cm). Collection of the Tokyo Institute of Polytechnics. [J]

26. *Actor, Tenjō Sajiki Theater*, 1967 9 x 6⅝ in. (22.9 x 16.8 cm). Collection of the Tokyo Institute of Polytechnics. [J]

27. *Actress, Tenjō Sajiki Theater*, 1967. 6⅛ x 9 in. (15.6 x 22.9 cm). Collection of the Tokyo Institute of Polytechnics. Plate 11 [J]

28. *A Castle for Two*, 1967. 6¹¹⁄₁₆ x 8¹⁵⁄₁₆ in. (17 x 22.7 cm). Collection of the Tokyo Institute of Polytechnics. [J]

29. From the film *Bonnie and Clyde*, 1967. 7⅛ x 9⅞ in. (18 x 25 cm) Collection of the Tokyo Institute of Polytechnics. Plate 9 [J]

30. *Housing Development, Tokyo*, 1967. 6¼ x 9 in. (15.9 x 22.9 cm). Collection of the Tokyo Institute of Polytechnics. Frontispiece [J]

31. *Housing Development, Tokyo*, 1967. 9 x 5⅞ in. (22.9 x 14.9 cm). Collection of the Tokyo Institute of Polytechnics. Plate 10 [J]

32. *Otsuka*, 1967. 7 x 9⅝ in. (17.8 x 24.5 cm). Collection of the Tokyo Institute of Polytechnics. [J]

33. *Shibuya*, 1967. 6¾ x 9 in. (17.2 x 22.9 cm). Collection of the Tokyo Institute of Polytechnics. Plate 13 [J]

34. *Shibuya*, 1967. 9 x 6⅝ in. (22.9 x 16.8 cm). Collection of the Tokyo Institute of Polytechnics. [J]

35. *Underground Actress, Tenjō Sajiki, Tokyo*, 1967. 8¹⁵⁄₁₆ x 7¼ in. (22.7 x 18.4 cm). Collection of the Tokyo Institute of Polytechnics. [J]

36. *Shinbashi*, c. 1967. 9⅞ x 7⅛ in. (25 x 18 cm). Collection of the Tokyo Institute of Polytechnics. [J]

37. *Shinjuku*, c. 1967. 5⅞ x 9⅜ in. (14.9 x 23.8 cm). Collection of the Tokyo Institute of Polytechnics. [J]

38. *Accident, Tomei Expressway*, 1968. 9⅝ x 11¹⁵⁄₁₆ in. (24.5 x 30.3 cm). Collection of the Tokyo Institute of Polytechnics.

39. *Coffee Shop, Hamamatsu*, 1968. 7 x 10⅝ in. (17.8 x 27 cm). Collection of the San Francisco Museum of Modern Art. Accessions Committee Fund, 98.446. Plate 26 [H]

40. *Dawn, Route 1, Shizuoka*, 1968. 7⅝ x 11⅜ in. (19.4 x 28.9 cm). Collection of the Tokyo Institute of Polytechnics. [H]

41. *Maiko, Kyoto*, 1968. 11⁹⁄₁₆ x 8½ in. (29.4 x 21.6 cm). Collection of the Tokyo Institute of Polytechnics. [H]

42. *North Vietnam, Television News*, 1968. 7½ x 9¼ in. (19.1 x 23.5 cm). Collection of the Tokyo Institute of Polytechnics. Figure 12

43. *Osaka*, 1968. 7⅞ x 11⁵⁄₁₆ in. (20 x 30.3 cm). Collection of the Tokyo Institute of Polytechnics. [H]

44. *Pilgrimage Road, Tokushima*, 1968. 7½ x 11⅛ in. (19.1 x 28.3 cm). Collection of the Tokyo Institute of Polytechnics. [J]

45. *Stripper*, 1968. 8⅞ x 10⅝ in. (22.5 x 27 cm). Collection of the artist. Entrusted to the National Museum of Modern Art, Tokyo. Plate 34 [J]

46. *Television News*, 1968. 6¼ x 9⅜ in. (15.9 x 23.8 cm). Collection of the Tokyo Institute of Polytechnics.

47. *Tire, Yokkaichi*, 1968. 7⅝ x 11¹¹⁄₁₆ in. (19.4 x 29.7 cm). Collection of the San Francisco Museum of Modern Art. Anonymous gift, 81.165. Plate 21 [H]

48. *Yokkaichi*, 1968. 18¹⁵⁄₁₆ x 10⅞ in. (48 x 27.6 cm). Zeit-Foto. [H]

49. *Tomei Expressway*, c. 1968. 7⅞ x 11⁹⁄₁₆ in. (20 x 29.4 cm). Collection of the Tokyo Institute of Polytechnics. Plate 1

50. *Tomei Expressway*, c. 1968. 8 x 11⅞ in. (20.3 x 30.2 cm). Collection of the Tokyo Institute of Polytechnics.

51. *Tomei Expressway*, c. 1968. 8¹¹⁄₁₆ x 11⅞ in. (22.1 x 30.2 cm). Collection of the Tokyo Institute of Polytechnics.

52. *Tomei Expressway*, c. 1968. 8⁵⁄₁₆ x 11⅞ in. (21.1 x 30.2 cm). Collection of the Tokyo Institute of Polytechnics.

53. *Accident*, 1968–70. 8¼ x 12 in. (21 x 30.5 cm). Collection of the Tokyo Institute of Polytechnics. [F]

54. *Chickens*, 1968–70. 6¹³⁄₁₆ x 9⁹⁄₁₆ in. (17.3 x 24.3 cm). Collection of the Tokyo Institute of Polytechnics.

55. *Gutter*, 1968–70. 6⅞ x 9⅝ in. (17.5 x 24.5 cm). Collection of the Tokyo Institute of Polytechnics.

56. *In the Train*, 1968–70. 6⅞ x 9⅝ in. (17.5 x 24.5 cm). Collection of the Tokyo Institute of Polytechnics. Plate 57

57. *Postal Delivery Truck*, 1968–70. 6¹³⁄₁₆ x 9⅝ in. (17.3 x 24.5 cm). Collection of the Tokyo Institute of Polytechnics. [F]

58. *Poster, Shinjuku*, 1968–70. 10¹¹⁄₁₆ x 6⁵⁄₁₆ in. (27.2 x 16 cm). Collection of the Tokyo Institute of Polytechnics.

59. *Professional Midget Wrestling, Television*, 1968–70. 7⅜ x 10⁹⁄₁₆ in. (18.7 x 26.8 cm). Collection of the Tokyo Institute of Polytechnics. Plate 58 [F]

60. *Roadside*, 1968–70. 7⅞ x 9⅝ in. (20 x 24.5 cm). Collection of the Tokyo Institute of Polytechnics.

61. *Stairs in Subway*, 1968–70. 6⅞ x 9⅝ in. (17.5 x 24.5 cm). Collection of the Tokyo Institute of Polytechnics.

62. *Street*, 1968–70. 6¹⁵⁄₁₆ x 9¹¹⁄₁₆ in. (17.6 x 24.6 cm). Collection of the Tokyo Institute of Polytechnics. [F]

63. *Street*, 1968–70. 6¹³⁄₁₆ x 9½ in. (17.3 x 24.1 cm). Collection of the Tokyo Institute of Polytechnics. Plate 59

64. *Subway*, 1968–70. 9⁹⁄₁₆ x 6¾ in. (24.3 x 17.2 cm). Collection of the Tokyo Institute of Polytechnics.

65. *Subway*, 1968–70. 6⅞ x 9⅝ in. (17.5 x 24.5 cm). Collection of the Tokyo Institute of Polytechnics.

66. *Subway*, 1968–70. 7 x 9⅝ in. (17.8 x 24.5 cm). Collection of the Tokyo Institute of Polytechnics. Plate 61

67. *Television*, 1968–70. 7¾ x 9¾ in. (19.7 x 24.8 cm). Collection of the Tokyo Institute of Polytechnics. Plate 55

68. *Tokyo Hotel*, 1968–70. 7⁵⁄₁₆ x 9¹¹⁄₁₆ in. (18.6 x 24.6 cm). Collection of the Tokyo Institute of Polytechnics.

69. *Tokyo, Night*, 1968–70. 7⁵⁄₁₆ x 9¾ in. (18.6 x 24.8 cm). Collection of the Tokyo Institute of Polytechnics. Plate 63

70. *Tokyo Subway*, 1968–70. 6¹⁵⁄₁₆ x 9⅝ in. (17.6 x 24.5 cm). Collection of the Tokyo Institute of Polytechnics.

71. From the series *Accident*, 1969. 12 x 8⅛ in. (30.5 x 20.6 cm). Collection of the Tokyo Institute of Polytechnics. Plate 65

72. From the series *Accident*, 1969. 12 x 8³⁄₁₆ in. (30.5 x 20.8 cm). Collection of the Tokyo Institute of Polytechnics. Plate 66

73. *Accident at Sea, Chōshi, Chiba*, 1969. 10¼ x 7⅜ in. (26 x 18.7 cm). Collection of the Tokyo Institute of Polytechnics.

74. *Accident at Sea, Chōshi, Chiba*, 1969. 11⅞ x 8⁹⁄₁₆ in. (30.2 x 21.8 cm). Collection of the Tokyo Institute of Polytechnics.

75. *Accident at Sea, Chōshi, Chiba*, 1969. 7⅜ x 10¼ in. (18.7 x 26 cm). Collection of the Tokyo Institute of Polytechnics. Plate 43 [H]

76. *Accident at Sea, Chōshi, Chiba*, 1969. 11⁹⁄₁₆ x 7¾ in. (29.4 x 19.7 cm). Collection of the Tokyo Institute of Polytechnics. Plate 44 [H]

77. *American Base, Route 16, Yokota*, 1969. 7⁹⁄₁₆ x 11½ in. (19.2 x 29.2 cm). Collection of the Tokyo Institute of Polytechnics. Plate 27 [H]

78. *Aoyama*, 1969. 9⅜ x 11⅞ in. (23.8 x 30.2 cm). Collection of the Tokyo Institute of Polytechnics.

79. *Aoyama*, 1969. 8½ x 11⅞ in. (21.6 x 30.2 cm). Collection of the Tokyo Institute of Polytechnics. Plate 51

80. *Aoyama*, 1969. 8¾ x 11½ in. (22.2 x 29.2 cm). Collection of the Tokyo Institute of Polytechnics. Plate 52

81. *Aoyama*, 1969. 8¾ x 11⅝ in. (22.2 x 29.5 cm). Collection of the Tokyo Institute of Polytechnics. Plate 54

82. *Aoyama*, 1969. 8 x 11½ in. (20.3 x 29.2 cm). Collection of the Tokyo Institute of Polytechnics.

83. *Aoyama*, 1969. 7¾ x 11⅝ in. (19.7 x 29.5 cm). Collection of the Tokyo Institute of Polytechnics.

84. *Brigitte Bardot Poster, Aoyama*, 1969. 9³⁄₈ x 11⁹⁄₁₆ in. (23.8 x 29.4 cm). Collection of the Tokyo Institute of Polytechnics. Plate 38 [H]

85. *Detail from Police Safety Poster*, 1969. 12 x 8⅛ in. (30.5 x 20.6 cm). Collection of the Tokyo Institute of Polytechnics.

86. *Detail from Police Safety Poster*, 1969. 12 x 8⅛ in. (30.5 x 20.6 cm). Collection of the Tokyo Institute of Polytechnics.

87. *Detail from Police Safety Poster*, 1969. 11¹⁵⁄₁₆ x 8¼ in. (30.3 x 21 cm). Collection of the Tokyo Institute of Polytechnics. Plate 64

88. *Detail from Police Safety Poster*, 1969. 11¹⁵⁄₁₆ x 8¾ in. (30.3 x 22.2 cm). Collection of the Tokyo Institute of Polytechnics.

89. From the film *Bonnie and Clyde*, 1969. 8⅛ x 11⁹⁄₁₆ in. (20.6 x 29.4 cm). Collection of the Tokyo Institute of Polytechnics. Plate 37 [H]

90. *Hallmark Card*, 1969. Silkscreen. 12⅞ x 10⅛ in. (32.7 x 25.7 cm). Takayuki Komori Collection.

91. *Hotel, Shibuya*, 1969. 7⅛ x 10⅞ in. (18.1 x 27.6 cm). Private collection. Plate 47 [H]

92. *Hotel, Shibuya*, 1969. 7⅛ x 10⅞ in. (18 x 27.6 cm). Private collection. [H]

93. *Hotel, Shibuya*, 1969. 4⅞ x 7⅜ in. (12 x 18.7 cm). Private collection.

94. *Hotel, Shibuya*, 1969. 4⅞ x 7⅜ in. (12 x 18.7 cm). Private collection.

95. *Hotel, Shibuya*, 1969. 8 x 11⅞ in. (20.3 x 30.2 cm). Collection of the Tokyo Institute of Polytechnics. [H]

96. *Hotel, Shibuya*, 1969. 8 x 11½ in. (20.3 x 29.2 cm). Collection of the Tokyo Institute of Polytechnics.

97. *Hotel, Shibuya*, 1969. 12 x 8¾ in. (30.5 x 22.2 cm). Collection of the Tokyo Institute of Polytechnics. Plate 53

98. *Hotel, Shibuya*, 1969. 4¾ x 7⅜ in. (12.1 x 18.7 cm). Collection of the Tokyo Institute of Polytechnics.

99. *Hotel, Shibuya*, 1969. 4⅞ x 7⅜ in. (12.4 x 18.7 cm). Collection of the Tokyo Institute of Polytechnics. Plate 49

100. *Hotel, Shibuya*, 1969. 7⁷⁄₁₆ x 11³⁄₈ in. (18.9 x 28.9 cm). Collection of the Tokyo Institute of Polytechnics.

101. *Hotel, Shibuya*, 1969. 4¾ x 7⁷⁄₁₆ in. (12.1 x 18.9 cm). Collection of the Tokyo Metropolitan Museum of Photography.

102. *Hotel, Shibuya*, 1969. 4¾ x 7⁷⁄₁₆ in. (12.1 x 18.9 cm). Collection of the Tokyo Metropolitan Museum of Photography. Plate 50

103. *Police Safety Poster*, 1969. 7⅜ x 10⁹⁄₁₆ in. (18.7 x 26.8 cm). Collection of the Tokyo Institute of Polytechnics. Plate 62 [H]

104. *Room, Tokyo*, 1969. 8¹⁄₁₆ x 11¾ in. (20.5 x 29.9 cm). Collection of the San Francisco Museum of Modern Art. Purchased through a gift of Carla Emil and Rich Silverstein, 98.45. Plate 35 [H]

105. *Route 16*, 1969. 8⅛ x 12 in. (20.6 x 30.5 cm). Collection of the Tokyo Institute of Polytechnics.

106. *Route 16, Kanagawa*, 1969. 7³⁄₁₆ x 10¹⁵⁄₁₆ in. (18.2 x 27.8 cm). Private collection. [H]

107. *Route 16, Kanagawa*, 1969. 7⅛ x 10¹¹⁄₁₆ in. (18.1 x 27.2 cm). Private collection. Plate 23 [H]

108. *Route 16, Saitama*, 1969. 7³⁄₈ x 11⁵⁄₁₆ in. (18.7 x 28.3 cm). Collection of the Tokyo Institute of Polytechnics. Plate 40 [H]

109. *Route 16, Tachikawa*, 1969. 5⁷⁄₁₆ x 8³⁄₁₆ in. (13.8 x 20.8 cm). Collection of the Tokyo Institute of Polytechnics. Plate 31 [H]

110. *Route 16, Yokota*, 1969. 8⅛ x 11⅛ in. (20.6 x 28.3 cm). Collection of the Tokyo Institute of Polytechnics. Plate 19 [H]

111. *Scandal*, 1969. 8¼ x 11¾ in. (21 x 29.9 cm). Collection of the Tokyo Institute of Polytechnics.

112. *Scandal*, 1969. 8¼ x 11⅞ in. (21 x 30.2 cm). Collection of the Tokyo Institute of Polytechnics. Plate 32 [H]

113. *Setagaya, Tokyo*, 1969. 8 x 11½ in. (20.3 x 29.2 cm). Collection of the Tokyo Institute of Polytechnics. Plate 36 [H]

114. *Shinjuku*, 1969. 7¹³⁄₁₆ x 10¹¹⁄₁₆ in. (19.9 x 27.2 cm). Collection of the Tokyo Institute of Polytechnics. Plate 29 [H]

115. *Shinjuku (October 21 International Peace Day Demonstration)*, 1969. 12 x 9 in. (30.5 x 22.9 cm). Collection of the Tokyo Institute of Polytechnics.

116. *Zushi*, 1969. 7³⁄₈ x 10½ in. (18.7 x 26.7 cm). Collection of the Tokyo Institute of Polytechnics. [H]

117. *Shinjuku*, c. 1969. 13¼ x 17 in. (33.7 x 43.2 cm). Courtesy of the artist.

118. *Akasaka Prince Hotel, Tokyo*, 1970. 8¹/₁₆ x 11¹¹/₁₆ in. (20.5 x 29.7 cm). Collection of Robin Wright Moll. [H]

119. *Amagasaki, Hyōgo*, 1970. 8⁵/₈ x 11⁵/₈ in. (21.9 x 29.5 cm). Takayuki Komori Collection.

120. *Bikeriders, Yokohama*, 1970. 7³/₁₆ x 10¹⁵/₁₆ in. (18.3 x 27.8 cm). Courtesy of Zeit-Foto. Plate 30 [H]

121. *Ferry, Inland Sea*, 1970. 7 x 10⁵/₈ in. (17.8 x 27 cm). Collection of Jane Levy Reed. Plate 39 [H]

122. *Sunset, Osaka*, 1970. 7 x 10³/₄ in. (17.8 x 27.3 cm). Collection of the Prentice and Paul Sack Photographic Trust of the San Francisco Museum of Modern Art. Plate 46 [H]

123. *Woman on Street, Tokyo*, 1970. 10¹/₂ x 7³/₈ in. (26.7 x 18.7 cm). Collection of the Tokyo Institute of Polytechnics. Plate 60 [F, H]

124. *Yokosuka*, 1970. 10⁷/₁₆ x 6⁷/₈ in. (26.5 x 17.5 cm). Collection of Sandra Lloyd. Plate 28 [H]

125. *Coffee Shop, Kobe*, 1971. 7⁵/₈ x 11⁵/₈ in. (19.4 x 29.5 cm). Collection of the Tokyo Institute of Polytechnics. [H]

126. *Dam Site Construction from Film Screen, Nagano*, 1971. 7³/₈ x 11⁹/₁₆ in. (18.7 x 29.4 cm). Collection of the Tokyo Institute of Polytechnics. Plate 45

127. *Kushiro, Hokkaido*, 1971. 7³/₁₆ x 10¹⁵/₁₆ in. (18.3 x 27.8 cm). Collection of the Prentice and Paul Sack Photographic Trust of the San Francisco Museum of Modern Art. [H]

128. *Kushiro, Hokkaido*, 1971. 7 x 10⁵/₈ in. (17.8 x 27 cm). Collection of the Tokyo Institute of Polytechnics. Plate 20 [H]

129. *Misawa, Aomori*, 1971. 9¹/₈ x 11⁵/₈ in. (23.2 x 29.6 cm). Collection of the Tokyo Institute of Polytechnics. Plate 33 [H]

130. *Misawa, Aomori*, 1971. 7³/₄ x 11³/₈ in. (19.7 x 28.9 cm). Collection of the Tokyo Institute of Polytechnics. [H]

131. *Noto Peninsula, Ishikawa*, 1971. 7³/₄ x 11⁵/₈ in. (19.7 x 29.6 cm). Collection of the Tokyo Institute of Polytechnics. [H]

132. *Noto Peninsula, Ishikawa*, 1971. 7⁵/₈ x 11³/₈ in. (19.4 x 28.9 cm). Collection of the Tokyo Institute of Polytechnics. [H]

133. *Stray Dog, Misawa, Aomori*, 1971. 7⁹/₁₆ x 11¹¹/₁₆ in. (19.2 x 29.7 cm). Collection of the San Francisco Museum of Modern Art. Gift of Van Deren Coke, 80.320. Front cover, plate 22 [H]

134. *Yokohama, Kanagawa*, 1971. 7³/₁₆ x 11⁹/₁₆ in. (18.3 x 29.4 cm). Collection of the Tokyo Institute of Polytechnics. [H]

135. *Cherry Blossoms, Nagano*, 1972. 7³/₄ x 11³/₄ in. (19.7 x 29.8 cm). Courtesy of the artist.

136. *Cherry Blossoms, Nagano*, 1972. 9¹/₁₆ x 11³/₄ in. (23 x 29.9 cm). Collection of the Tokyo Institute of Polytechnics. Plate 70

137. *Cherry Blossoms, Nagano*, 1972. 7³/₄ x 11³/₄ in. (19.7 x 29.8 cm). Collection of the Tokyo Institute of Polytechnics.

138. *Cherry Blossoms, Nagano*, 1972. 8¹/₁₆ x 11¹¹/₁₆ in. (20.5 x 29.7 cm). Collection of Takeo Moriya. Plate 67

139. *Game Center, Yokohama*, 1972. 7¹/₈ x 11⁹/₁₆ in. (18.1 x 29.4 cm). Collection of the Tokyo Institute of Polytechnics. Plate 25 [H]

140. *Cherry Blossoms, Nagano*, 1972–75. Photo silkscreen. Three panels, 22¹/₁₆ x 22³/₁₆ in. (56 x 56.3 cm) each. Collection of Koko Yamagishi.

141. *Tokyo Station, Tokyo*, 1973. 8¹/₁₆ x 11¹¹/₁₆ in. (20.4 x 29.7 cm). Collection of Dr. Eugene H. Rogolsky.

142. *Yubari, Hokkaido*, 1973. 12⁵/₁₆ x 17⁵/₁₆ in. (31.3 x 44 cm). Collection of Takeo Moriya.

143. *Osaka*, c. 1973. 8⁷/₁₆ x 12 in. (21.4 x 30.5 cm). Takayuki Komori Collection. Plate 48

144. *Cabbage*, 1974. 7¹/₄ x 11 in. (18.4 x 27.9 cm). Courtesy of Laurence Miller Gallery, New York City. [T]

145. *Matsushima, Miyagi*, 1974. 7³/₈ x 10¹³/₁₆ in. (18.7 x 27.4 cm). Collection of Kenji Shimoda. Plate 68

146. *Miyajima, Hiroshima*, 1974. 7¹/₈ x 10¹¹/₁₆ in. (18.1 x 27.2 cm). Collection of Kenji Shimoda. Plate 69

147. From the series *The Tales of Tōno*, 1974. 10 x 12¹/₄ in. (25.4 x 31.1 cm). Private collection. [T]

148. From the series *The Tales of Tōno*, 1974. 13¹¹/₁₆ x 16⁵/₈ in. (34.7 x 42.2 cm). Collection of the Shimane Art Museum. Plate 71 [T]

149. From the series *The Tales of Tōno*, 1974. 13⁵/₈ x 16⁹/₁₆ in. (34.6 x 42.1 cm). Collection of the Shimane Art Museum. [T]

150. From the series *The Tales of Tōno*, 1974. 13¹¹/₁₆ x 16⁹/₁₆ in. (34.7 x 42.1 cm). Collection of the Shimane Art Museum. [T]

151. From the series *The Tales of Tōno*, 1974. 13¹¹/₁₆ x 16⁹/₁₆ in. (34.8 x 42 cm). Collection of the Shimane Art Museum. [T]

152. From the series *The Tales of Tōno*, 1974. 13⁹/₁₆ x 16⁹/₁₆ in. (34.5 x 42 cm). Collection of the Shimane Art Museum. Plate 74 [T]

153. From the series *The Tales of Tōno*, 1974. 13¹¹/₁₆ x 16⁹/₁₆ in. (34.7 x 42.1 cm). Collection of the Shimane Art Museum. [T]

154. From the series *The Tales of Tōno*, 1974. 13⁵/₈ x 16⁵/₈ in. (34.6 x 42.2 cm). Courtesy of Zeit-Foto. [T]

155. From the series *The Tales of Tōno*, 1974. 13⁵/₈ x 16⁵/₈ in. (34.6 x 42.2 cm). Courtesy of Zeit-Foto. [T]

156. From the series *The Tales of Tōno*, 1974. 13¹¹/₁₆ x 16⁵/₈ in. (34.7 x 42.3 cm). Courtesy of Zeit-Foto. Plate 72 [T]

157. From the series *The Tales of Tōno*, 1974. 13⁵/₈ x 16⁵/₈ in. (34.6 x 42.2 cm). Courtesy of Zeit-Foto. Plate 73 [T]

158. *Tōno, Iwate*, 1974. 7¹/₁₆ x 10¹¹/₁₆ in. (17.9 x 27.2 cm). Private collection. [T]

159. *Lips from a Poster*, 1975. 8⁷/₁₆ x 11¹³/₁₆ in. (21.4 x 30 cm). Collection of the Tokyo Institute of Polytechnics. Plate 56

160. *Hakodate, Hokkaido*, 1977. 8¹/₁₆ x 11⁵/₈ in. (20.5 x 29.6 cm). Collection of Takeo Moriya.

161. *A Cat*, late 1970s. 8¹/₄ x 11¹/₁₆ in. (21 x 28 cm). Courtesy of the artist. [L]

162. *Zushi*, 1980. 7³/₄ x 11³/₄ in. (19.7 x 29.9 cm). Courtesy of the artist. [L]

163. *Kamakura*, 1981. 7³/₄ x 11¹³/₁₆ in. (19.7 x 30 cm). Courtesy of the artist. Plate 77 [L]

164. *A Man in the Train, Yokosuka Line*, 1981. 17⁵/₈ x 21⁵/₈ in. (44.8 x 54.9 cm). Kushiro Art Museum, Hokkaido. Plate 78 [L]

165. *Nagano*, 1981. 17⁵/₈ x 21⁵/₈ in. (44.8 x 54.9 cm). Kushiro Art Museum, Hokkaido. Plate 80 [L]

166. *Sakata, Yamagata*, 1981. 9¹/₂ x 12¹/₈ in. (24.1 x 30.8 cm). Takayuki Komori Collection.

167. *Shibuya*, 1981. 9¹/₄ x 13⁵/₈ in. (23.5 x 34.6 cm). Courtesy of the artist. Plate 82 [L]

168. *Tachikawa*, 1981. 17⅝ x 21⅝ in. (44.7 x 54.9 cm). Collection of the Kushiro Art Museum, Hokkaido. [L]

169. *Tachikawa*, 1981. 17⅝ x 21⁹⁄₁₆ in. (44.8 x 54.8 cm). Collection of the Kushiro Art Museum, Hokkaido. [L]

170. *Tokyo*, 1981. 9¼ x 13⅝ in. (23.5 x 34.6 cm). Courtesy of the artist. Plate 86 [L]

171. *Towel, Sakata, Yamagata*, 1981. 12⅛ x 9¼ in. (30.8 x 23.5 cm). Takayuki Komori Collection.

172. *Yokota*, 1981. 8⅛ x 11⅞ in. (20.6 x 30.2 cm). Courtesy of the artist. [L]

173. *Shibuya*, c. 1981. 17⁹⁄₁₆ x 21⅝ in. (44.6 x 54.9 cm). Collection of the San Francisco Museum of Modern Art. Accessions Committee Fund, 93.222. Plate 76

174. *Suwa, Nagano*, 1982. 8¼ x 11¾ in. (21 x 29.9 cm). Courtesy of the artist. Plate 84 [S]

175. *Yokohama*, 1982. 12⅞ x 17 in. (32.7 x 43.2 cm). Courtesy of the artist. Plate 75 [L]

176. *Aoyama*, 1983. 13½ x 9¼ in. (34.3 x 23.5 cm). Courtesy of the artist. [S]

177. *A Place in the Sun—Sakuragaoka, Shibuya*, 1983. Gelatin silver transfer print (Polaroid). 24⁵⁄₁₆ x 21¹⁄₁₆ in. (61.7 x 53.5 cm). Collection of the National Museum of Modern Art, Tokyo.

178. *A Place in the Sun—Sakuragaoka, Shibuya*, 1983. Gelatin silver transfer print (Polaroid). 24⁵⁄₁₆ x 21¹⁄₁₆ in. (61.7 x 53.5 cm). Collection of the National Museum of Modern Art, Tokyo.

179. *A Place in the Sun—Sakuragaoka, Shibuya*, 1983. Gelatin silver transfer print (Polaroid). 24 x 20 in. (61 x 50.8 cm). Collection of the San Francisco Museum of Modern Art. Accessions Committee Fund, 98.245. Plate 89

180. *Setagaya*, 1985. 9¼ x 14 in. (23.5 x 35.6 cm). Collection of the San Francisco Museum of Modern Art. Accessions Committee Fund, 92.237. [S]

181. *Gotokuji*, c. 1985. 13¾ x 17 in. (34.9 x 43.2 cm). Courtesy of the artist. Plate 87 [S]

182. *Setagaya, Tokyo*, 1986. 13⅝ x 9⅛ in. (34.6 x 23.2 cm). Courtesy of the artist. [S]

183. *Yamanashi*, 1987. 9⅛ x 13⅝ in. (23.2 x 34.6 cm). Courtesy of the artist. Plate 83

184. *Shibuya*, 1988. 9⅛ x 13⅝ in. (23.2 x 34.6 cm). Courtesy of the artist. Plate 85 [S]

185. *Shibuya*, c. 1990. 13⅝ x 9½ in. (34.6 x 24.1 cm). Courtesy of the artist. Plate 81 [S]

186. *Shimoda, Shizuoka*, 1992. 17 x 14 in. (43.2 x 35.6 cm). Collection of the San Francisco Museum of Modern Art. Members of Foto Forum, 95.76. Plate 79

187. *Iidabashi, Tokyo*, 1993. 23½ x 37½ in. (59.7 x 95.3 cm). Courtesy of the artist.

188. *Monzen-naka-chō, Tokyo*, 1993. 23½ x 37½ in. (59.7 x 95.3 cm). Courtesy of the artist. Plate 88

189. *Shibuya*, 1993. 23½ x 37½ in. (59.7 x 95.3 cm). Courtesy of the artist.

190. *Osaka*, 1996. 42 x 26 in. (106.7 x 66 cm). Courtesy of the artist.

191. *Osaka*, 1996. 42 x 26 in. (106.7 x 66 cm). Courtesy of the artist.

192. *Osaka*, 1996. 42 x 26 in. (106.7 x 66 cm). Courtesy of the artist. Plate 91

193. *Osaka*, 1996. 42 x 26 in. (106.7 x 66 cm). Courtesy of the artist. Plate 93

194. *Osaka*, 1996. 42 x 26 in. (106.7 x 66 cm). Courtesy of the artist. Plate 94

195. *Osaka*, 1996. 42 x 26 in. (106.7 x 66 cm). Courtesy of the artist.

196. *Osaka*, 1996. 42 x 26 in. (106.7 x 66 cm). Courtesy of the artist. Plate 90

197. *Osaka*, 1996. 31½ x 46 in. (80 x 116.8 cm). Courtesy of the artist.

198. *Osaka*, 1996. 31½ x 46 in. (80 x 116.8 cm). Courtesy of the artist.

199. *Osaka*, 1996. 31½ x 46 in. (80 x 116.8 cm). Courtesy of the artist. Plate 92

200. *Osaka*, 1996. 30½ x 46 in. (77.5 x 116.8 cm). Courtesy of the artist.

201. *Polaroid. Polaroid*, 1997. Gelatin silver transfer prints (Polaroids). 3,400 photographs, 4 x 4 in. (10.2 x 10.2 cm) each. Courtesy of the artist.

Books and Periodicals

202. Daidō Moriyama. *Japan: A Photo Theater*, 1968. Offset lithography. 8⅝ x 8¼ x ¾ in. (21.8 x 21 x 2 cm) (closed). Collection of the San Francisco Museum of Modern Art. Library.

203. Daidō Moriyama et al. *Provoke 2*, 1969. Offset lithography. 9½ x 7 x ¼ in. (24.1 x 17.8 x 1 cm) (closed). Collection of the San Francisco Museum of Modern Art. Library.

204. Daidō Moriyama et al. *Provoke 3*, 1969. Offset lithography. 9⁷⁄₁₆ x 7¼ x ⅜ in. (24 x 18.4 x 1 cm) (closed). Collection of the San Francisco Museum of Modern Art. Library.

205. Daidō Moriyama. *Hunter*, 1972. Offset lithography. 10⁷⁄₁₆ x 8⁹⁄₁₆ x ¹¹⁄₁₆ in. (26.5 x 21.8 x 1.7 cm). Collection of Koko Yamagishi.

206. Daidō Moriyama. *Farewell Photography*, 1972. Offset lithography. 9 x 7¼ x ¾ in. (23 x 18.4 x 2 cm) (closed). Collection of the San Francisco Museum of Modern Art. Library.

207. Daidō Moriyama. *Document 5: 6.12.73 Baseball Park*, 1973. Offset lithography. 10⅜ x 7⅝ x ¹⁄₁₆ in. (26.4 x 19.4 x 1 cm) (closed). Collection of the San Francisco Museum of Modern Art. Library.

208. Daidō Moriyama. *Another Country in New York*, 1974. Silkscreen cover with electrographic prints. Cover: 12½ x 8½ x ⅛ in. (32 x 22 x 0.32 cm) (closed). Twenty-two loose sheets, 11⅝ x 8⅜ in. (29.5 x 21.3 cm) each. Collection of the San Francisco Museum of Modern Art. Library.

209. Daidō Moriyama. *The Tales of Tōno*, 1976. Offset lithography. 6¾ x 4½ x ½ in. (17.2 x 11.4 x 1.3 cm) (closed). Collection of the San Francisco Museum of Modern Art. Library.

210. Daidō Moriyama. *Toyko: Daidō Hysteric*, no. 4, 1993. Offset lithography. 14¼ x 12⅜ x ⅝ in. (36.2 x 31.4 x .6 cm) (closed). Collection of the San Francisco Museum of Modern Art. Library.

211. Daidō Moriyama. *Toyko: Daidō Hysteric*, no. 6, 1994. Offset lithography. 14¼ x 12⅜ x ⅝ in. (36.2 x 31.4 x .6 cm) (closed). Collection of the San Francisco Museum of Modern Art. Library.

212. Daidō Moriyama. *Osaka: Daidō Hysteric*, no. 8, 1997. Offset lithography. 14¼ x 12⅜ x ¾ in. (36.2 x 31.4 x .8 cm) (closed). Collection of the San Francisco Museum of Modern Art. Library.